The Artist by Himself

Self-portrait drawings from youth to old age

THE ARTIST BY HIMSELF

*Self-portrait drawings
from youth to old age*

Edited by Joan Kinneir
Introduction by David Piper

St Martin's Press
New York

Printed in Great Britain

First published in the United States of America in 1980

Library of Congress Cataloging in Publication Data

Main entry under title:
The Artist by himself.
 1. Self-portraits. 2. Portrait drawing.
 I. Kinneir, Joan.
 NC772.A77 743'.9'2 79–20726
 ISBN 0–312–05498–X

Contents

Acknowledgements

It has been a very great pleasure to meet and correspond with artists and their families who have so very generously allowed drawings and text to be included in this book. Without exception they have given much time, understanding help and unique information. My thanks go to Luke Gertler, Mrs. Marjorie Kostenz, Mrs. Renée Diamond; Mrs. Laura Hockney, the late Mr. Kenneth Hockney, David Hockney; Masuo Ikeda; Miss Sara John, Sir Caspar John, the late Edwin John, Ben John; Henry Moore and Mrs. Betty Tinsley, his secretary; Claes Oldenburg; John Bensusan-Butt, nephew of Lucien Pissarro; Mme. Arï Redon; Mme. Isabelle Rouault; "Papas"; Mrs. Edmund Schilling; Miss Shirin Spencer, Miss Unity Spencer; Richard Carline; Graham and Katharine Sutherland.

Friends old and new have undertaken all the special translations with the greatest dedication and have played an invaluable part in the making of the book. I thank Dr. Karel Bostoen, Denis Brearley, Caroline Bridger and Señor Guillermo Diaz-Plaja (from whose book *Epistolario de Goya* the Spanish text of Goya's letters was taken), Evelyn Burges, Gertrude Cuthbertson (for this and much besides), Karin Hartmann, Kjersti Kolstad, Judith Landry, Sylvia Matthews, Grete and Otto Meyer, Yasu Mizoguchi, Joseph lo Piccolo, Antoinette and Nigel Rubbra, Eveline Vaane (for help in so many ways), Elizabeth Yates and Maria Saekel-Jelkman. I would also like to remember here Lisa Bass and Leonora Hodakova, my interpreters in Leningrad and Moscow.

I should like to thank the individual owners of works who have kindly allowed them to be reproduced: Alexander Glezer, Mrs. Olga Matthiesen, Mme. Dina Vierny, and the owners of the Matisse, the Picasso and the Spencer self-portraits. Also I have appreciated individual help from the keepers, curators and directors of museums and galleries as follows: Robin Adèr at the Museum Boymans-van Beuningen, Rotterdam; Dr. J. L. Locher at the Gemeentemuseum, The Hague; Kenneth Garlick and Christopher Lloyd at the Ashmolean Museum, Oxford, and Reginald Williams at the British Museum, Print Room; J. S. Dearden at the Ruskin Galleries, Isle of Wight; the late Dr. Otto Kallir at the Galerie St. Etienne, New York; Bernard Sternfield at the Fieldborne Galleries, London; and Nicholas Tooth at Waddington and Tooth Galleries, London. Special thanks go to Mrs. Mary Taubman and the very Rev. Dr. Walter Hussey for great generosity in agreeing to the use of the letters of Gwen John and Graham Sutherland, and to Wieslaw Czyzynski who wrote about Scottie Wilson specially for me. I owe much to J. R. Kist and J. A. F. de Rijk for being so forthcoming with text by Escher.

I have sought help from many who have never failed to respond, and I should like to express my gratitude for scores of unspecifiable services: to Kenneth Armitage, to my cousin Gwen Carter, to Lynn Chadwick, Sir Alec Clegg, Henri and Raphael Frère (friends of Maillol), Helen Goldie and Alec Hudson, Igor Golomshtok (co-author of *Unofficial Art from the Soviet Union*), Lydia Hess-Nielsen, Sigrid Hofmann, George Hatchard, Susie and the late Charles Morley-Fletcher, Vivienne Noakes, Omar Pound, Michael Scammell, Diana Silbermann, Peter and Vera Simlinger, Donald J. Smith, Corien Teunissen van Manen, Ulrich Wagner, Lilo and Albrecht Zipfel and Ruth Herd.

I thank Harold Bartram for designing the book, Moira Johnston of Paul Elek, my editor, for her guidance and patience, and David Piper for his incalculable generosity in time and thought in writing his Introduction.

And finally I thank my family: Jock, Elspeth, Ross, Oliver, and Elizabeth who have always done their utmost to help, and to whom, with my love, I dedicate my book.

Joan Kinneir

Publisher's Acknowledgements

Acknowledgements of the owners of the self-portraits are given in the text. In most cases, the owners also supplied photographs; where they did not, the photographs are acknowledged below. Publishers of the texts are usually credited below the extracts. Where special acknowledgement is required the organisation involved is credited below. Translators of texts are given, except where the translations were done by the Editor.

The Publishers would like to acknowledge permission to reproduce self-portraits, photographs and texts as follows: the self-portrait of Rubens is reproduced by gracious permission of Her Majesty Queen Elizabeth II; © by ADAGP 1979 for Brancusi (self-portrait and *Histoire de Brigands*), Chagall, (self portrait and text), Sutherland, Bonnard (self-portrait and letter to Lungé-Poë); Bernini, Palma Giovane, Palmer, Pissarro, Pontormo and Sirani (photographs) and the manuscripts of Pissarro's letters are reproduced by courtesy of the Visitors of the Ashmolean Museum, Oxford; the Arts Council of Great Britain for Gwen John (photograph); George Allen and Unwin Ltd, London, as Ruskin's literary trustees, for the extract from Ruskin's *Hortus Inclusus*; Benteli Verlag, Berne, for Paul Klee, *On Modern Art*; the Estate of Dr. T. D. N. Besterman for Gertler; the Trustees of the British Museum, London, for Beardsley, Gauguin, Goltzius, Munch, Raphael, Rembrandt, Van Dyck, Blake (photographs); Bijutsu Shuppan-sha, Tokyo, for Ikeda (photograph); Herrn Nikolaus Barlach, as literary trustees to Barlach; Bandinelli, from the Devonshire Collection, Chatsworth, is reproduced by permission of the Trustees of the Chatsworth Settlement; The Courtauld Institute of Art, London, for Bandinelli and Inigo Jones (photographs); Deutsche Fotothek, Dresden for Barlach, Kollwitz (photographs); the Escher Foundation, Haags Gemeentemuseum The Hague, for Escher; the Trustees of the will of Major George Evelyn, Deceased, for the Bernini text from John Evelyn's Diary; the Galerie St. Etienne, New York, for Schiele (drawing and photograph); the Guggenheim Museum, New York, for the Mondrian text; the Munch text from *Edward Munchs Kriseår—Belyst i brever*, edited by Erna Holmboe Bang, is © Gyldendal Norsk Forlag, 1963, Oslo; Letter No. 235 from *The Letters of Peter Paul Rubens*, translated by Ruth Saunders Magurn, Harvard University Press, 1955, © 1955 by the President and Fellows of Harvard College, is used by permission of the publisher; Verlag Klinkhardt & Biermann, Richard Carl Schmidt, Brunswick, for the Huber text; the Van Gogh text is from *The Complete Letters of Vincent van Gogh*, 1968, by permission of Little, Brown & Co. in conjunction with the New York Graphic Society— © All rights reserved by the New York Graphic Society; the Munch-Museet, Oslo Kommunes Kunstsamlinger, Oslo, for Munch; the National Portrait Gallery, London, for Sutherland (photograph); the extracts from *The Letters of Peter Paul Rubens*, are used by permission of Oxford University Press; Philadelphia Museum of Art for Matisse (photograph); Photographie Giraudon, Paris, for Holbein (photograph); Prinzhorn Collection, Psychiatrische Klinik der Universität Heidelberg, for Pohl (photograph); Phaidon Press Ltd, Oxford, for permission to quote from *The Literary Works of Leonardo da Vinci*, by Jean Paul Richter, 1970; the Preston Blake Library, Westminster Central Reference Library, London, for permission to use Blake's letter to Butts; Service de Documentation Photographique de la Réunion des Musées Nationaux, Paris, for Fantin-Latour, Ingres, Isabey, Brancusi (photographs—Cliché des Musées Nationaux, Paris); © by SPADEM 1979 for Escher, Klee (© 1979 COSMOPRESS, Genève, SPADEM, Paris 1979), Kokoschka, Maillol, Matisse (self-portrait and text), Mondrian, Picasso (self-portrait and text), Redon, Rouault (self-portrait and text), Bonnard (self-portrait and letter to Lungé-Poë); Stanley Spencer Gallery, Cookham-on-Thames; Somerset Record Office for the Lear Text; Society for Cultural Relations with the USSR; Archives Department and Library, Tate Gallery, London, for use of Spencer manuscripts; Writers and Scholars Educational Trust for general help with Kalugin; reproduction and © permission from the estate of the late Mrs. G. A. Wyndham Lewis for Wyndham Lewis (self-portrait and text); the *Guardian* for Biggins (photograph).

Introduction

by David Piper

The ancient tradition of portraiture in Western Art goes back to the fourth century BC in Greece, though in Egypt far earlier, while at least a germ of it may be guessed at in the skulls fleshed with clay, their eye-sockets startling with cowrie shells, excavated at Jericho and not of 800 but of nearer 8000 BC. The self-portrait is a sub-category of the portrait, but while the portrait flourished in Greece, particularly in the Hellenistic period, and then in Rome reached a pitch of naturalism hardly to be surpassed later, no surviving examples from antiquity can be certainly identified as self-portraits.

From around 400 to 1400 AD portraits of any kind, demonstrably intended as recognisable likenesses, attempts to preserve the mortal individuality of a particular human being, are very rare indeed. Only with the Renaissance, not the least element in which was the study of man as mankind's proper study, does portraiture re-emerge and history become populated again with unique, individual faces. Amongst them appear the faces of artists like those of anyone else—except that the luxury of portraiture was largely monopolised by the rulers, the aristocracy, and then, later, wealthy merchants and bankers, amongst whom the craftsmen, painters or sculptors would not normally be classified, so that quite early on self-portraits can be read as claims for status, social and intellectual. They occur astonishingly early. That by the sculptor Peter Parler in the triforium at Prague, of the second half of the fourteenth century, is already vivid but an isolated phenomenon, and a consolidated interest in self-portraiture is first apparent, as one might expect, in Italy. So Ghiberti, balding, shrewd, but benign, if fairly quizzical, appears in striking if miniature self-facsimile on his great bronze *Gates of Paradise* (finished in 1452): significantly, Ghiberti was the first artist to record a written autobiography. The founding father of Renaissance artistic theory, Alberti, appears about the same date in two reliefs, echoing classical medallic form, in profile, presenting himself almost as the re-incarnation of classical virtue and values.

The profile view in a self-portrait normally involves not one, but two or more mirrors. At once, we are confronted by the conditioning agent which distinguished self-portraiture from the mainstream of portraiture, apart from the fact that the subject is the artist himself. That agent is the mirror, and it is easy to forget that, apart from any technical flaws there may be in any particular mirror, its reflection is not only not the object itself but a reproduction of its three-dimensional existence on a two-dimensional plane, but, further, that it reverses the object. Our own faces as we know them in daily life, are the wrong way round and no face, once it develops from childhood, is symmetrical. We do not "see ourselves as others see us". Alice, even when through the looking-glass, had problems about the nature of reality.

Self-portraits are then inevitably subject to distortion if considered as attempts at exactly accurate description. The nature of human perception allows of no such

thing, and even a life-mask distorts. Nevertheless a considerable part of the very real fascination of self-portraits, most of all when they are of artists of great quality, rests in the hope of a more revealing glimpse of a remarkable personality, perhaps even an insight into the nature of genius, of a kind that a portrait by someone else, or a photograph, cannot offer. This may not follow, for most self-portraits obey the same conventions that govern portraiture in general. Naturally the ordinary client's wish is to be shown by his artist at his best and an occupational hazard for all portrait painters who depend on portraiture for their livelihood is the temptation to flatter. When the sitter is the artist the portrait is unlikely to be cash-productive, but there is no likelihood that his personal vanity will be less than that of any other sitter, and he may only too easily see himself through rose-coloured spectacles in "the deceiving mirror of self-love". Moreover, he, unlike the ordinary sitter, is in complete charge of the production. Flattery may include factors other than the approximation of the sitter to the currently fashionable view of ideal beauty, and the playing down of physical flaws. The sitter can be dressed in expensive clothes that do not belong to him, as Pepys was when he sat, or may be provided with attributes, armour or even a martyr's palms, and so shown equated with historic or mythological heroes. Skilful control of lighting can achieve wonders.

In an age when, following the full establishment of photography and swift techniques of reproduction, our retinas are bombarded incessantly with imagery, it is difficult, probably impossible, to realise the significance of the earlier "hand-made" portrait. It was then only through the medium of art that physical likeness could be preserved, whether simply for the record or as memorial. Artists were no doubt as conscious of this function for their self-portraits as for any other portrait, more so perhaps as it was their own reputation, not only as artist but as a human being, with which they were concerned. They did not always characterise themselves as working artists; Rubens in his relatively rare self-portraits, does not— one would not expect him to—he was too grand. But many did, not least Rembrandt in many studies within the profoundest and most various autobiography in paint and line ever recorded. Yet when the artist shows himself with palette and brushes in hand, there is often, perhaps almost always, a hesitation in the directness of his statement. This arises, again, from the reversal of the image: the brushes will appear in the wrong hand, whether he be left or right handed, unless, as was usually the case, he cheats, and corrects the reversal as far as his hands are concerned.

There are some artists of whom anyway a self-portrait might seem almost improper. Maybe the painter in Vermeer's painting *The Artist's Studio* in Vienna is the enigmatic Vermeer himself, but, if so, he is seen from behind and apparently in fancy dress. In this book, M. C. Escher seems to narrow himself down, in the tight frame of the round mirror, towards the condition of being essentially a pair of eyes. Henry Moore is represented by his own hands. Yet the artists, especially the great ones, cannot escape themselves, for their whole work is an autobiography in a sense. They compound the visible world by the alchemy of their style into an amalgam in which their own personality is the dominant factor. In literal detail, with portrait painters, this can be quite startling, as the observer becomes aware how often the

features of the sitters seem to approximate to those of the painter's own face. Of the fashionable Restoration painter, Lely, it was noted that though his portraits were all like one another, as if one great sleepy family, they were not like their sitters, "Because", thought Dryden, "he always studied himself more than those that sat to him!" And there is disagreement over more than one of Rembrandt's portraits as to whether it is a self-portrait or not.

There are a very few great sequences of self-portraits that really are autobiographies in paint. Rembrandt is the supreme example—none of his drawn or etched self-portraits approach the mystery of the late self-portrait paintings, in which, putting the question to himself, he puts it to mankind with an enduring relevance that no other artist has matched. But Rembrandt's self-portraits are a subject in themselves, and have already been studied at book length elsewhere, and indeed in film. So too could Dürer's images of himself be the subject of a volume, but himself as child prodigy is startling enough, and an irresistible opener to the book. The Van Gogh drawing is arguably the most touching in all that haunted series which reads almost like the build-up of a police record of a hunted man—better even, than the painting with the bandaged ear, an omen of assassination no less brutal than the physical self-assault on the painter's ear.

The advantages in most self-portrait drawings include directness of approach and unpretentiousness, for most of them are not done for exhibition. Even if they have not been undertaken in the spirit of psychological exploration, but rather as essentially formal exercises, practice almost like a pianist doing scales, they may inadvertently reveal greater depth than a more considered and elaborate approach. They should be more relaxed, partly because drawn more swiftly, and partly, especially when the artist is young and not rich, because the patient model is free and has no particular compulsion, of prospective publicity, to show off.

Mrs. Kinneir's juxtapositions of text and image have given me great delight; whether it be young Mr. Hockney, temporary hospital porter, writing to his parents and looking out from the page through the familiar specs, or Ingres aligned with domestic accounts of his household expenditure. It is very strange how the method of ordering the portraits produces internal echoes within groups within the book's progression. Yet of them all, I was most startled by the (to me) entirely unknown hallucinatory image of Master Michael Biggins, aged 13 in 1969, dashed off with black printing-ink in fantastic swift competence, larger than life, on to a spread of the local Yorkshire newspaper. Michael Biggins, we gather, left school as early as possible, diagnosed as of low IQ, and has since vanished from public knowledge. Where is he now? At least here he exists in a disturbing actuality: one of the most remarkable amongst these many remarkable images that look at themselves who look at you who look at them.

1979

Introduction

by Joan Kinneir

Self-portraiture is unique. It gives us access to an intimate situation in which we see the artist at close quarters from a privileged position in the place of the artist himself and through his own eyes. The intensity of the observation has a fascination and arouses curiosity about the man. It is magnetic.

In self-portrait drawings, the artist intends to communicate only with himself and the onlooker is often an intruder into a private world. The artist has frequently made the drawing out of curiosity, to explore his outer and inner image, and not to make a statement, or to use himself as the subject of a picture. To me this is self-portraiture in its truest sense.

In all creative activities, any restriction, such as in drawing a restriction to one colour, is a challenge to our resourcefulness, and the whole of our inventiveness, imagination, sensitivity and creative purpose is expressed within the limits imposed. In music, by limiting himself to even one note the composer can create a pattern of sound, a musical identity, by means of rhythm, accent, tempo, the character of sound of his chosen instrument or instruments, and the quality of touch; for example, the four spine-chilling B flats in the third movement of Chopin's *Sonata in B Flat Minor* (the *Funeral March*); and the twelve successive Gs for the flute which open the Allegro movement of Beethoven's *Fifth Symphony*.

In drawing, the restriction to one colour also offers unlimited scope for sensitivity in the division of the space into areas of different size and shape, in the qualities of line and texture, and in the degrees of density and lightness of tone. These subtleties are rarely shown perfectly in reproduction, which is no real substitute for the original. In this collection of drawings, however, the self-portraits benefit from the insights given in the accompanying folio of carefully selected words, as far as possible written by the artists themselves.

The artists are arranged in order of age because the only common denominator in humanity, the only certainty in which we are all equal, is the fact that everyone is given a date of birth and, sooner or later, a date of death. This arrangement transcends centuries and schools of painting, countries and race. The texts grow up and grow old with the faces. The extracts from diaries, letters or statements relating to the drawings supplement each artist's graphic view of himself and provide an extension of his personality. But more than that, the words, like the drawings, present a theme: the artist portrayed, not only as an artist but (to quote Paul Klee) "as a being, who like you has been brought, unasked, into this world of variety, and where like you, he must find his way for better or for worse." For many their way was for worse. In terms of the Seven Ages of Man, the theme seems to demonstrate that, far from being "sans everything", we can show resilience, fortitude and wisdom as we approach old age. The book ends happily, even exuberantly, with Hokusai aged 82.

During the years of research I have travelled extensively to see the original works, with only a few exceptions, wherever they are preserved. Drawings are not easy to find; they are often in private collections or locked away in museums' departments of prints and drawings, by no means always catalogued, and infrequently on exhibition. They do not often come to light by accident and long hours have been spent thumbing through card-indices.

My routes have criss-crossed Europe, from the Palace of Cloux where Leonardo died, to Hungary and fields of sunflowers; from the small arid village of Fuendetodos where, in a humble dwelling, Goya was born, to Leningrad, Moscow and the Ukraine. I have been through Checkpoint Charlie; I have seen Cézanne's Mont St. Victoire, and Gwen John's view of the Pyrenees. Standing on the empty stage of Wagner's Festspielhaus I have thought of Fantin-Latour; and, on the stony shores of Coniston in the English Lakes, of Ruskin pushing off in his rowing boat to visit the three Miss Beevers who lived at Thwaite on the other side of the lake. Crossing the Alps many times I have thought of Carl Philipp Fohr who made the one-way journey on foot, alone except for his dog. The collecting of these self-portraits has given me a much greater understanding for each artist and his work.

Much of the text is unpublished, unknown or very little known. It has been taken from manuscripts whenever possible and translations have been done in the most conscientious way. The letters of Goltzius written in 1605 were translated first from old Dutch into modern Dutch, and from modern Dutch into English. Some of the text on Huber is a free translation from a mediaeval German dialect. Ikeda's autobiography shows a boisterous *joie de vivre* that is a match even for his compatriot Hokusai: it would be nice to know the rest of the story, but this remains in Japanese as Ikeda wrote it. The autobiographies of Kokoschka and Chagall—and Gertler's unfinished one—are, of course, available to be read in full.

It is a revelation to discover how vividly and lucidly so many artists write. Klee's ideas are so fresh, his way of expressing things irresistible. The long letters of Rubens and Van Gogh illustrate an art which has been largely lost since the widespread use of the telephone; in addition to skill, a lot of time and stamina are required to write letters of this length and quality and it was a disappointment not to be able to use them here in their entirety.

Unexpectedly, the texts fall into groups. There are those leaving home: Raphael at only eight; Isabey, Hockney and Fohr. Among those in their early twenties is a new-found independent thinking, enthusiasm and conviction for their art, for music, religion, pacifism. Two shattering interviews come together, one with Beardsley, a youthful victim of tuberculosis, the other with Kalugin, a victim of oppression. Cézanne and Goya both write to old school friends; one needs money, the other has money to offer. Käthe Kollwitz' denial of war in 1916—"I shall never see it"—is followed by Escher's reminder thirty years later that not only did we fail to learn but it seemed we were worse. Both Escher and Odilon Redon received letters from strangers who, having seen their work, say they have been helped spiritually.

It has been left to the artists, and those writing on their behalf, to introduce historical and art-historical information. The boy Toulouse-Lautrec, for instance,

tells in his words of the accidental fall from a low chair, which led to his later deformity. John Evelyn, in an extract from his diary, describes Bernini's famous "baldacchino" which he saw when he visited St. Peter's, Rome. Many specific works are described or referred to. The news of Epstein's first public commission, the eighteen carved figures for the British Medical Association building in the Strand, London, is announced with shocked indignation by the press, demonstrating the bigoted climate of art in Britain in 1908. It was hard-going for *avant-garde* artists. Wyndham Lewis pioneered the Vorticist movement to try to shock society out of its complacency and mediocrity. Epstein, with Gaudier-Brzeska, contributed to the second issue of *Blast*, which the 1914 war brought, with Gaudier and the Vorticist movement, to an untimely end. Almost forty years later, in one short letter Graham Sutherland mentions three works of art; his *Crucifixion* which was not yet started (see page 145), Henry Moore's *Madonna and Child*, also commissioned by Canon Walter Hussey for St. Matthew's Church, Northampton, and already finished, and Benjamin Britten's opera *Peter Grimes* for which London eagerly awaited the first performance.

The third cycle of Wagner's complete *Ring* is the subject of a letter written by Fantin-Latour. He describes the occasion in the new Festspielhaus in Bayreuth, with the innovation of the "hidden" orchestra below the stage. King Ludwig II was there, and Wagner himself. Stanley Spencer talks about two of his paintings, the *Apple Gatherers* and his larger-than-life *Self-portrait*, both in the Tate Gallery. Kokoschka talks about Rembrandt's last self-portrait painting, in the National Gallery, London. Another famous self-portrait is described by Vasari, the *Self-portrait in a convex mirror* by Parmigianino, in Vienna. Besides Vasari, other art historians whose writings have been chosen are Carlo Ridolfi, Joachim von Sandrart, George Vertue, Philipp M. Halm and Edmund Schilling.

Professional practice is illustrated in the account of Van Dyck's studio procedure, in Picasso's written agreement between himself and Daniel-Henry Kahnweiler, in the meticulous record Elisabetta Sirani kept of all her works, and in the description by Francis Place of how Wenceslaus Hollar used an hour-glass to keep a check on his working hours. The relationship between artists and their patrons is interesting: Rembrandt is owed money by His Highness Prince Frederick Hendrick of Orange; for the young Carl Philipp Fohr everything depends on being financed by the Fürstin: "I mean to hold on to that lady tighter and tighter", he writes to his parents. Pontormo is visited while at work by Duke Cosimo de' Medici who commissioned the frescoes in S. Lorenzo. The apprentice system is also referred to in the texts accompanying Dürer, Grünewald and others.

Some artists are witness to World War I and World War II. Chagall writes of pogroms in Petrograd, of the February Revolution, of the arrival of Lenin: "Lenin, who's he?" Barlach is persecuted and his work displayed in Hitler's exhibition of "degenerate" art in Munich in 1937, the *Entartete Kunst* exhibition. Kalugin is also persecuted, because he will not conform to Socialist Realism, and his self-portrait represents him either as he feels, being denied the freedom to paint as he wants, or as he felt when he was confined in a psychiatric hospital; or both. Schiele is also confined—to prison, for alleged obscenity; and William Blake would have been in

prison except for two kind friends who stood bail for him.

The pilgrimage to Rome is one which almost all artists have aimed to make. Gwen John set off to walk there but never arrived, and Carl Philipp Fohr set off to walk there and did arrive, but never returned. Overbeck was already there when Fohr arrived, working with a big colony of other German artists who were nicknamed "Nazarenes". Ingres was in Rome at the time he drew the self-portrait of 1835 and inscribed on it "à mes élèves". He was Director of the French Academy there. Rouault tried several times for the Prix de Rome, but failed each time.

The hand-to-mouth existence which many artists experience at some time is described, with irrepressible verve, in accounts by Gwen John and Masuo Ikeda, of how they frequented inns and bars, respectively, to try to find clients willing to have their portraits drawn on the spot. Their next meal depended on it.

A study of this kind can never be complete. Unknown old works will always turn up, and new ones be made, and there are already a number of obvious omissions—drawings it was hard to leave out—but there was no room for more. I have become very attached to these artists. The effort I have had to make to locate drawings, establish dates and connections with artists' other works has been more than worth while. Grünewald's self-portrait, for example (plate 53), is in itself a poor introduction to this important artist; it has been folded into six, smudged, worked over with a pen, and signed and wrongly dated by another hand. But Grünewald was an astonishing and unique draughtsman (no wonder his apprentice Grimer collected all the drawings he could lay hands on), and author of the famous Isenheim Altar of 1515, a folding screen of ten paintings now in the Musée d'Unterlinden at Colmar, in which Grünewald used this self-portrait as a study for St. Paul the Hermit. How much I wish we could see the drawing as it then was, particularly the hand holding the brush. The way in which he drew hands is very individual and explicit; another Grünewald drawing, a woman with clasped hands, in the Ashmolean Museum, Oxford, demonstrates this.

Grünewald's self-portrait is one of several in the book not accountable as a certain self-portrait, though Sandrart, who describes the provenance of Grünewald's drawings, was clearly made to believe that it was. Pontormo's is another uncertain self-portrait, and again one which does not do justice to the great draughtsmanship of the artist, and with only a suggestion of the characteristic round eyes. But it earns its place if it is an introduction, as it was to me, to the frescoes of Pontormo, and to the queer old recluse who had a rope ladder instead of a staircase, and kept a diary during the last years of his life.

Pissarro, the man, his paintings and his self-portrait here, are favourites with me and I think with many others. As a man, and a father, one has a great deal of understanding for him. The exchange of letters between him and Lucien, his eldest child, was rapid and constant over many years. He was tireless in his encouragement to Lucien to "draw unceasingly" if he wanted to become an artist. I believe in that too. It is amazing that Pissarro was prepared to try to support his grown son financially for many years, when he still had to provide for a young family, and his own pictures were not selling. Mme. Pissarro, though apparently difficult, must also have had a hard time, and I wish he did not always sound so exasperated with her.

But in these human traits the artist shows he is no better and no worse than any other. "No one is good, no one is evil, everybody is both." Cézanne is driven to deceipt, Goya unbearably full of his own importance; William Blake is hot-tempered, and Wyndham Lewis shows great courage. They are not insulated against debt or debtors, accident, illness, or leaving their coats behind. Inevitably I have felt personally involved in the lives of the artists and have observed how the work charts the human condition in its progress through life. I have been moved, as Kokoschka was when he stood in the National Gallery looking at Rembrandt's last self-portrait. The faces could be our faces, and the words our words.

Why were these self-portraits made? Not many express vanity. Van Dyck is certainly one who seems to enjoy his own face, also Isabey—although we know that at the time this self-portrait was drawn he was only a home-sick boy, dressed up to look like a man in the new fashionable clothes his parents had saved up to provide for him when he left Nancy for Paris, to try to make his way as an artist. Perhaps the drawing helped him to come to terms with himself in his new role. There are two self-portrait drawings by Rubens, one in the Louvre and the other in the Albertina, which show the artist as the fine picturesque man he was, proud of his own looks. But there is no vanity in this one.

Käthe Kollwitz is one of a number of artists who left a life-long record of themselves in self-portraits. But her concern was with others, not herself. She lived with her doctor husband in the slums of north Berlin, witnessed the hardships of the poor and fought their cause through her art all her life. It is as if she finds the evils of poverty, oppression, and war reflected in her own face and, by constant reference to it, is keeping her finger on the pulse of sick and suffering humanity. The self-portraits of Elisabetta Sirani and Toulouse-Lautrec are topographical. Sirani depicts herself in a domestic scene, an imaginary one, although the setting may be authentic, as a lady of rank. She is wearing a gown, with a page to bear her train, accoutrements which, as a hard-working painter largely supporting her parents and family, she would have had no time or money to indulge in. Toulouse-Lautrec shows himself at home in bed after one of his accidents, a protective cage over his fractured leg. His is one of three self-portraits made from the sick-bed. The Monogrammist I.B. and Graham Sutherland with mumps are the others. Each is looking at a different self, an unfamiliar encapsulated form, too interesting to go unrecorded. As was common practice, Holbein, Grünewald and Gentile Bellini made their self-portraits as studies, to be used later in paintings.

One or two artists only produced self-portrait drawings which seem to be entirely straightforward, uncomplicated and accomplished works intended just to represent the artist as he was, for the record. Goltzius is one, and Ingres certainly another. We do not need his wife's housekeeping books to tell us that he was protected from worldly worries; that his diet and cultural needs were well supplied and his wardrobe clean and cared for, with never a button missing.

Carl Philipp Fohr made his drawing for his parents before he left home to walk to Rome. It is as well he did as they never saw him again. Pissarro used himself as a subject for practice in etching. The boy Dürer must also have been using himself for practice to see how well he could draw.

The highest concentration of self-portraits is in the late teens and early twenties. Youth has become searching and questioning, there is curiosity in these faces, and sincerity. Of them all, the Spencer and Palmer are the most intense and searching self-portraits. The Palmer, hanging in the Ashmolean Museum, has such magnetism that it is almost impossible to move away. Franz Pohl's self-portrait places him at once in a world apart, in which he was. But others, too, are distressingly introspective: Richard Gertler who made several drawings of himself at this time, shortly before he committed suicide; Van Gogh, Munch and Ruskin, all of whom suffered mental illness.

A completely different group sees and expresses everything, including themselves, in terms of their current artistic idiom. Gaudier-Brzeska and Wyndham Lewis, Oldenburg, Scottie Wilson, Ikeda, Klee. The real-life Scottie, with his little eyes and big droopy nose, shines out of this fish-fantasy. Klee states "I am my style", and Matisse explains this artistic phenomenon in *L'exactitude n'est pas la Vérité*. And Paul Klee again (Diary 1905, entry 675): "If I had to paint a perfectly true self-portrait, I would show a peculiar shell. And inside—it would have to be made clear to everyone—I sit like a kernel in a nut. This work might also be named: allegory of incrustation."

The sculptors Maillol and Moore have both drawn self-portrait hands. "A sculptor is a person obsessed with the form and the shape of things, . . . of anything and everything." Henry Moore says; and the form he sees, more than any other, is that of his own hands, in front of him all the time, the creative agent. He has drawn them repeatedly, as other artists, over the years, have drawn their own faces.

Parmigianino's profile was surely drawn for the sheer love of drawing. His looks are exquisite, but perhaps whatever his face had been like it would have fallen under the spell of the master's prodigious draughtsmanship.

But above all these reasons, I think it is the mystery of the subject which holds a fascination for the artist. Escher ends his letter quoting from St. Paul: "Now we see through a glass darkly": and Leonardo, at sixty, tranquil and philosophical as he appears in his drawing—was he resigned that although his great brain had solved so many questions—there was one he could not solve? Did he have in 1512, the same thoughts as Theodore had in one of the last issues of the London *News Chronicle*:—

Theodore by Papas

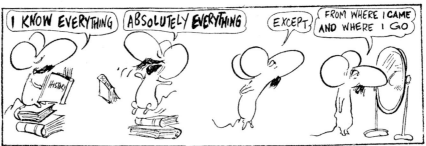

Albrecht Dürer

b. 21 May, 1471. Nürnberg, Germany
d. 6 April, 1528. Nürnberg, Germany

Plate 1. Self-portrait, 1484; age 12 or 13.
Silverpoint, 27.5 × 19.6 cms. Graphische Sammlung, the Albertina, Vienna.

In the year 1524, I, Albrecht Dürer the younger, have put together from my father's papers the facts as to whence he was, how he came hither, lived here, and drew to a happy end. God be gracious to him and us! Amen.

Like his relatives, Albrecht Dürer the elder was born in the kingdom of Hungary, in a village named Eytas, situated not far from a little town called Gyula, eight miles below Grosswardein; and his kindred made their living from horses and cattle. My father's father was called Anton Dürer; he came as a lad to a goldsmith in the said little town and learnt the craft under him. He afterwards married a girl named Elisabeth, who bore him a daughter, Katharina, and three sons. The first son he named Albrecht; he was my dear father. He too became a goldsmith, a pure and skilful man. The second son he called Ladislaus; he was a saddler. His son is my cousin Niklas Dürer, called Niklas the Hungarian, who is settled at Köln. He also is a goldsmith and learnt the craft here at Nürnberg with my father. The third son he called John. Him he set to study and he afterwards became parson at Grosswardein, and continued there thirty years.

So Albrecht Dürer, my dear father, came to Germany. He had been a long time with the great artists in the Netherlands. At last he came hither to Nürnberg in the year, as reckoned from the birth of Christ, 1455, on S. Eulogius' day (11 March). And on the same day Philip Pirkheimer had his marriage feast at the Veste, and there was a great dance under the big lime tree. For a long time after that, my dear father, Albrecht Dürer, served my grandfather, old Hieronymus Holper, till the year reckoned 1467 after the birth of Christ. My grandfather then gave him his daughter, a pretty upright girl, fifteen years old, named Barbara; and he was wedded to her eight days before S. Vitus' (8 June). It may also be mentioned that my grandmother, my mother's mother, was the daughter of Oellinger of Weissenburg, and her name was Kunigunde.

And my dear father had by his marriage with my dear mother the following children born—which I set down here word for word as he wrote it in his book:

1. *Item*, in the year 1468 after the birth of Christ on the day before S. Margaret's eve (12 July) in the sixth hour of the day my wife Barbara bare me my first daughter; and old Margaret of Weissenburg stood godmother to her, and she named me the child Barbara after its mother.

2. *Item*, in the year 1470 after the birth of Christ, on S. Mary's day in Lent (14 March), two hours before daybreak, my wife Barbara bare me my second child, a son. Fritz Roth of Bayreuth held him over the font and named my son Johannes.

3. *Item*, in the year 1471 after the birth of Christ, in the sixth hour of the day, on S.

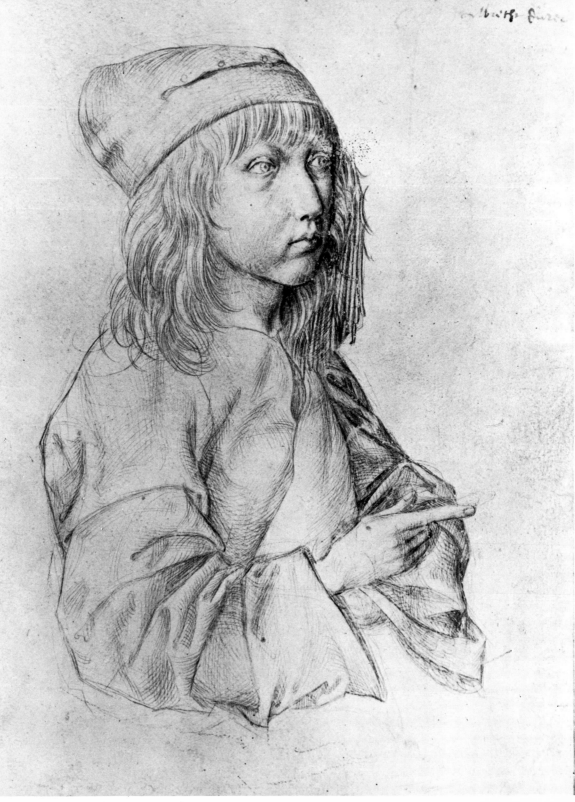

Prudentia's day, a Tuesday in Passion Week (21 May), my wife bare me my second son. His godfather was Anton Koburger, and he named him Albrecht after me.

The remaining fifteen *Items* are of the same type and need not be catalogued here. Dürer then continues:

All these, my brothers and sisters, my dear Father's children, are now dead, some in their childhood, others as they were growing up; only we three brothers still live, so long as God will, namely: I, Albrecht, and my brother Andreas, and my brother Hans, the third of the name, my father's children.

This Albrecht Dürer the elder passed his life in great toil and stern, hard labour, having nothing for his support save what he earned with his hand for himself, his wife, and his children; so that he had little enough. He underwent moreover manifold afflictions, trials, and adversities. But he won just praise from all who knew him, for he lived an honourable, Christian life, was a man patient of spirit, mild and peaceable to all, and very thankful towards God. For himself he had little need of company and worldly pleasures; he was also of few words and was a God-fearing man.

This my dear Father, was very careful with his children to bring them up in the fear of God; for it was his highest wish to train them well that they might be pleasing in the sight both of God and man. Wherefore his daily speech to us was that we should love God and deal truly with our neighbours.

And my Father took special pleasure in me because he saw that I was diligent in striving to learn. So he sent me to the school, and when I had learnt to read and write he took me away from it, and taught me the goldsmith's craft. But when I could work neatly my liking drew me rather to painting than to goldsmith's work, so I laid it before my father; but he was not well pleased, regretting the time lost while I had been learning to be a goldsmith. Still he let it be as I wished, and in 1486 (reckoned from the birth of Christ) on S. Andrew's day (30 Nov.) my Father bound me apprentice to Michael Wolgemut, to serve him three years long. During that time God gave me diligence so that I learnt well, but I had much to suffer from his lads.

When I had finished my learning, my Father sent me off, and I stayed away four years till he called me back again. As I had gone forth in the year 1490 after Easter (Easter Sunday was April 11), so now I came back again in 1494, as it is reckoned, after Whitsuntide (Whit-sunday was May 18).

When I returned home, Hans Frey treated with my Father, and gave me his daughter, Mistress Agnes by name, and with her he gave me 200 florins, and we were wedded; it was on Monday before Margaret's (7 July) in the year 1494.

From *The Literary Remains of Albrecht Dürer*, translated and edited by William Martin Conway, 1889; reprinted with an introduction by Alfred Werner, PH.D., under the title *Writings of Albrecht Dürer*, Peter Owen, 1958.

Henri de Toulouse-Lautrec

b. 24 November, 1864. Hôtel du Bosc, Albi, Tarn, France.
d. 9 September, 1901. Malromé, France.

Plate 2. Self-portrait, in bed, *c.* 1879; age 14.
Pencil, 22.5 × 33 cms. Musée Toulouse-Lautrec, Albi.

Letter addressed to his friend Charles Castelbon,[1] from Toulouse-Lautrec, explaining the circumstances of his first accident on 30 May, 1878, at his home in Albi, when he was 13 years 6 months. The drawing was probably done at the time of his second accident the following year.

My dear Charles,

You will excuse me I'm sure for not having written earlier when you know the cause of my delay. I fell on the floor from a low chair and have broken my left thigh.

But now, thank God, it is mended and I am starting to walk with a crutch, and someone to help. I am sending you the first water-colour I have done since I have been up. It is not very good but I hope you will only consider the wish to give you a souvenir.

We don't know yet when we will be able to go to Barèges.[2] My good mother and my cousins are going but the doctor is afraid that the waters might be bad for me.

My uncle Raymond de Toulouse has come to see me but has not been able to give me any of your news. Goodbye my dear friend. Mother asks me to include her kind remembrances to you and yours, and please convey mine also to Mme your mother and Mlle your sister.

<div align="right">

Yours ever

Henry de Toulouse-Lautrec

</div>

P.S. Hôtel du Bosc, rue École Mage, Albi, Tarn.

[1] The envelope is addressed to: Monsieur Charles Castelbon, Puylaurens, Tarn. It is postmarked 2 September, 1878, when Henri would be 13 years, 9 months old. The original letter is in the Musée Toulouse-Lautrec, Albi.
[2] Barèges is a spa in the Pyrenees.

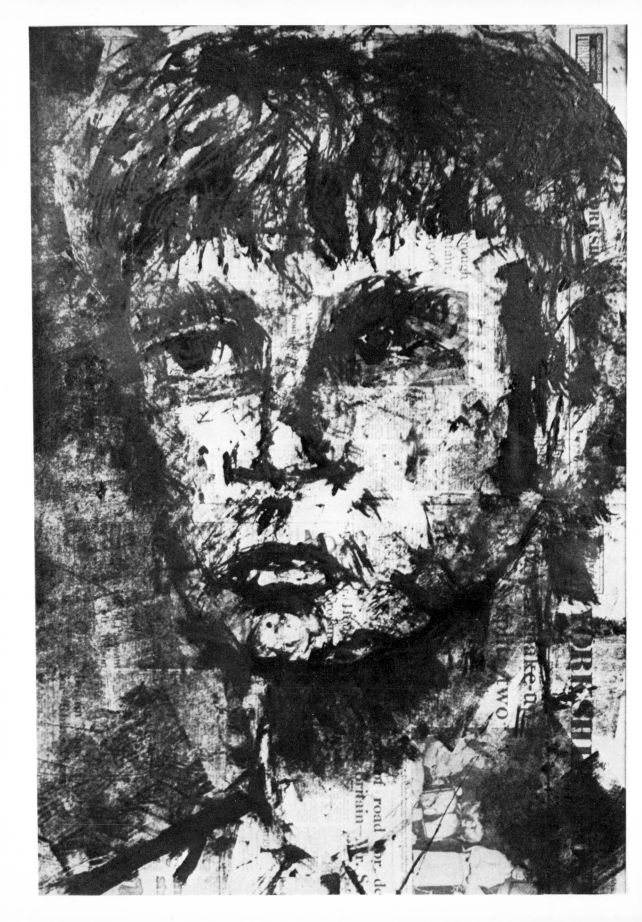

Michael Biggins

b. 31 August, 1954. Woodlands, near Doncaster, Yorkshire, England.

Plate 3. Self-portrait, 1969; age 14.
Black printing ink on newspaper, 76.2 × 53.3 cms. Collection Wakefield
Metropolitan District Council, Yorkshire.

Portrait of a Failure

Sir Alec Clegg yesterday showed reporters attending the North of England
Education Conference at Leeds this self-portrait painted on a sheet of newspaper by
a boy of 14. Sir Alec, chief education officer for the West Riding, described it as "the
most moving picture I have seen".

Sir Alec said the young artist had a low IQ and no formal art training. He had left
school at the earliest opportunity, and was now 17. "The last I heard about him was
that he had been in some trouble with the police. He had a job as a labourer, but
knowing that he lives in Doncaster, I would not be surprised if he was now
unemployed," Sir Alec said.

"This picture came from a child who is branded as an educational failure. We
have no right to talk about this child in these terms. His fate is a failure for me and
for the West Riding. I wrote to his parents to suggest we get him into an art school.
We never had a reply."

From the *Guardian*, 5 January, 1972.

Note: Michael Biggin's art teacher at the school he attended, Adwick School near
Doncaster, was Mr. Michael Shirbon.

Ritratto di te medesimo quando giovane.

Raphael

b. Good Friday, 1483. Urbino, Italy.
d. Good Friday, 1520. Rome, Italy.

Plate 4. Self-portrait, undated; age *c.* 16/17.
Black chalk, 31.4 × 19 cms. The British Museum, London.

Raphael of Urbino, Painter and Architect

. . . Raphael was born at Urbino, a most important city of Italy, in 1483, on Good Friday, at three in the morning, of Giovanni del Santi, a painter of no great merit, but of good intelligence and well able to show his son the right way, a favour which bad fortune had not granted to himself in his youth. Giovanni, knowing how important it was for the child, whom he called Raphael as a good augury, being his only son, to have his mother's milk and not that of a nurse, wished her to suckle it, so that the child might see the ways of his equals in his tender years rather than the rough manners of clowns and people of low condition. When the boy was grown, Giovanni began to teach him painting, finding him much inclined to that art and of great intelligence. Thus Raphael, before many years and while still a child, greatly assisted his father in the numerous works which he did in the state of Urbino. At last this good and loving father perceived that his son could learn little more from him, and determined to put him with Pietro Perugino, who, as I have already said, occupied the first place among the painters of the time. Accordingly Giovanni went to Perugia, and not finding Pietro there he waited for him, occupying the time in doing some things in S. Francesco. When Pietro returned from Rome, Giovanni being courteous and well bred, made his acquaintance, and at a fitting opportunity told him what he wished in the most tactful manner. Pietro, who was also courteous and a friend of young men of promise, agreed to take Raphael. Accordingly Giovanni returned joyfully to Urbino, and took the boy with him to Perugia, his mother who loved him tenderly, weeping bitterly at the separation. . . .[1]

From Vasari's *Lives of the Painters, Sculptors, and Architects*, translated by A. B. Hinds, edited by William Gaunt, J. M. Dent & Sons Ltd, 1927. Giorgio Vasari, born in 1511, was about nine when Raphael died and this book was originally published in 1550.

[1]Raphael's mother died in 1491 when he was only eight years old. His father remarried and himself died in 1494.

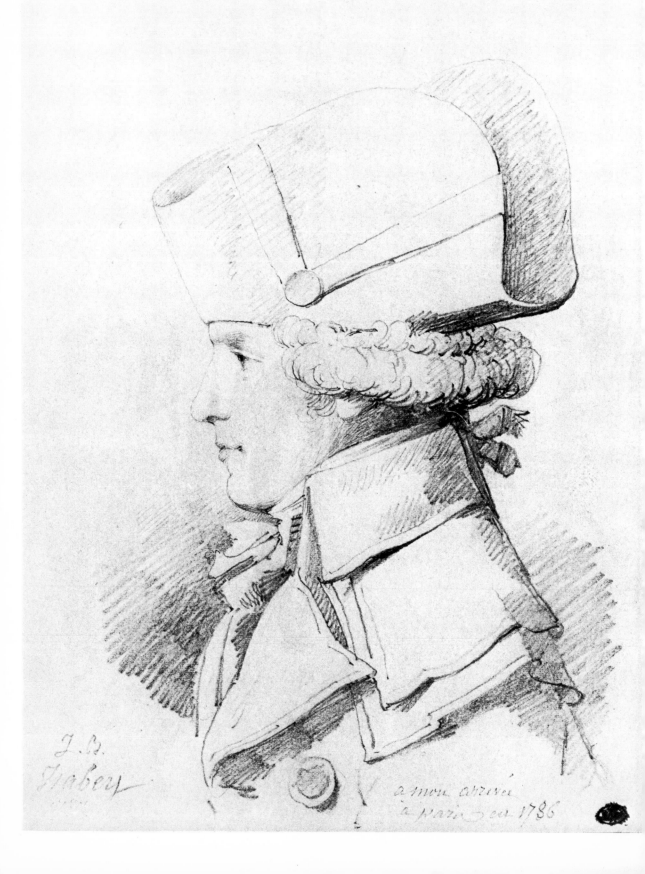

J.B.
Isabey

a mon arrivée
à Paris en 1786

Jean-Baptiste Isabey

b. 11 April, 1767. Nancy, France.
d. 18 April, 1855. Paris, France.

Plate 5. Self-portrait, *À mon arrivée à Paris en 1786*; age 17/18
Pencil on yellowed paper, 17 × 13.5 cms. Cabinet des Dessins, Musée du Louvre, Paris.

Description, taken from Isabey's journal, of his first leaving his home-town of Nancy to make his way as an artist in Paris.

It was with a heavy heart that I came to leave this friendly town, and the paternal home where my mother could dry my tears with kisses. Wide-eyed, the locals came to ask if it was really true that I was going away, and predicted for me every marvel and success. On the eve of my departure my mother made me sit beside her, and struggling to give me the courage which was failing her, she entrusted me with a little purse with five twenty-four franc pieces. I slept little that night, before the great day of our separation. At five in the morning my father came into my room, his voice trembling as he gave me his benediction. As I left the house I saw the curtain lift, and my mother's hand sadly blow a last kiss. All my friends had gathered to say good-bye. . . .

Then the stage-coach moved away, and when the last house of my birth-place had disappeared in the morning mist, my suppressed emotions gave way to a fit of sobbing which continued throughout the eight days' journey.

I emerged from my misery when we reached the coach station in Paris. It was the 24th of January, 1785; I was eighteen.[1] A cab drove me to the mansion of Count d'Helmestadt, rue Cassette. I was to be lodged there. I handed the butler a letter of introduction to M. Bocquet, the Count's steward, who welcomed me with kindness and showed me to a tiny room which gave onto the servants' quarters. I can still see my eight-foot square cell with its whitewashed walls; a trestle bed, a straw padded chair, and an old deal table had been got in with great difficulty. On the casement window which opened onto a stable yard hung a small broken mirror. I could not help smiling through my tears as I contemplated this luxury—and my beardless chin!

From *J. B. Isabey, sa vie, son temps*, by Mme de Basily-Callimaki, Paris, 1909. This extract was translated by Joseph lo Piccolo.

[1]Isabey has miscalculated. Either the year was 1786, as recorded in his self-portrait, or he was still seventeen.

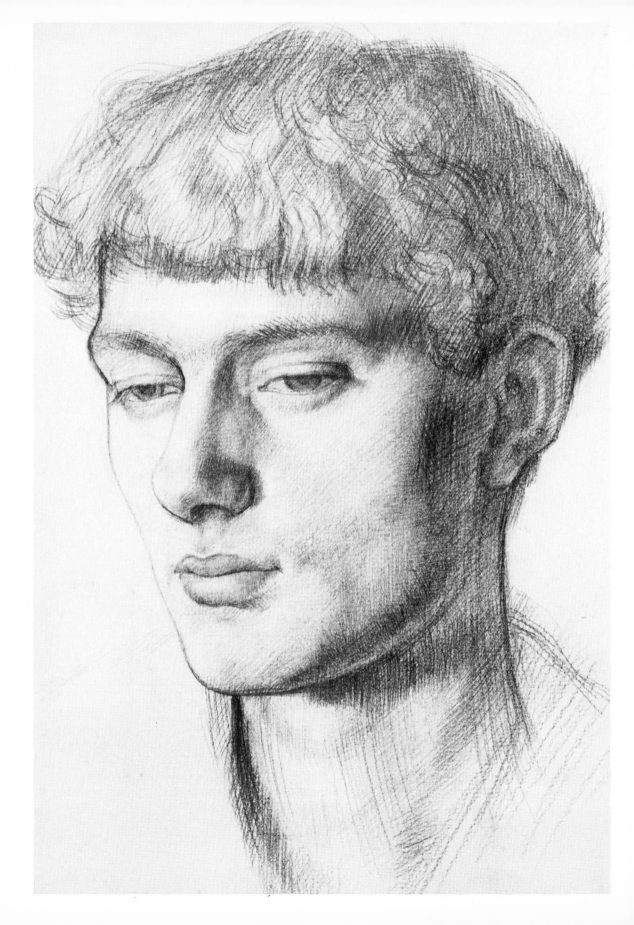

Mark Gertler

b. 9 December, 1891. 16 Gun Street, Spitalfields, London, England.
d. 22 June, 1939. 5 Grove Terrace, London. NW5., England.

Plate 6. Self-portrait, undated; age about 19/20.
Pencil, 29.2 × 22.9 cms. The Estate of Dr. T. D. N. Besterman.

First Memories[1]
by Mark Gertler
18 October 1934

I don't know exactly how old I was, and unfortunately I cannot ask my family to help me because the first incident I remember with clarity contains a certain amount of deception, even slyness on my part, that is if one can call it sly to pretend not to hear what one is not intended to hear and is not in the position to avoid hearing. I say I cannot appeal to my family, because it was them I deceived, and have never since mentioned the incident in their presence. But I could not have been more than four. We were in Austria—that is all of us except my father, who was somewhere in America—and I was supposed to be asleep when I heard the following: Mother to my eldest brother Harry, "Harrish, it is cold and Maxalla will suffer. Could you not bring home with you from the factory a warm little coat?" Harry, "All right, all right, I'll try, perhaps." Mother, "If you succeed we'll say father sent you a present, Maxalla, from America." The next evening at the same time, when I am supposed to be asleep again, by brother arrives. I am terribly impatient—this time it is hard for me to keep up the pretence of sleep. I keep cocking one eye open every second and, sure enough, my brother extricates from inside his trousers a coat!—a coat I was to wear a long time and get to love very much though I knew it was not my father who sent it.

It is curious that I cannot remember anything else at all clearly during the four or five years we spent in Austria. But I should like, before leaving that period, to tell what I subsequently learnt about it and about my birth from my people. Although all my family was born in Austria, I myself was born in Spitalfields, London. My father and mother a few years previous to this decided to leave Austria and "try their luck" in London. They arrived almost penniless with four children and settled in a street called Gun Street, Spitalfields. When I was a year old they decided that there was no luck forthcoming and with the help of the Jewish Board of Guardians returned to their native country with only me, as it were, to show for it. They were not received exactly with enthusiasm by their relations, who realised that something would have to be done and who had by this time decided that my father was a good-for-nothing, especially those on my mother's side, who had often warned her—as she used to relate so frequently—not to marry him, "For if you do, Golda, take warning you will never have enough to eat." However, they clubbed together and between them managed to collect enough money to buy them a small inn on the outskirts of the Town. . . .

How the inn came to an end and what happened later my mother used to tell in a derisive manner, in order to show up what a simpleton my father was, for she always used to blame him for our failure and tell us how much better things would have turned out had he waited and taken *her* advice. I will tell the story in the way my mother would tell it me so often when we were alone together. My mother spoke mostly in Yiddish. Even after forty years in England she could speak very little English. But her Yiddish was extremely expressive and in translating it I shall try and keep to her kind of expressions and phrasing—"Oh what an inn that was—what a hell—and how does your tuttalla (derisive way of referring to my father) wind up with this inn? Perhaps sell it? No fear! Not he! One day in he comes with that smile of his—of course I know already what that smile means—and says to me, Golda don't worry any more—no more inn, we've got something better than that inn now. Oh woe me, I says, what have we got better—tell me—be quick—and what do you think he tells to my unhappy self? BOOTS! Oh! God help me, I says, Boots? What do you mean, boots? BOOTS, he says. Well I go and look and what do I see. Oh woe for my troubles. Not even a single pair of BOOTS!!! All odd, all odd, as I live today, God help me. All odd! Why did you not wait for my advice I says—but not he—he even gets angry, if you please, and runs out. A few days later, as sure as I live, he returns with the same smile and says, Golda you didn't like the boots eh? No I did *not* like the boots, I says. All right, he says, come and look here—and what does he show me this time—perhaps something valuable you may think? No, even worse, BUTTONS! A sack full of buttons—and *such* buttons—where could he have got such buttons from—that's all. I have never seen such buttons, not even on Christians' garments, let alone Jewish ones. Well what more can I tell you? You know your tuttalla. Soon there was nothing in the house to eat. He asks me for a clean shirt, and off he is to America—leaving me to starve with five children. . . ."

[1] Mark Gertler took his own life on 22 June 1939. This unfinished manuscript, on which he had been working with a view to publication, and from which this extract is taken, was found in the studio at 5 Grove Street, NW5 on the night of Monday, the 26th. It was subsequently published in *Mark Gertler; Selected Letters*, edited by Noel Carrington, Rupert Hart-Davis, 1965.

David Hockney

b. 9 July, 1937. St. Luke's Hospital, Bradford, Yorkshire, England.

Plate 7. Self-portrait, 1957; age 19/20.
Pen drawing, 33.7 × 19.7 cms. Private collection.

A selection from the letters Hockney wrote to his parents on first leaving home in 1958 to work in a hospital in Hastings, in lieu of National Service. The spelling and punctuation are his own.

<div align="right">

Cliffe Cottage
West Hill
St Leonards-on-Sea
Sussex

</div>

Tuesday 21st Oct '58

Dear Mum Dad and John,

I hope everything is going O.K. up there.[1] I commenced work at St Helen's Hospital Hastings yesterday. (Monday). It is alright. The ward is rather similar to the one at St Lukes, although here it is all male patients.

Since we finished apple picking last Friday John and Peter[2] haven't got employment, although on Thursday, (my day off from the hospital) we are all going to see a gent, who is trying to get us *all* work on the land, although of course now, John and Peter will come first.

Dad, don't worry about my apperiance at the hospital. We are keeping house very well indeed, in fact I think we can congratulate ourselves. We even washed some sheets the other day, and I ironed them all,—and they were "Persil White,

Did I tell you we are going to evening classes, for life drawing, on Monday evenings at the Hastings College of Art. It is, though, a very small college. The gentleman who is trying to get us work on the land,—(as quite naturally I would rather do that, than work in the hospital although the Hospital is very nice,) seems very interested in us, and very helpful.

By the way, I believe I mentioned in a previous letter that if you, or for that matter anybody else, who has some snaps of Philips Wedding, I wouldn't mind seeing them.

And Dad,—If Mr Ashton is interested in buying pictures cheap, all those, stacked in the attick, can be sold, apart from the "road menders." This painting is on a canvas worth at least £5, so that would be "cheap" at anything around say, £10. Yes, I expect to send a couple of pictures up to the Yorkshire Artists exhibition, and I also hope to send to next years Royal Academy. I have already started 3 pictures, and done quite a bit of drawing.

—We had a visit from David Fawcett on Saturday, and he was saying that this new school he's teaching at, wants some original paintings, and there

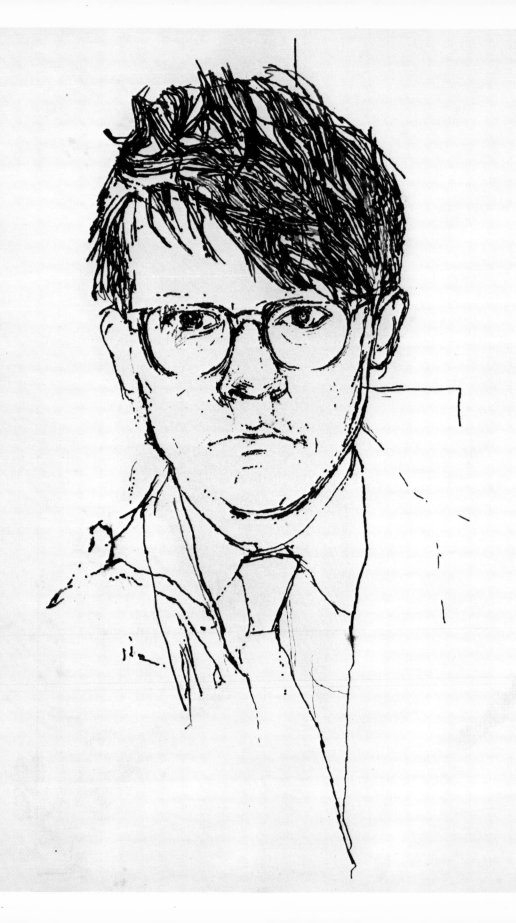

interested in young painters, so he's put our names foreward,—not bad eh.

Anyway I am just off to bed now, I begin at 9-0am tomorrow and finish at 7pm. with an hour for dinner, and half an hour for tea. This morning I began at 8am, and finished at 5pm—with an hour for dinner.

> All my love,
> Cheerio
> David

> Cliffe Cottage
> West Hill
> St. Leonards-on-Sea
> Sussex

Wednesday. Oct. 29th

Dear Mum, Dad and John,[3]

Hope everything is alright up there.—Well Dad as you know I am working at the Hospital, and a very nice hospital it is,—the people are very friendly, but I might leave. The situation is like this. John is working temporarily at potato picking,—the local ministry of Labour got him the job. When the work is done, he signs on again at the Labour Exchange, and gets benefit,—because he has no other choice of work. Now then as you know I wouldn't mind farm work, and we have a job offered. It is from the father of an art student at Hastings College of Art. He has a 150 acres of poultry farm near here. The trouble is he can only take one, so we have to decide wether John or I take the job. You see if I take it, John is still alright with the Ministry of Labour, but I couldn't get benefit from the ministry, because I have two choices of work i.e. hospital or agriculture. Anyway we shall decide today, so I'll let you know what we shall do.

Everything is going O.K. here. They have already asked me at the hospital if I can help them with the Christmas decorations—here we go again. By the way there is one difference from St Lukes here,—the pay. Because I am employed as a nursing auxcillary here, and not an orderly (no differance really) I get a flat weekly rate, which is much less than I got at St Lukes,—much less. Anyway were getting on O.K, especially with the painting.

> Cheerio
> David.

> Cliff Cottage
> West Hill
> St Leonards-on-Sea
> Sussex

Friday. November 21st '58

Dear Mum,

I hope you are well I'm sorry I havn't written before this week but I seem to be always doing something, working at the hospital, painting or doing housework.

I was sorry to hear of the death of Uncle Willy, he was a nice chap, who I don't think I shall forget so easily.

Well, we are just about on our feet now financially, as both John and myself are working and bringing in weekly pay packets. David Oxtoby is leaving us on Sunday, and so there'll only be John and myself. Peter is back in Bradford, and as far as I know has to go to a tribunal in Leeds on December 11th. On Sunday John and I are going out for tea to a gentleman who lives at a place called Pett, near here. He is a Quacker[4] and is very interested in Painting, and he might buy some pictures. Anyway I might be up home just before Christmas, but only for day. I have written to Margaret.[5] I lost her adress but then I recieved a letter from her and so I wrote back. If anybody asks you how I am going on you can tell them I am alright and enjoying the experience of really fending for ourselves. Up to press we have done all our own washing and ironing, including sheets,— not bad eh. I am thinking of buying a bike next week, to go to work on, as it would save bus fares as the bus goes a long way round to the hospital from here,—but still it all depends on the price of bike.

> All my love
> Cheerio
> David

> Cliff Cottage
> West Hill
> St Leonards-on-Sea
> Sussex

Thursday. Nov. 27th '58

Dear Mum,

It is a cold wintry day here although there is no fog, wind, snow or ice. At the moment I am off work with a septic finger. I think I got a bit of wire wool in it at the Hospital, anyway they'll give me full pay. Norman[6] came down for a few days drawing last week, but is now back in London, and will be back in Bradford in a fortnight. I am knocking on with some painting. Christmas is nearly here, (a month today I believe). Time seems to have absolutely flown since July, I only hope the next six or seven months goes as quick.

You can tell Dad to keep sending Telegraph & Arguss now and again, especially if theres anything interesting in them. I heard on the news yesterday that there was a bus smash in Bradford yesterday caused by the fog.—Well we seem to miss it all. Give my regards to Mrs Bell!!!![7]

> Cheerio
> David

Cliffe Cottage
West Hill
St Leonards-on-sea
Sussex

Monday. December 1st. '58

Dear Mum,

Thanks for the letter, I'm sorry to hear you have been ill. I went back to work on Saturday morning, as my finger is alright now.—I didn't go to the hospital to have it dressed, I went to the doctors, about a hundred yards away from us, as the hospital told me to go to a doctors as I couldn't go to work with it, and I would need a certificate to be off work for more than three days.

Thank Dad for the papers, although he has no need to send "Tribune" and "Peace News" as I get them down here. Now then a job for somebody. IMPORTANT. please check to see if my name is on the electoral register. (you may see a copy at the G.P.O, or Darley St Library), if it isn't on, please cheque to to [sic] see if it should be, because if it isn't, and it should be, I will have to fill in a form and post it to the town clerk, before December 16th. Thankyou.

We have just recieved a letter from Frank Lisle,[8] asking us to send some pictures up to college for an exhibition there in February.

Anyway I must close now to go to bed.

Cheerio
David.

[1]"Up there" means in Bradford.
[2]The friends John and Peter were John Loker and Peter Vaugh.
[3]The envelope is addressed to Mr. and Mrs. Kenneth Hockney, and John, David's brother. It is datestamped Oct 30, 1958, and also stamped CIVIL DEFENCE JOIN NOW. David has also "stamped" in his own hand-printing—CIVIL DEFENCE IS
FUTILE EXPENSE
[5]The "Quacker" who lived at Pett was Stephen Brunskill, "a great character and a gentle pacifist who had once been an army officer in India."
[5] David's sister.
[6]Norman Stevens.
[7]Mrs. Bell was an old lady "who lived alone and whom we befriended; all the family were kind to her. She sometimes came at the most inconvenient times, hence the !!!! but I guess we brightened many a lonely hour for her".
[8]Frank Lisle was Lecturer at the former Regional College of Art, Bradford. During his eleven years' service he built up the Painting Department where Hockney was a student between autumn 1953 and summer 1957.

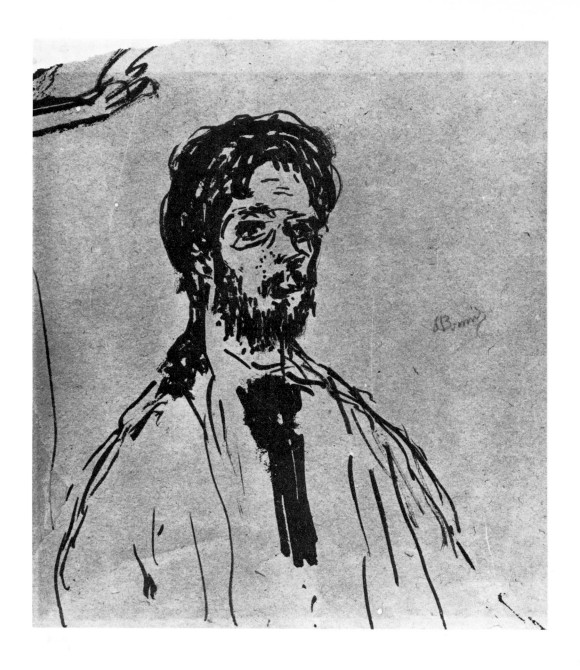

Pierre Bonnard

b. 3 October, 1867. Fontenay-aux Roses, France.
d. 23 January, 1947. "Le Bosquet", Le Cannet, France.

Plate 8. Self-portrait, undated.
Brush drawing in black on torn sheet of warm brown paper, 15.6 cms × 15.2 cms.
Szépmüvészeti Muzeum, Budapest, Hungary.

A letter of 1890 from Pierre Bonnard to the actor Aurélien Marie Lugné-Poë,[1] who was doing his military service; Bonnard had already done military service in 1889/90. The letter is written from Bonnard's grandmother's house, but some time in 1890 he came to share a studio at 28 Rue Pigalle with Lugné-Poë, and the painters Maurice Denis and Edouard Vuillard.[2]

8, Rue de Parme.

My dear Lugné,

I should have sent you news of myself long ago because I know how much pleasure a letter gives in the first days of being in the army. One needs to be conscious of being something other than a registered number, and of having led hitherto a life different from that of an animal. Anyway, that was my impression of the army: I couldn't connect my present existence with my past civilian life. I was saying that I would have written to you long since but that I am an accomplished lazy-bones, and it is only by addressing myself in a rude fashion that I can stir myself to make a decision.

It appears that they drive you hard at Reims, but I am happy to observe that though the body is wracked, the morale is always buoyant; the physical fatigue always passes; it is all a matter of training.

Here I lead an absolutely exemplary, studious existence—a bit of inertia, but one is not perfect. I am working on a serious picture which is going well, and which will, I hope, appear in the Indépendants. I also have in mind a screen which will also be in the exhibition. Apart from that, nothing at all. I am going perhaps with Vuillard to see a music publisher, but I do not hold out many hopes as far as that goes. I have abandoned chromolithographie (ouf!) for the moment, but I will resume it when I feel the need to abandon oil painting, in order to vary my pleasures. I am not giving you news of Vuillard, Denis, Sérusier;[3] they have written to you themselves and have put you in the picture better than I could do myself. Altogether things are good for Vuillard at the moment. As for you, do try not to worry too much; "*l'espoir luit*", as our master Verlaine says. And that is all you need to be able to bear the painful moments in life.

<div style="text-align: right">

Affectionately
P. Bonnard.

</div>

Lugné-Poë published this letter in his auto-biography La Parade. *He also gave the following description of Bonnard at this vital period of his life when, at twenty-one, he sold a poster for* France Champagne *for 100 francs, and had parental approval to give up the law and the civil service and to become a professional artist. With Maurice Denis, Paul Sérusier, Edouard Vuillard and also Maillol, he formed a group known as* Les Nabis *(the prophets).*

P. Bonnard was the humorist amongst us: his nonchalent gaiety, his fun, expressed themselves in works of flamboyant wit, always with a certain satiric edge, which he dropped later; remember his Champagne poster, but above all his illustrated *Méthode* of *solfeggio*,[4] incredibly witty, and a source of joy to children having to practice a rather tedious exercise, thanks to Claude Terasse.[5]

Bonnard did not in any way resemble Denis or Vuillard; however, all three attacked life with a gusto which was a timely help to me. This Bonnard, with his individual touch, in line and in colour, with this fresh vision and joy in his compositions, he carried me with him! Everything seemed possible after talking to them. Praise be to Darzens[6] who translated *les Revenants* for Antoine, gave new life to Free Verse and brought out spontaneously the spirit of *L'Oeuvre*.[7] We went to see *Revenants*, also to *Canard*, and we felt that this naturalism which the poet thrust on us, regarded as symbolism by the whole of Europe, was preparing the way for great change.

From *La Parade: Le Sot du Tremplin*, Gallimard, 1930

[1]Lugné-Poë: 1869–1940.
[2]Maurice Denis: 1870–1943; Edouard Vuillard: 1868–1940.
[3]Paul Sérusier: 1865–1927.
[4]*Solfeggio*: a musical exercise in sol-fa syllables.
[5]Claude Terasse: a musician who married Bonnard's younger sister, Andrée, in 1890.
[6]Rodolphe Darzens: 1865–1938. Poet, playwright, novelist.
[7]*L'Oeuvre* was a dramatic society, started by Lugné-Poë in 1893, to make known young dramatists and foreign playwrights, such as Ibsen, whose *Ghosts* (*les Revenants*), and *Wild Duck* (*Canard*) Lugné notes had been performed there. In 1920 it became a proper theatre in rue de Clichy, Paris.

Gwendolen Mary John

b. 22 June, 1876. Haverfordwest, Pembrokeshire, Wales.
d. 18 September, 1939. Dieppe, France.

Plate 9. Self-portrait, undated.[1]
Pencil on paper, 25.4 × 21 cms. Collection Mrs. Olga Matthiesen.

Letter to her friend Ursula Tyrwhitt from Gwen John, written during her "walk to Rome"
which she embarked on with Dorelia McNeil (later Mrs. Augustus John). They reached
Toulouse, from where this letter was written, but not Rome. The letter, which is in pencil on
graph paper, is reproduced here with the spelling and punctuation of the original.[2] It is
undated but was probably written late in 1903 and certainly after 2 September.

Toulouse (Poste Restante)

Dear Ursula

I have been slaving at my picture[3] & now it will not be done for the N.E.[4] Are
you sending? We have been staying here whilst I do the picture we are going to
stay some time longer it is such a beautiful place. Your last letter gave me such
pleasure—we were feeling very desperate in a little unsympathetic village, we
were in the inn & had not done any work at all there & I felt I *could* not tell
them we draw portraits—they looked so unsympathetic—it was of course very
stupid. Your letter quite changed the feeling we had of the place & everything—
& the 5 centimes seemed a good omen. We had a good dinner on the strength of
it & then I had the courage to ask them to have their portraits drawn. They all
sat & I worked there all the afternoon. We have been here so long now the time
of trudging from village to village seems a long way off. It is very pleasant here,
the people give me plenty of work but I have not done much besides my
picture. We shall never get to Rome I'm afraid—it seems further away than it
did in England. Are you really going to that place in Switzerland? Of course we
shall go to see you if we are any way near—I do wish you were here! You
would like this place, it is very artistic—the country round is wonderful especially
now—the trees are all colours—I paint my picture on the top of a hill—
Toulouse lies below & all round we can see the country for many miles & in the
far distance the Phrynnees I cannot tell you how wonderful it is when the sun
goes down, the last two evenings have had a red sun—lurid I think is the word,
the scene is sublime then, it looks like Hell or Heaven.

Our adventures are not now of such a thrilling nature as we live in a town &
have a room to sleep in like any bourgeoise—but I must tell you of one which
happened the night before last. We hire our room from a tiny little old woman
dressed in black with a black handkerchief over her head, she is very very wicked
everybody says so in this house & the next (where we go to dine sometimes)

43

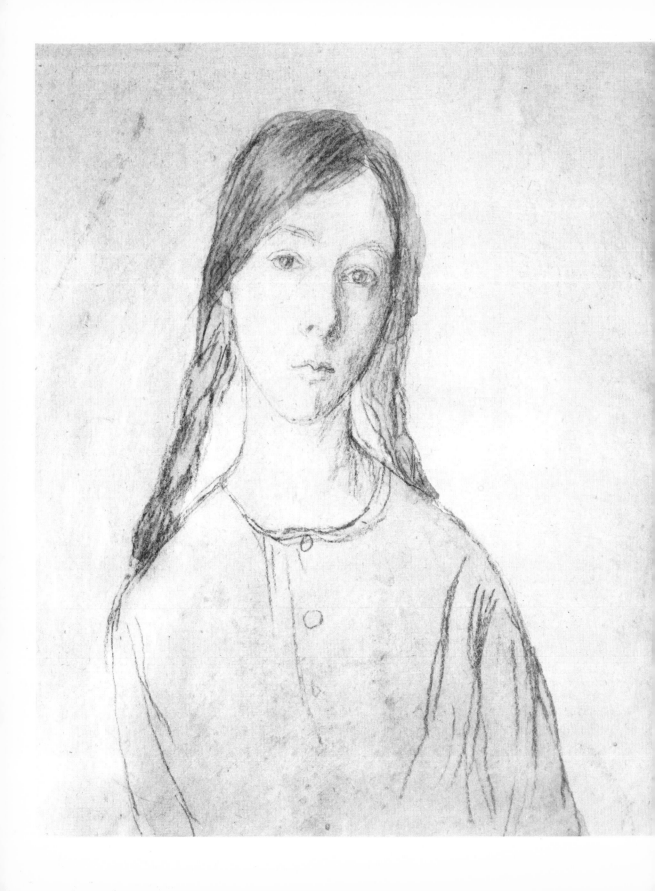

there is something very strange about her face, I cannot look at her much she frightens me so but she has been very civil to us in fact very nice she seems to try to be. She is frightfully particular to make us pay our 2 francs in the day & we have been out so much the last 3 or four days she has been coming they say for the rent & has found us away. The night before last I had a frightful dream of a ghost & I woke up terrified, there was such a strange feeling in the room—I looked at once at the door & it was wide open—it opens into another little room with a door opening on to the stairs—I was surprised to see the door open because I shut it carefully & you cannot open it without taking off a kind of latch or else making a frightfully loud noise. I said to Dorelia "Look at the door" she said she had seen a figure like the little old woman's standing by the door a few moments before—she was frightened too because there was such a horrid sensation in the air—neither of us could think of the little old woman without nearly dying of fright, & of course we heard some strange noises & a dog in the house barked suddenly. I suppose the old woman was thinking so hard about us & the rent that she appeared there—I don't know why she opened the door I suppose it was habit. Last night it was all right but I don't know how I shall look the old woman in the face again—Dearest Ursula I wish you were here, write soon & tell me about your work—I long sometimes to be in London & to take a walk in the Park with you—& go to some exhibitions to-gether. If you go away you will be home on Many n'est pas?

> Yours with much love
> Gwen

[1]Mary Taubman, Gwen John's biographer, believes that although she looks so young, Gwen was considerably older than twenty at the time of the self-portrait. It is with artistic licence that she appears here next to Carl Philipp Fohr.
[2]The original letter was given to Mary Taubman by Ursula Tyrwhitt when a very old lady; and Mary Taubman gave it, with others, to the National Library of Wales in summer 1975.
[3]The picture referred to could be *Dorelia by Lamplight*, or Dorelia as *The Student* (City of Manchester Art Gallery), both painted in 1903 at Toulouse.
[4]The New English Art Club.

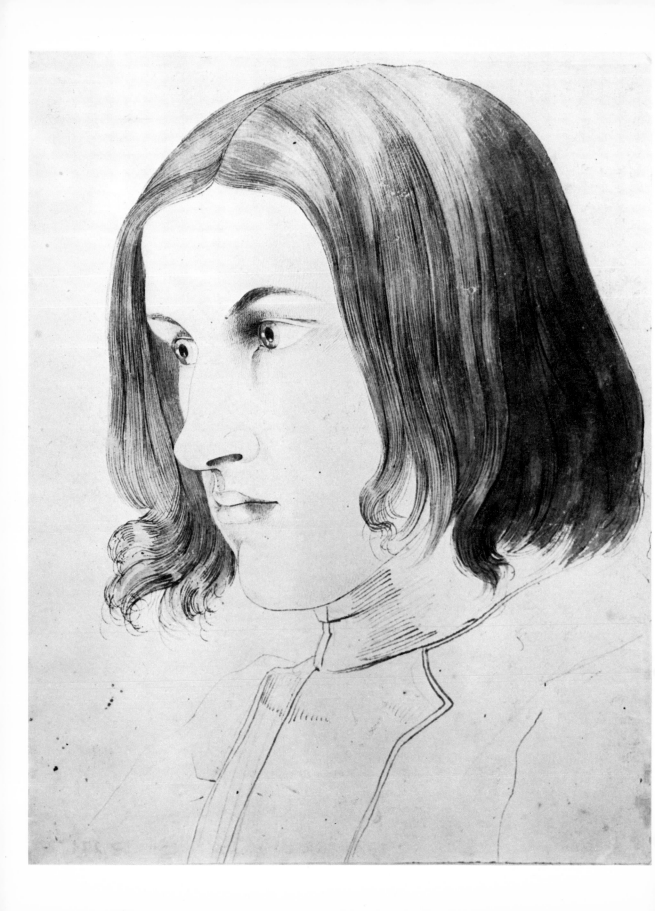

Carl Philipp Fohr

b. 26 November, 1795. Heidelberg, Germany.
d. 29 June, 1818. Rome, Italy.

Plate 10. Self-portrait, 1816; age 20.
Blue-grey pen and brush, touched with pencil, 23.9 × 18.6 cms. Kurpfälzisches
Museum der Stadt, Heidelberg.

*Fohr made this drawing for his parents before he left Heidelberg in the late autumn of 1816 to
walk to Rome, from where the following letter was written. He never returned. He was
drowned in the Tiber, aged twenty-two.*

Rome, 15 December 1816

Dearest beloved parents,

At last I have arrived here, in a cosy little room where I can think of you dear
father, and good mother, undisturbed; and although unhappily it is too late
once again, my soul is oppressed by the memory of my terrible behaviour
towards you. When will the dear Lord grant me a more gentle nature, which
does not constantly rebel, especially against you who have done the most for
me? You forgave me, but our heavenly Father can never forgive.

I am unable to give you an exact account of my journey. I saw little of the
mountains, valleys, and plains, because from the moment we parted I was
overcome by a sadness which will not leave me, especially when I think of the
cares and hardships, my dearest ones, which must weigh on you doubly this
unhappy winter. But I have my share as well, because it is more expensive here
than I could have imagined, and I have to take myself in hand in order to be
able to manage; particularly as I am beginning two big pictures, which requires
money.

I have already sent a long letter to the Fürstin[1] asking her pardon for delaying
my journey for so long. I mean to hold on to that lady tighter and tighter, that
with God's help our future may look more cheerful.

I changed my route in order to see Freiburg, as it was near, and walked
through the Höllenthal, via Schwarzwald to Schaffhausen, Zürich, Zug, and
Altdorf, and from there over the Gotthard. But it meant that I missed seeing
Issel in the neighbourhood of Lucerne, and I was sorry. However in Ursern, in
an inn on the summit of the Gotthard, as I was leafing through the visitor's book
I found his name and that of a General. Enquiring further, I learned they had
been there a fortnight before, coming the way I had come, and going by way of
the Furka in the Hasli-Thal. So I was destined not to see him.

After leaving the ice-covered Gotthard behind, I walked through the
Rheinthal via Lake Como to Milan. From there I took a *vetturino* for Bologna

and Florence. In both towns I saw magnificent works of art,—paintings and sculpture.

My *vetturino* fell ill in Florence, so I took another to Rome. I was heartily glad when I arrived at Nero's memorial on the outskirts of Rome, having got to the end of my journey with its innumerable hardships—so was Grimsel,[2] that this walk had come to an end. Having reached my inn, I went straight to the Café Greco where immediately I met lots of Germans. Lerch from Darmstadt conducted me to Overbeck's[3] dwelling, where there was Ludwig Ruhl, together with many other German artists. I directed Lerch to tell him "a Göttinger student is waiting downstairs and wishes to speak with him". Imagine his surprise when all of a sudden I fell into his arms, and it was as if we had never been separated! At once I left the expensive inn and had the good fortune to find, in Ruhl's house, a lovely little room adjoining his two rooms. They are about the most decent people in Rome, and one can be sure not to be cheated. Our relationship with the other artists is very happy too, they are very fond of us and help us and educate us whenever they can, and God willing I shall be able to do wonderful things here, and establish the foundations of my future fame.

I shall also be starting on the *alte Speirer*[4] very soon, and will send him to the Werles with the request to pay you 6 *louis d'or* so that you need not pay the postal charges because this little roll will probably come to 6 or 7 *gulden*. When I next write to the Fürstin I will ask her for the travelling-money to Sicily, because all the landscape painters go there, where nature is at its grandest and most magnificent.

Now, dear father and mother, I must finish. Write very soon telling me what news time has produced, and also how you are. I enclose this in a letter to Simon to avoid your paying postage as it may be fairly expensive from here. Take care of yourselves my dear good parents, Daniel, and many greetings to dear George.

May the almighty and heavenly Father watch over you and keep you in his holy protection. And remember, with love, your very loving son. K.F.

From one of six letters to his parents published in *Das Leben des Malers Karl Fohr*, by Philipp Dieffenbach, Darmstadt, 1823. The original letters are now lost. This translation is by Maria Saekel-Jelkmann.

[1]Fohr was a young Romantic genius. His patron was the Fürstin, Gross und Erbprinzessin Wilhelmine von Hessen. Fohr produced an impressive number of watercolour landscapes, and during the eighteen months he spent in Rome before his death he made exquisite portrait drawings of the many German artists there, including the Nazarenes Peter Cornelius and Friedrich Overbeck.
[2]Fohr had taken his dog with him.
[3]See plate 19.
[4]This must refer to a commission to paint a portrait of a native of Speyer, near Heidelberg.

Jacob Epstein

b. 10 November, 1880. East Side, New York City, USA.
d. 19 August, 1959. Hyde Park Gate, London, England.

Plate 11. Self-portrait, 1901; age 20/21.
Red chalk, 30.5 × 23 cms. The Garman Ryan Collection, Walsall Museum and Art
Gallery.

*A furore, stirred up by the press, greeted Epstein on the unveiling of his first big sculpture
commission in 1908.*

Evening Standard and St. James's Gazette. London, Friday, June 19th, 1908.

BOLD SCULPTURE
AMAZING FIGURES ON A STRAND BUILDING
IS IT ART?

We draw attention with some reluctance to five amazing statuary figures which are
meant to adorn the fine new building of the British Medical Association in course of
erection at the corner of the Strand and Agar-Street. . . .[1] They represent a
development of art to which the British public, at any rate, are not accustomed
. . .; a form of statuary which no careful father would wish his daughter, or no
discriminating young man his fiancée, to see.

The degree of Nudity.
Nude statuary figures in an art gallery are seen for the most part by those who know
how to appreciate the art they represent. . . . To have art of the kind indicated laid
bare to the gaze of all classes, young and old, in perhaps the busiest thoroughfare of
the Metropolis of the world is another matter. The degree of nudity which has been
chosen for the figures is not calculated to enhance the artistic effect of the
statuary. . . . For a certain type of mind, on the other hand, it cannot but have a
demoralising tendency, and it is surely unnecessary, having regard to the condition
of our West-End streets, to give further opportunities for vulgarity.

We are concerned most of all, however, with the effect which the figures will
produce on the minds of young people. The sight is not one which it is desirable in
the interests of public morality to present to their impressionable minds.

POLICE INQUIRY
SCOTLAND YARD CONSIDERING THE POSITION
PRIVATE ACTION TO BE TAKEN

The Scotland Yard authorities, we are informed, have the question of the Strand
statues under consideration . . .

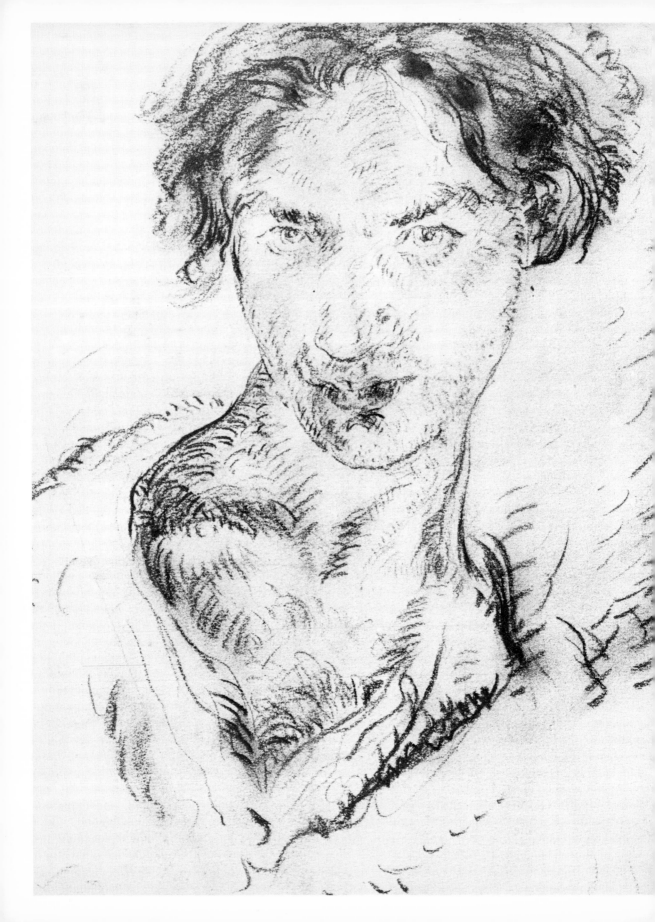

The National Vigilance Association has also taken action. "I have personally, on behalf of the Association," Mr. W. A. Coote, the secretary, informed our representative, "lodged a protest with the secretary of the British Medical Association. . . . At present the sight is bad enough, but when the hoarding in Agar-street is removed it will become a public scandal. . . . We intend, unless the offending figures are removed, to take action, and see whether the law is strong enough to deal with such a display. If it is not, the fact will lend additional interest to the proceedings of the Parliamentary Committee which is at the present time inquiring into the publication of certain books and pictures, and the holding of certain exhibitions."

The Times, June 25, 1908

BRITISH MEDICAL ASSOCIATION: NEW BUILDING.

THE QUESTION OF THE STATUES.

A meeting of the premises committee of the British Medical Association was held yesterday afternoon. The committee will report to the council on July 1. The terms of the report are private, but it is understood that the committee is favourable to the work's being allowed to proceed.

To the Editor of The Times

Sir,

The action of the British Medical Association in setting up a building which is actually beautiful in the Strand, and adorning it with decorative sculpture that is even good enough to attract attention, is, it appears, calling forth one of those periodical outbursts of rage against the nude in sculpture which lovers of art have to endure from time to time. These periodical outbursts tempt the small minority who love art in this country to blaspheme; but perhaps you will grant me the hospitality of a few of your valuable lines to invite them to possess their souls in patience. The people of this country, as all the world knows, are an astounding and but incompletely fused mixture of all sorts of races. Some learned persons tell us that ultimately the bulk of these races may be classified down to two main constituent groups—the descendants of an ancient group of Arctic peoples and the descendants of an ancient group of Mediterranean peoples. It is the strong, big, law-and-order-loving Arctic lot that make all this pother. The small, artistic, go-as-you-please wanderers up from the warm lands are the sufferers. Those gaunt, red cold folk have deep down inside them the memory of the glacial epoch, when they clothed themselves in skins and hunted the reindeer, not far away from the edge of enormous glaciers. The poor things, in this miserable English climate, have not, in a mere ten or twenty thousand years, had time to get warm through. It will take countless more of our ordinary English summers to drive the Arctic shivers out of their subconscious selves.

Naturally, when they see the representation of a nude figure it puts their teeth on edge, and they howl out and hurl against it such handy anathemas as come easiest on their tongues—"immoral" and the like. Sculptured nudes have an exactly contrary effect on the "small dark man." They stir in him the pleasant memory of ancestors who knew what it was to live in a decent climate, where it was not necessary to "wear flannel next to the skin." Let the happy English substratum of art-lovers, instead of railing at their fellow-countrymen with the pleistocene constitutions, pray earnestly for much hot weather. If we could have even a couple of months of it only, the protests of the "large red" gentry would grow feeble, and the British Medical Association would find that, after the "large red" fashion, the building and its decoration would be forgotten by its present foes, who are by nature an unobservant lot, and only rail at what is new because for the moment it happens to attract the attention of their normally unseeing eyes.

I am, Sir, yours faithfully,

Martin Conway.[2]

British Medical Journal, July 18, 1908.

In this issue of the BMJ *the controversy is brought to a close in a leader which ends:*

. . . We are glad that a sculptor of genius awoke one morning, like Byron, and found himself famous. But we are sorry, and not a little ashamed, that he should owe the foundation of his fame to the hypocrisy with which other countries, not wholly without reason, reproach the British people.

[1] Epstein described his 18 figures as symbolic "of scientific study and research and a presentment of life, its origin and growth. Apart from my desire to decorate a beautiful building, I wished to create noble and heroic forms to embody in sculpture the great primal facts of man and woman." *BMJ.*
[2] Martin Conway was Professor of Fine Art first at Liverpool then at Cambridge University until 1904.
Note: The BMA building was sold in 1935 to the Southern Rhodesian Government who decided the statues were to be removed. Press protests, this time, secured their reprieve, and there they remain, badly mutilated and weather-worn, looking from a distance like mummies.

Henri Gaudier-Brzeska

b. 4 October, 1891. Saint-Jean de Braye, near Orléans, France.
d. 5 June, 1915. Neuville Saint Vaast, France.

Plate 12. Self-portrait, Christmas, 1912; age 21 years 2 months.
Thick black pencil, 55.9 × 39.4 cms. National Portrait Gallery, London.

Vortex Gaudier-Brzeska
(Written from the Trenches)

Note: The sculptor writes from the French trenches, having been in the firing line since early in the war. In September he was one of a patrolling party of twelve, seven of his companions fell in the fight over a roadway. In November he was nominated for sergeancy and has been since slightly wounded, but expects to return to the trenches. He has been constantly employed in scouting and patrolling and in the construction of wire entanglements in close contact with the Boches.

I HAVE BEEN FIGHTING FOR TWO MONTHS and I can now gauge the intensity of Life.

HUMAN MASSES teem and move, are destroyed and crop up again.

HORSES are worn out in three weeks, die by the roadside.

DOGS wander, are destroyed, and others come along.

WITH ALL THE DESTRUCTION that works around us NOTHING IS CHANGED, EVEN SUPERFICIALLY. LIFE IS THE SAME STRENGTH, THE MOVING AGENT THAT PERMITS THE SMALL INDIVIDUAL TO ASSERT HIMSELF.

THE BURSTING SHELLS, the volleys, wire entanglements, projectors, motors, the chaos of battle DO NOT ALTER IN THE LEAST, the outlines of the hill we are besieging. A company of PARTRIDGES scuttle along before our very trench.

IT WOULD BE FOLLY TO SEEK ARTISTIC EMOTIONS AMID THESE LITTLE WORKS OF OURS.

THIS PALTRY MECHANISM, WHICH SERVES AS A PURGE TO OVER NUMEROUS HUMANITY.

THIS WAR IS A GREAT REMEDY.

IN THE INDIVIDUAL IT KILLS ARROGANCE, SELF–ESTEEM, PRIDE.

IT TAKES AWAY FROM THE MASSES NUMBERS UPON NUMBERS OF UNIMPORTANT UNITS, WHOSE ECONOMIC ACTIVITIES BECOME NOXIOUS AS THE RECENT TRADE CRISES HAVE SHOWN US.

MY VIEWS ON SCULPTURE REMAIN ABSOLUTELY THE SAME.

IT IS THE VORTEX OF WILL, OF DECISION, THAT BEGINS.

I SHALL DERIVE MY EMOTIONS SOLELY FROM THE ARRANGEMENT OF SURFACES, I shall present my emotions by the ARRANGEMENT OF MY SURFACES, THE PLANES AND LINES BY WHICH THEY ARE DEFINED.

Just as this hill where the Germans are solidly entrenched, gives me a nasty feeling, solely because its gentle slopes are broken up by earth-works, which

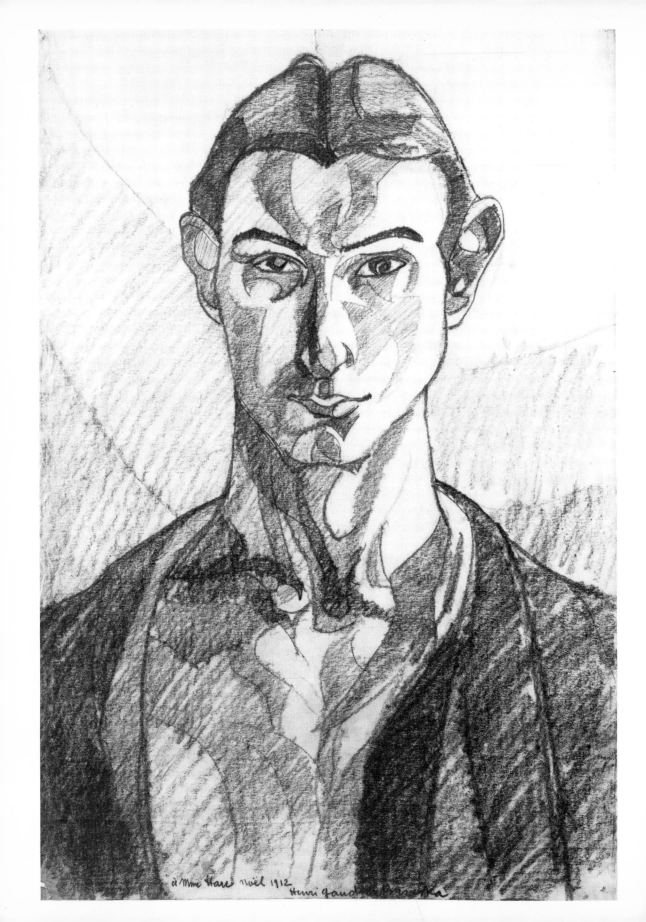

à Mme Hare Noël 1912
Henri Gaudier-Brzeska

throw long shadows at sunset. Just so shall I get feeling, of whatsoever definition, from a statue ACCORDING TO ITS SLOPES, varied to infinity.

I have made an experiment. Two days ago I pinched from an enemy a mauser rifle. Its heavy unwieldy shape swamped me with a powerful IMAGE of brutality.

I was in doubt for a long time whether it pleased or displeased me.

I found that I did not like it.

I broke the butt off and with my knife I carved in it a design, through which I tried to express a gentler order of feeling, which I preferred.

BUT I WILL EMPHASISE that MY DESIGN got its effect (just as the gun had) FROM A VERY SIMPLE COMPOSITION OF LINES AND PLANES.

<div align="right">GAUDIER–BRZESKA</div>

MORT POUR LA PATRIE

Henri Gaudier-Brzeska: after months of fighting and two promotions for gallantry Henri Gaudier-Brzeska was killed in a charge at Neuville St. Vaast, on June 5th, 1915.

From *Blast*, No 2, July, 1915, edited by Wyndham Lewis.

Stanley Spencer

b. 30 June, 1891. "Fernlea", Cookham, Berkshire, England.
d. 14 December, 1959. Cliveden Hospital, Cookham, Berkshire, England.

Plate 13. Self-portrait, January 1914; age 22
Pen with brown and black ink, 29.8 × 20.3 cms. Private collection.

Letters which mark the start of Spencer's friendship with the painter Henry Lamb (1883–1960). They are addressed to Lamb at 3 Vale Hotel Studios, Hampstead, London.

Fernlea, Cookham on Thames, Berks, June 1. 1913
Dear Mr Lamb,

Your friend Mr Japp[1] told me that you liked my picture[2] at the Contemporary. It gives me pleasure to enclose herewith a photo of it. I think it looks better in this photo than it does in the original. I hope to see you someday—I don't go to London now & so I hardly ever see anybody or any works of art. Japp comes to Cookham sometimes, & tells me about everything—you know he knows everything.

<div align="right">Yours very sincerely
Stanley Spencer.</div>

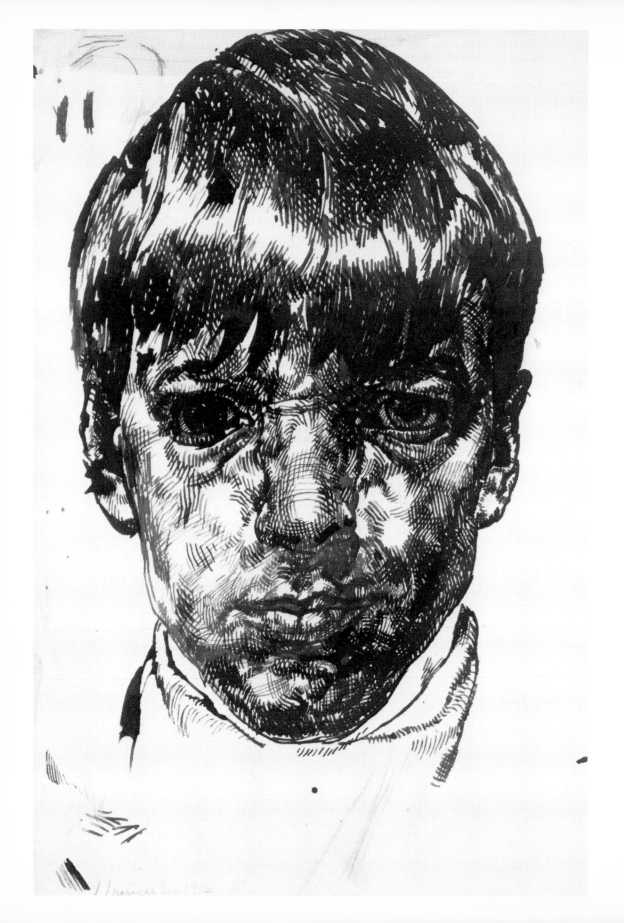

Spencer Dec 1914.

Postmark Oct. 24(?) 1913
Fernlea, Cookham on Thames

Dear Mr Lamb,

Thank you for your letter. I should like to see you & I will bring your picture
on what ever day you should suggest as convenient.

Many people have tried to convert me to Hampstead Heath, but with all its
fine trees wonderful views etc, I always get horribly depressed whenever I go
there. Mr Edward Marsh[3] wrote to me a day or so ago asking me if, in the
event of my Apple picture not being sold, I should be willing to let him have it
for £50.

I told him it was sold, & asked him to communicate with you. I have written
accepting an invitation from him asking me to lunch some day next week, I
have left him to choose a day & when I know it I might be able to see you on
that day. Any day, except the day of my visit to Mr Marshs will be convinient
for me to bring the Apple picture. When Mr Marsh has settled upon a day for
my visit to him, I will let you know what day that is, so that you can decide on
a day upon which I could see you & give you the picture. . . .

You will not think me ungracious if I refuse your king invitation after Nov
1st to stay with you: I have not been away since last March, I have refused all
invitations since then. Invitations to Mr Raverat, (do you know him. Both he &
his wife[4] are good to me) I also refused Japps kind invitation, & many others. I
have done so because I have something 'on the board' & I want to get it done.
You see this place Cookham has a lot to do with this new picture I am going to
do,[5] it has everything to do with it. If I go away, when I come back I feel
strange & it takes me some time to recover from these feelings. If only I had a
little room in Cookham that I could invite you down to. I had a little, very little
kitchen last winter & that is where I did your Apple picture, most part of it. I
want to get cheap heating apparatus for an old attic I want to take. It has old
sunburnt walls. I should be interested to see MrAnrep's[6] exhibition. I liked your
portrait of a young man you had at the Contemporary, at the same exhibition as
my Apple picture. I wish the National Gallery was in Cookham, but I have
many reproductions of fine pictures of old masters lent to me by the Raverats,
they stimulate me. They 'quicken' me, do they not do so to you?

Yours very sincerely
Stanley Spencer

Spencer has written in the left-hand margin: "Please correct any incorrect spelling".

Fernlea, Cookham, August 12th 1914

Dear Lamb.

I should like to be able to do some thing.[7] Gilbert[8] is keen on joining you but— he cannot ride though he is keen on learning. It is intolerable to be out of it: I can not think. If you know of anything that either Gil or I could do, let us know. I expect it is rather selfish but I am determined that Gilbert shall not volunteer for Foreign service there is not the least necessity for him to do so. It would be better if he could simply put his name on the list of those to be called if required, so that he could get on with his picture (its going to be finer, much finer, that the last one) But he has never done any training. I do not see that I could be of any use except of course those other dutys to do besides fighting. What ghastly things those Liège forts are:— [*here is a diagram of a fort*]

There seems to be no sport in war now. I would like you to advise us what to do. . . .

Cookham.
Stanley Spencer is only my professional name.

There is a note in the margine in Spencer's hand: "I have finished my portrait.[9] I have done some Landscapes & am going on with my big picture".

[1] Darsie Japp: a fellow student at the Slade School of Art, University College, London.
[2] The *Apple Gatherers*, now in the Tate Gallery, London.
[3] Edward Marsh: later Sir Edward, patron of young poets and artists, 1872–1953.
[4] Gwen Raverat (née Darwin) also a student at the Slade. She married Jacques Raverat.
[5] Perhaps his first thoughts on *Zacharias and Elizabeth*.
[6] Boris von Anrep.
[7] Britain declared war on Germany on August 4, 1914.
[8] Gilbert Spencer, the painter (1892–1975): the youngest of the eleven Spencer children and Stanley's junior by just over a year.
[9] This is the larger-than-life self-portrait now in the Tate Gallery, London.

Egon Schiele

b. 12 June, 1890. Tulln, near Vienna, Austria.
d. 31 October, 1918. Vienna, Austria.

Plate 14. Self portrait, 1912; age 22.
Pencil and watercolour. 33 × 24.2 cm. Private collection USA.

In the Austria of 1912, Schiele's erotic drawings and a charge of seducing a young girl landed him in prison, on April 13th. The following are the first three entries in the journal[1] he kept during his twenty-four days of confinement.

Neulengbach Prison, 16 April 1912

At last!—at last!—at last!—at last deliverance from pain! At last paper, pencils, brushes, paints for drawing and writing. Agonising were those wild, chaotic, hideous, uniform, those shapeless, monotonous grey, grey hours which I, bereft, had to spend like an animal, naked between cold stark walls.

If this utterly deprived, dreary day-to-day existence had continued I would surely have gone mad, as those with no inner strength would have done; and in order to avoid really going mad I painted, with a force drawn from the very roots of my being, with trembling fingers dipped in bitter spit: and using spots in the plaster I painted landscapes and heads on the walls of the cell, and then watched how they gradually dried, and paled, and disappeared into the depths, as though they had been wiped away by an invisible, magically mighty hand.

Now, happily, I again have materials for drawing and writing; they even gave me back the dangerous little penknife. So in this way I can be active and able to endure what otherwise would have been unendurable. For this I have been down on my knees, have humbled myself, have requested, have beseeched, have begged for this, and would have whimpered if there had been no other way. Oh, art!—what would I not do for you!

17 April 1912

13—13—13—thirteen times the thirteenth of April. I have never thought of thirteen in a superstitiously frightened way, but now there has been a disastrous 13th day of the month for me. On the 13th of April 1912 I was arrested and locked up in the Neulengbach district courthouse.

Why? why? why? I do not know—to my question I got no answer.

Vienna does not echo with screams about my imprisonment—because no one knows as yet that I have been violated against and have disappeared into an abyss. And if anyone knew, would there be an outcry, would anyone help me? G. K. and A. R. perhaps; others would in cowardice withdraw and T. F.[2] would behave like a Jesuit and, with stiff face and expressionless eyes, would shrug his shoulders and secretly feel freed of one who stood in his way.

Hell! a hell, not the hell, but a hell, abject, vulgar, dirty, lamentable, humiliating, is the one into which I have been pushed unawares.

Dust, cobwebs, phlegm, drops of sweat and tears have sprinkled the rough crumbling mortar of this chamber. Where the pallet stands against the wall the stains are at their densest, the chalky whitewash is rubbed off, the bricks, like blood-clots completely smooth and polished, shine dark and greasily. I know now what a dungeon is—here it is a dungeon. If one looks at the thick, coarse, heavy door with its strong, large lock, the door which cannot be broken down by a push of the shoulder or by a kick; if one looks at the grille with its shutter, the bunk roughly carpentered out of stout posts and the coarse tattered blankets on it (a horse's back would shudder to be covered with them) which stink peculiarly of carbolic or lysol, and human sweat and musty dampness and

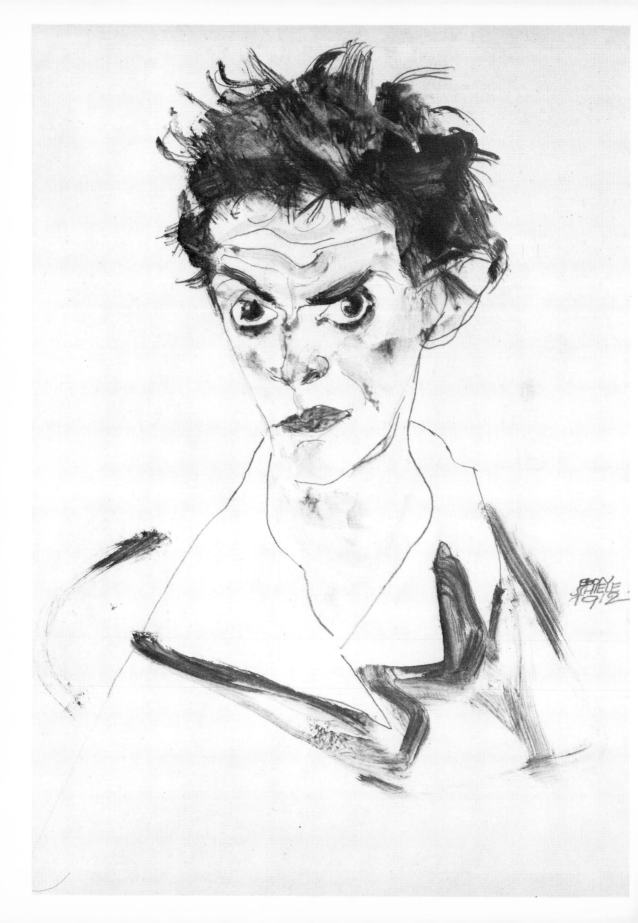

animal wool—if one looks at all this one experiences the dungeon of olden times, the horrific pit of an old fortress, of an old Town hall, in which the prisoners were thrown and then rotted away.

Only the button of the electric bell above the head of the sleeping place doesn't fit, is present-day, is modern. And therefore I know that I am not dreaming, that I am not seeing visions. No, I am not dreaming, I am alive, I experience, unless life is altogether just a dream—in which there are nightmares.

18 April 1912

I have to live in my own excrement, inhale poisonous putrid vapour. I am unshaven, cannot even wash myself properly. But I am a human being!—still, even if I am imprisoned; doesn't anybody think of that?

The key-jangling keeper puts a bucket, a broom, brush etc in the cell and orders me to scrub the floor. Is that permitted? Insulting, this imposition. Still I was glad of it, just to be active is a help. I scrubbed and scoured, washed and wiped with all my strength. Knees, spine and arms hurt me for a long time and my fingers are worn and the nails broken. I waited for the keeper, almost proud of what I had done and believed that he would praise me for it. He came, looked at the floor, then spat here and there, disgusting spit, and grumbled: "That supposed to be scrubbed?—that's just pigs' mess. You'll do that floor again at once and, let me tell you, proper this time!" And I dragged water and knelt down again, and scrubbed and scrubbed.

How can it be a joy for people (*Freude!—Götterfunke!!*)[3]—to humiliate others in such a way? Whence this base obsession? How is such vileness possible? I am not yet convicted, how is it they should want to punish me? No one knows yet whether I am innocent, and if I am how can it be allowed to treat me so badly. Is it done with all prisoners on remand? It would be good to imprison all politicians once arbitrarily, like me, so that these thoughtless law-makers might experience and comprehend with their own bodies (for they have no soul anyhow, or only an impoverished one) what it means to be in prison.

[1] The prison journal *Egon Schiele im Gefängnis*, was published by Schiele's friend and patron, the art critic Arthur Roessler, in Vienna, 1922. The early death of the artist in 1918, aged 28, a victim of the influenza epidemic, was a further loss to the Expressionist movement (see Richard Gerstl, plate 22). This translation into English was made by Karin Hartmann and Elspeth Kinneir.
[2] The three initials stand for Gustav Klimt, Arthur Roessler, and Anton Faistauer, painter.
[3] From Schiller's poem *An die Freude* ("To Joy"), further immortalised in Beethoven's *Choral Symphony*.

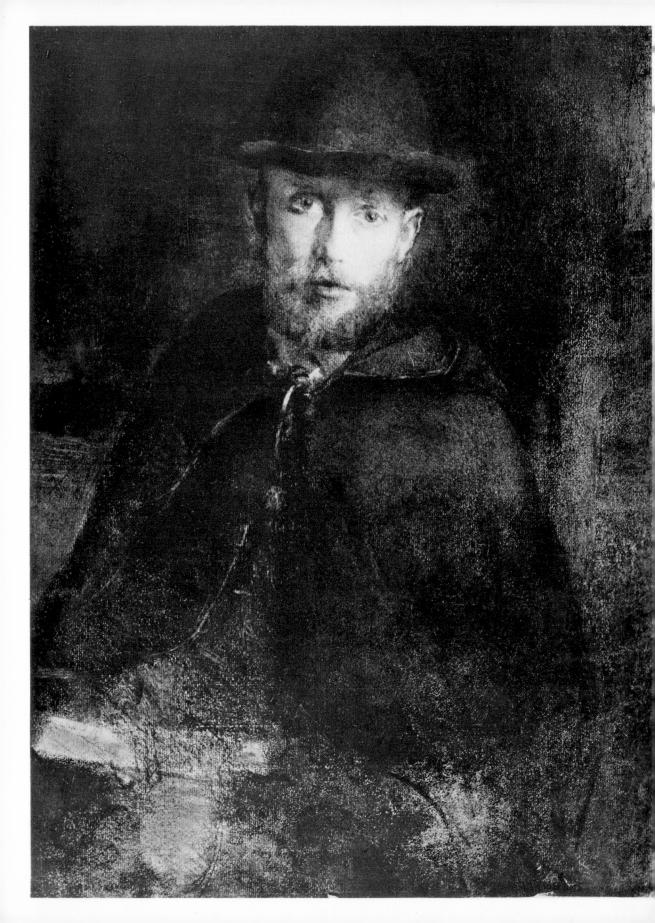

Georges Rouault

b. 27 May, 1871. 51 rue de la Villette, Paris, France.
d. 13 February, 1958. Paris, France.

Plate 15. Self-portrait, 1895; age 23/24.
Charcoal and crayon with pastel. 73.1 × 54 cms. Private collection.

Selected paragraphs from the recollections which Rouault wrote when he was seventy-two.

> *Souvenirs du Jeune Age*
> *sont gravés dans mon coeur*
>
> To my dear Mother

These were the words, I remember, which went with an old air by Grétry,[1] a musical-box air, very old-fashioned, which I was fond of; people are ready to affirm that everything is new under the sun, oblivious that in the subtle and innumerable nuances in this beloved art of painting, everything can seem new to the tender adolescent, but as for being able to express it—congruously—*Miserere*—that is, has always been, will always be quite another story.

Having nothing to lose and driven by pressing necessity, I was, before my entry into the School,[2] a glass painter,[3]

> *Au verre si franc d'aloi*
> *je me coupais souvent les doigts.*

and being still but a child, I felt timid in the distinguished company of certain master restorers. Tall, and nothing but a bag of bones, I crossed Paris at the end of the day, towards six o'clock, to go to the Arts Décoratifs, rue de l'École-de-Médecine. I had only an hour and a half to go on foot from rue Gauthey where I worked close by the Porte de Clichy, to the rue du Pré-aux-Clercs where I lived then, and straightaway after a hurried meal, still at a run, to rue de l'École-de-Médecine, hoping I wouldn't find the door closed, which it did at half-past seven.

I have no regrets over the time it took and the severe discipline, because of the tremendous joy I had in drawing two hours each day; above all when I could work from life or from the antique, after I had left the class where I drew from pictures. There, I had incidents with an old professor who refused to correct me because, together with two or three lads who had attached themselves to me, I did not fall in with his views. He would hiss through his teeth: "Velasquez, Velasquez", as if he were denouncing us when we had had the misfortune to indicate in the background of the drawing, since we were working by lights, some propitious shade behind or at the base of our principal figure.

One evening when the model wasn't there, I passed through the sculpture department and rapidly sketched a head. Aimé Millet—whose Vercingétorix[4]

with flowing moustaches *à la Gauloise* is to be seen in the middle of Boulevard de Clichy in front of his studio where there is a little open yard—stopping in front of my modest sketch said to me, "You are a sculptor". At which I replied that I had never done sculpture. Three times he repeated, "You are a sculptor", although I replied three times, "No, I am a painter". It was not until after he had left that I tumbled on his meaning, in a plastic sense. Later, when I knew Rodin,[5] I learned that he used to go and sit down on the little tiers of the amphitheatre, where underfoot the rats rioted in battle, and sometimes came after the crumbs of bread which we used to pick out the highlights in our charcoal drawings.

Where are the snows of yester-year?[6]

The *Christ Mort*[7] was my last attempt, while attending the École des Beaux-Arts, at the Prix de Rome. "Christ's foot is too big," said Bonnat. "Granted," replied Gustave Moreau, a trifle paradoxically, "It is for that reason we must send him to Rome, for, as you say yourself, the student you propose will never improve on this chromo"; and he added, "No second prize for him, Rome or nothing; the time spent there will be excellent for him, I think; he likes to apply himself and enrich himself and if he takes a fancy to seeing the Roman countryside, and to send us something in that line, I would have no objection". It was Bonnat's student who got the prize.

For the Chenavard,[8] the official winner was denied the honour, a unique case I think in the annals of the École des Beaux-Arts; the judgement was contested, and I had the prize conclusively.

Gustave Moreau,[9] that discerning spirit, deplored seeing me enter for competitions, knowing very well I was not made for that kind of official sport. When he died, I was disposed to try it once again, but I was happy, in his absence, that I didn't succeed.

I remember a canvas of Cézanne's which I saw at Ambroise Vollard's,[10] rue Martignac, which had been lacerated with the stabs of a palette knife: the traces of it were still there. It had been rescued from the top of a tree in Cézanne's garden in Aix-en-Provence by the late A. Vollard who had had it restretched perfectly with the artist's consent. When Cézanne, with the fervour which he has for his art, slams his door with such violence that it makes the house tremble from top to bottom, it is the reaction of a recluse against the curiosity, the familiarity, or the puerile or misplaced jokes of so many well-meaning folk, infinitely too know-all, who seem sometimes to say: "We are now well-informed and enlightened; and nobody can tell us anything".

From *Le Point*, No 5, Aug–Oct, 1943.

[1] André Ernest Modeste Grétry was born in Liège, 1741. He composed mostly operas.
[2] L'École des Beaux-Arts.

[3]Between 1885 and 1890, aged 14–18 years, Rouault was apprenticed to a stained-glass maker.

[4]A leader of the Gauls, defeated by Caesar in 51 BC, imprisoned in Rome and finally put to death.

[5]Rodin entered the Arts Décoratifs 30 years before Rouault.

[6]". . . . où sont les neiges d'antan?" François Villon (1431–?) from *Ballade des dames du temps jadis.*

[7]*Le Christ mort pleuré par les Saintes*, 1895, the year the self-portrait (Plate 15) was drawn.

[8]The Prix Chenavard, which he won with *L'Enfant Jésus parmi les Docteurs* in July 1894. A student protest caused the judges to alter their decision in favour of Rouault.

[9]Gustave Moreau (1826–98) Rouault's teacher and his mentor. After his death a Moreau museum, of which Rouault became curator, was founded.

[10]Ambroise Vollard (1868–1939) was writer, publisher, art-dealer and art critic.

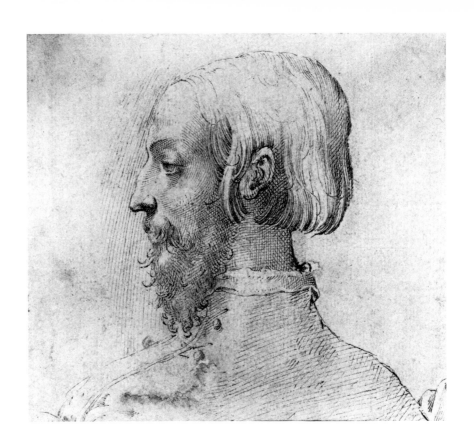

Francesco Parmigianino

b. 11 January, 1503. Parma, Italy.
d. 24 August, 1540. Casalmaggiore, Italy.

Plate 16. Self-portrait, undated.
Brown ink on off-white paper, 10.3 × 11.8 cms. Graphische Sammlung, the Albertina, Vienna.

Giorgio Vasari was eight years younger than Parmigianino; when the painter died at the age of thirty-seven, Vasari was twenty-nine. Here he describes another, more famous self-portrait by Parmigianino (c. 1523/4) now in the Kunsthistorisches Museum, Vienna.

... Being anxious to go to Rome after hearing the praises of the masters, especially of Raphael and Michelagnolo, he expressed his wish to his uncles, who thought his notion admirable, and gave their consent, at the same time advising him to take a specimen of his work in order to obtain an introduction to the patrons and artists. Thinking the advice good, Francesco did two small pictures and a fairly large one of a Madonna and Child, who is taking fruit from an angel's lap, and an old man with hairy arms, executed with art and judgment and beautifully coloured. One day he began to paint himself with the help of a concave barber's mirror. Noticing the curious distortions of the buildings and doors caused by the mirror he conceived the idea of reproducing it all. Accordingly he had a ball of wood made, and cutting it out to make it of the same size and shape as the mirror he set to work to copy everything that he saw there, including his own likeness, in the most natural manner imaginable. As things near the mirror appear large while they diminish as they recede he made a hand with wonderful realism, somewhat large, as the mirror showed it. Being a handsome man, with the face of an angel rather than a man, his reflection in this ball appeared divine. He was most successful with the lustre of his glass, the reflections, shadows and lights, in fact human ingenuity could go no farther. The work when completed was greatly admired by his seniors and connoisseurs, and being packed in a case with other pictures it was taken to Rome by one of his uncles. Upon the datary seeing the pictures and recognising their value, the youth and his uncle were immediately introduced to Pope Clement. When His Holiness saw the youth of Francesco he was amazed, as well as all his court. . . . I remember when quite young seeing the portrait at Arezzo in the house of M. Pietro Aretino,[1] where it was exhibited to strangers passing through as a curiosity. . . .

From Vasari's *Lives of the Painters, Sculptors, and Architects,* translated by A. B. Hinds, edited by William Gaunt, J. M. Dent & Sons Ltd, 1927, originally published in 1550.

[1] Pope Clement had given the mirror portrait to M. Pietro Aretino.

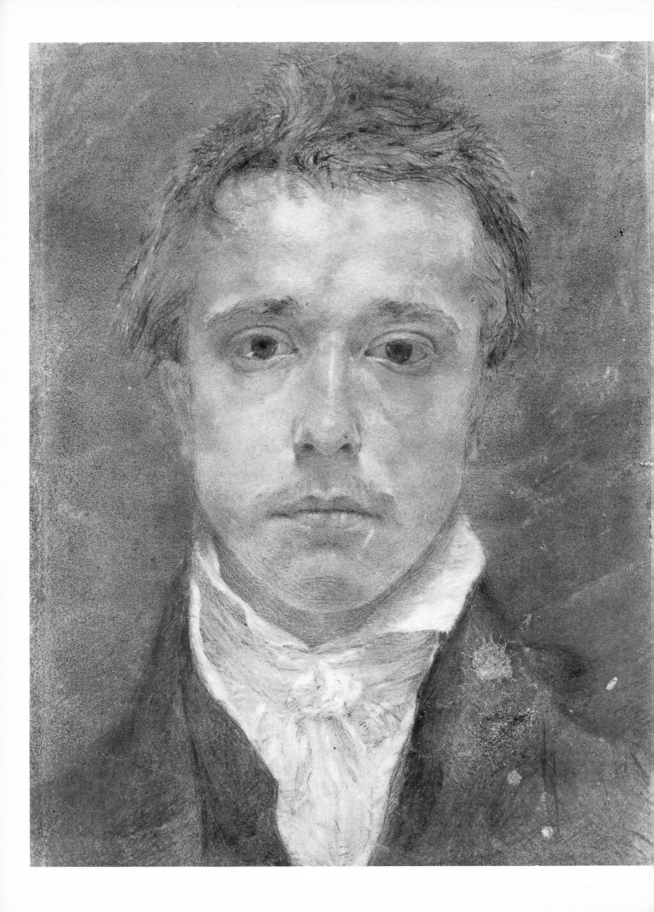

Samuel Palmer

b. 27 January, 1805. Surrey Square, Newington, London, SE17, England.
d. 24 May, 1881. Furze Hill, near Redhill, Surrey, England.

Plate 17. Self-portrait, undated;[1] age 23.
Black chalk heightened with white, buff paper, 29.1 × 22.9 cms.
Ashmolean Museum, Oxford.

Letter from the 22-year-old Samuel Palmer to his friend George Richmond.

Shoreham, Kent, Novr. 14 1827.

My dear Sir

Winter, shorn of the pleasure and instruction of your society which brighten'd
my summer—a Shoreham midsummer, is a very emission of loss; and this
gasping hiatus sucks in many dark and acrid crudities of the gloomiest month: I
mean in the jaded halts of intellect tugging up the hill of truth with the sun on
her head & this excrescent wen of flesh broiling on her back: for tho' the eclipses
of thought are to me a living inhumement & equal to the dead throes of
suffocation, turning this valley of vision into a fen of scorpions & stripes and
agonies, yet I protest, & glory in it for the sake of its evidence of the strength of
spirit that when inspir'd for art I am quite insensible to cold, hunger & bodily
fatigue, & have often been surprised, on turning from work to find the fingers
aching & nearly motionless with intense cold. Nor can the outward sense govern
thus in turn; it is a tyranny of those brothers cruelty & weakness for whom
the *rear* of spiritual thought is found too much; the recollections of happy
enlighten'd hours, spiriting up to resistance the whole territory of man, till all his
energies & desires break chains—march out & rush to prevent half way, with
hymns, triumphs, acclamations, the majesty of their returning Freedom.
 I want so much to be talking with you that you see I cannot wait till next
coming to town, but use (would I could as it deserves) that choice device, that
wing of lovers' thoughts which "Wafts a sigh from Indus to the Pole"; but not
to baulk Montesquieu's too true notion of an Englishman—he says had he been
British he had been a merchant—head & shoulders will I shove in mine own
secular interest, & beg the favour that if in your ivory researches, you meet with
3 or 4 morsels of very fine ivory, size & proportion not very particular so they
be from about 1 inch by 1½ inch up to about 3 inches by 2 inches, you would
buy them for me. Some thoughts have concocted & condensed in my mind of
what I have seen walking about in midsummer eves & and I should not care if I
got a few of the subjects on ivory now, to study upon with fresh recollections of
similar appearances next midsumer if God spare me; I prefer doing them very
small, for they are not things by themselves, but wings, terraces or outbuildings

69

to the great edifice of the divine human form—otherwise snares. But I have beheld as in the spirit, such nooks, caught such glimpes of the perfumed & enchanted twilight—of natural midsummer, as well as, at some other times of day, other scenes, as passed thro' the intense purifying separating transmuting heat of the soul's infabulous alchimy, would divinely consist with the severe & stately port of the human, as with the moon thron'd among constellations, & varieties of lesser glories, the regal pomp and glistening brilliance & solemn attendance of her starry train. Remembering me kindly to all friends you may see, if you think of it, would you, Sir, do me this kindness in particular to present Mrs. Blake[2] with my most affectionate & respectful remembrances; only the having nothing to shew prevented my going to Mr. Linnell's[3] when I was last in town. You will perhaps also, giving the same to Mr. Frederick Tatham & best respects to Mr. and Mrs. Tatham & Mr. Waters if he be there, most adoringly, vehemently & kissingly present my quaint but true knightly devotion to the young ladies One and All, collectively ador'd & individually belov'd— telling them, imploring them sometimes to think on me (for is it not an honour for fair ladies to think on me, tho'd it be only to set their pretty mouths a-giggle at the remembrance of my spectacles?)

Tell them that herein is my disadvantage—whereas mine eyes are dim save when I look at lady fair—& whereas I can only see their lustre thro' my goggles; those said unlucky goggles are so scratch'd & spoil'd that all the fire of the love darting artillery of my eyes is lost upon *them* & redounds not to my advantage, the ladies seeing only two huge misty spheres of light scratched & scribbled over like the sun in a fog or dirty dish in a dark pantry, as lustre lacking, as leaden, & as lifeless as a lad without a lady. But tell them sometimes to think on me, as I very often think of them, & as in sullen twilight rambles, sweet visions of [their] lovely bright eyes suddenly sparkle round me, [and il]lume my dusky path— double the vigour [of my] pace, rebuild my manhood & renew my y[outh]. You see the perfections of the ladies are unsp[aring?]—that is the reason that no sooner do I begin [to] write of *them* than lo! I scribble nonsense—arrant nonsense. Harvey's Meditations & the heaths of Fingal & the vapours of the hill of storms.

Ought I to send you such a scribble? but I will send it for the ivories' sake, & to speak my hope that you may have the blessing & presence of the Almighty for ever, & that absence has not yet rased from the tables of your memory, dear Sir,

Your Affectionate & Humble servant

Samuel Palmer

If you are so kind as to get me the ivories, pray, Sir, make no hurry, but let it be, till you go about materials for yourself & bring the ivories in your pocket when you do us the favour of a visit, when you will perhaps come in the coat you mention'd. Be pleas'd to present my best respects to Mr. & Mrs. Richmond.

I wish I could add "*& to Mrs. Richmond Jun.*'

I must let this note go upointed, uncorrected, with all its orthographic blunders whether of negligence or ignorance, for if I begin to revise I shall sentence it to the flames very speedily.

I am looking for a wife.

From *The Letters of Samuel Palmer*, edited by Raymond Lister, Oxford University Press, 1974.

[1]A very similar portrait of Palmer by George Richmond is dated February 3rd, 1828.
[2]The widow of William Blake, who had died three months earlier.
[3]Palmer married Hannah, the eldest of the Linnell daughters, ten years later, in September 1837 when she was aged 19 years.

Henri Fantin–Latour

b. 14 January, 1836. Grenoble, France.
d. 25 August, 1904. Buré, dans l'Orne, France.

Plate 18. Self-portrait, undated (1860?).
Black chalk on off white paper, 18.1 × 14.5 cms. Cabinet des Dessins, Musée du Louvre, Paris.

Wagner's Festspielhaus opened in August 1876, and Fantin-Latour arrived in Bayreuth at five in the morning on Sunday, 27 August, with his friends M. and Mme. Lascoux and Jules Bordier, to see the third performance of The Ring. *He wrote four letters in the form of quick notes, one after each part of* The Ring, *to his friend Edmond Maître.*

A Painter with Music–Mania

We go in. The interior is impressive, and discreet (outside there is nothing, no façade, nothing). At the most there were two or three French, Lizst and his ladies gathered among them in a French-speaking group; Madame Cosima[1] was there. Before lights out there is a half-light, one gets a feeling of expectancy. A military fanfare outside; it is the king;[2] but before there is a chance to see him the curtain-bell goes—it is (almost) completely dark. Then, with a murmuring, muted and sonorous, the orchestra merges into a single voice, an immense organ. It is a very beautiful sensation, a new experience, quite unique; and I must say I found it very moving.

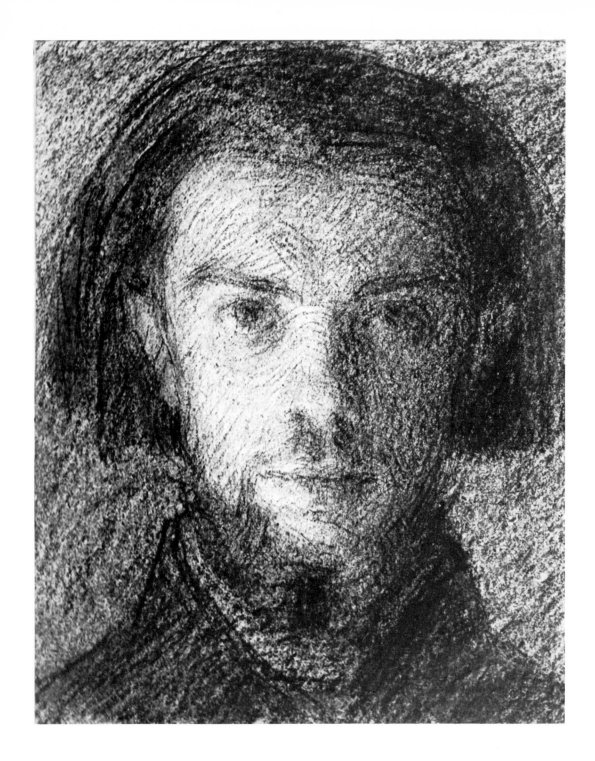

The curtain lifts gently, and there is something indescribable, vague, obscure, becoming green, slowly getting lighter. Then you see the rocks, and then softly forms pass and repass; the Rhinemaidens above, Alberich[3] below among the rocks. In all my memory I have never seen anything so enchanting, or more expressive. The movement as the Rhinemaidens swim and sing is perfect.[4] Alberich clambers up and snatches the gold; the lighting, the gold reflection on the water, it is all ravishing!

Here, as in the rest it is the sensation; not the music, not the décor, or the subject which grip the spectator; not the words, but all these things together. The gentlemen (Lascoux and Bordier) were overwhelmed by the orchestra and musical rendering; entirely successful, the invisible orchestra![5] Its concealment makes a great impression. The void, the mysterious empty space is baffling. The effect on me was enormous despite the unfamiliarity which prevented me quite following it all the time. It exhausted me more than a piano recital because the concentration is so strenuous; the combination of the décor, the action, even the effort to understand the language. I find myself having to relax sometimes, to unwind, to let my mind go blank. I am sure though, that a musician, having the score, and being familiar with it as with a language, would have no feeling of fatigue. M. Lascoux tells me he wasn't able to sleep: however I slept well, worn out by the experience; and the beer is so good! We talked until about ten o'clock after we got in. I like this country, it reminds me pleasantly of England. One is at peace.

We arrived at *Die Walküre*. It is superb, the flight of the Valkyries[6] on their chargers, the remonstrances of Wotan, their battle cries, then the confrontation with Wotan when they hide Brunhilde; incomparable. An impassioned violence beyond words. Very wearying the recitative of Wotan, charming the Spring song but sung badly by Niemann who is not good. Excellent Brunhilde and Sieglinde. The décor for Hundling's dwelling is lovely; the door which opens to the Spring, the sword on the tree, a great poetic idea, full of imagination. But one criticism: his ideals are sometimes beyond the reach of the theatre. He tempts the impossible; however, when he does succeed, that is, when they do as he wants, it is admirable. Wotan's adieu is very good, and the laments of Brunhilde. The scene between Brunhilde and Sieglinde, when she brings her amongst the Valkyries, is magnificent.

In the interval we went down into the orchestra which is superb. You could compare it to a magnificent kitchen, full of utensils of every sort (I will tell you all about it). Wagner was sighted in a corner of the theatre; there were shouts and applause, and in the end it was a riot of enthusiasm. . . . It is such an exhilarating occasion, it defies description. This theatre in the fields, the beautiful views all round, the restaurants, beer gardens everywhere, all the visitors coming and going. The inhabitants appear to be delighted. The King's presence enlivens the town which is usually as peaceful as Versailles used to be; at theatre time big coaches everywhere, one after another; undemonstrative, however; it is a select public. I am enchanted to be here, and only regret you are not here with me. We would go together where I am going now, to walk as far as Wagner's house and then turn round, and I am satisfied. Adieu; tomorrow *Siegfried*.

From *Fantin-Latour, sa Vie et ses Amitiés* by Adolphe Jullien, Lucien Laveur, Paris, 1909.

[1] Madame Cosima was Liszt's elder daughter; she became Wagner's mistress and later his wife. She was an influential figure in the musical world.

[2] King Ludwig II of Bavaria, Wagner's patron.

[3] Alberich is one of the Nieblung race of brutish dwarfs who burrow under the earth.

[4] What Fantin cannot see is that behind the back-cloth the Rhinemaidens, Woglinde, Wellgunde, and Flosshilde, are supported in a reclining position each on the top of a tall post fixed to a low chassis, and whirled round the stage by stagehands.

[5] Wagner made a breakthrough in the technique of acoustics by having the orchestra under the stage; thus the players and the conductor (who for this first presentation was Richter) were invisible to the audience.

[6] For the ride of the Valkyries (the eight sisters of Brunhilde), which was seen by flashes of lightning, young boys in winged helmets and brandishing spears represented the Valkyries, as they appeared smaller and gave the illusion of distance; and on their wooden chargers they were propelled by machinery across a fantastic back-cloth.

Friedrich Johann Overbeck

b. 3 July, 1789. Lübeck, Germany.
d. 12 November, 1869. Rome, Italy.

Plate 19. Self-portrait, undated.
Pencil on off-white paper, 26 × 19.3 cms. Kupferstichkabinet, Staatliche Museen,
East Berlin.

*Overbeck was a founder member of the Nazarenes, a brotherhood of German painters
working in Rome. He was brought up a strict Protestant, but adopted the Roman Catholic
faith on Palm Sunday, 1813, as he describes in the following letter to his friend Joseph
Sutter, a historian.*

Rome 21st May 1813

Were it not that I know your unshakeable friendship, I would in all seriousness
be afraid that my silence might have lessened your love for me; but I know you,
and need only to picture you vividly and all my worries vanish. Therefore, I can
confide to you that it was indeed quite impossible to write until now, the reason
for which you will find in the following lines.

Thank God it was neither poor health nor any similar misfortune which
prevented me, but something for which my soul will praise the Lord to all
eternity. Namely, on returning here from my summer holiday in the country I
made the acquaintance of a priest, who was in every respect the best example of
what could be called a "world priest", in that he combines an unshakeable faith
in the true belief, with a rational approach and exceptional enlightenment,
possesses untiring enthusiasm for his work, and wins everybody's heart by his
warmth and openness. Already I had been giving much individual thought to
what must be the ultimate question, here on this earth—the search for truth, and
I had come to the conclusion that there can only ever be one shepherd, and one
flock, which surely must be the fervent belief all true Christians; if only we
could forget the differences between Catholics and Protestants brought about by
ignorance and lack of understanding which breed hostility on both sides; that is
what I thought when I made the acquaintance of this priest.

Until then I had little knowledge of Catholicism, certainly nothing profound,
and I intended therefore to learn something from him, without thinking
seriously what the outcome might be. But after a few evenings, the priest
proved to me so clearly the necessity of a visible Church, that the scales fell from
my eyes and I felt it impossible to believe that not everybody could see it with
the same clarity.

With friends, I continued my evening visits, and after a short inner conflict I
was entirely persuaded as to the truth of the Catholic teaching, insofar as only
through the Church can we come by God's word complete and pure, and that it

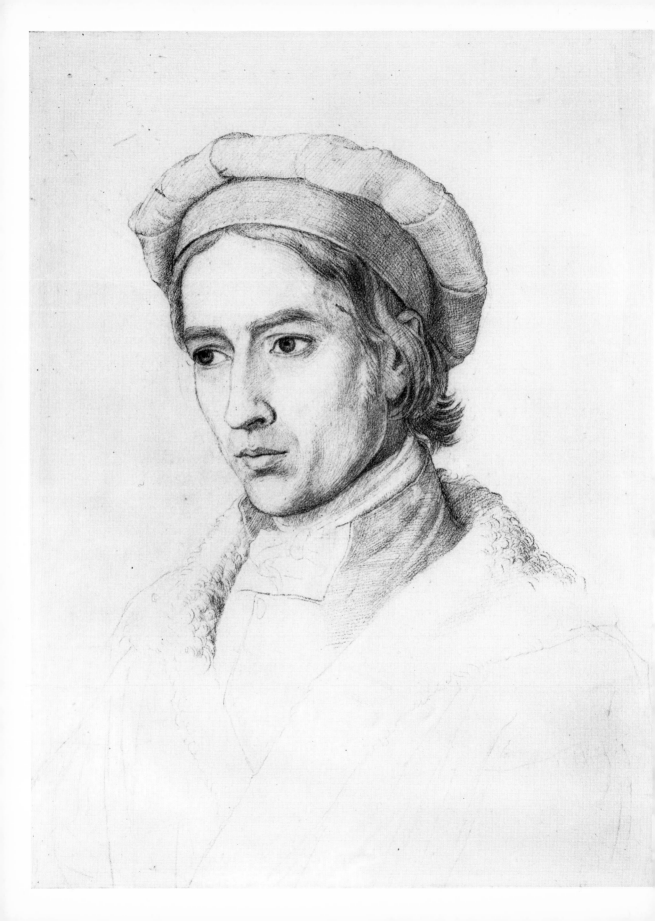

is our duty to grasp, in Her, the reality of salvation. With this recognition, how I began to see the light! I realised that with the Reformation, all of a sudden, this particular spirit of simplicity and piety, which speaks to us through all the old works of art and science, seemed to fade and was replaced by a sort of arrogance and rationalism, denying us a simple trust, and leaving us cold and insensitive to beauty and the influence of the arts. In short, wherever I looked, a new clarity, a new conviction radiated towards me, and I would have joined the Church immediately had I not been afraid to hurt my revered parents too deeply by such a sudden step.

But I immediately started an animated correspondence with my father to whom I wrote in great depth about my recently gained enlightenment, hoping that, moved by the weight of my arguments, he would not only give me his blessing, but would follow my example. This correspondence, to which I dedicated all my spare time from work, was the main reason for my silence towards you, dearly cherished Sutter, which I am sure you will forgive me. Unfortunately my letters did not have the success I desired. My father, grown old in rigid prejudice against Catholicism, opposed me violently. I wrote time after time, never succeeding. His responses were of such a nature that they weakened me rather in the beginning, but as I looked more closely at them only strengthened my belief. In the end I decided to solemnise my conversion here quietly, but to keep my step secret from him for the time being, until eventually I might hope to convince him.

Palm Sunday was the most significant, unforgettable day for me, when after four days of preparation in a monastery I was received into the bosom of the Church. The stillness of the ceremony belied my inner turmoil, which words cannot express. Since then, I have led a regulated Catholic life, and the receiving of the Sacrament brings such peace and Heavenly consolation that I can face with renewed courage the struggles which lie before me, and any suffering which God may think fit to send me.

My beloved brother, give thanks with me that the good Lord, who in his mercy has so radiantly graced the most humble of his servants, has moreover more closely united us, my most beloved, with a spiritual bond which will always endure, if with fervent prayer we follow Him, and never forget His love.

You will now understand that I have good grounds to keep the whole story secret, and I need not add that I have told it to you in strictest confidence. No one knows of it other than my friends, amongst whom only Vogel remains to be told, but I shall write rather than hope to convince him by discussion, as in conversation it is too easy to become passionate and therefore unable to think in a calm and clear way.

From *Friedrich Overbeck* by Franz Binder/Margaret Howitt, Freiburg, 1886, reprinted Bern, 1971. This translation by Maria Saekel-Jelkmann.

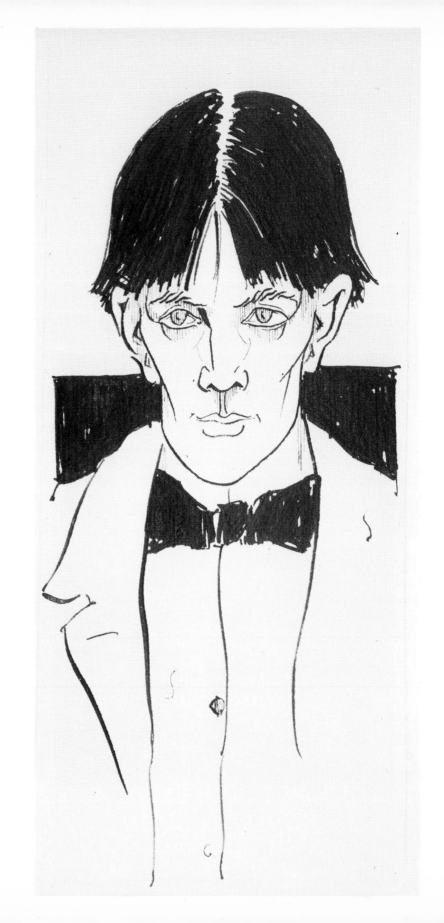

Aubrey Vincent Beardsley

b. 21 August, 1872. Brighton, England.
d. 16 March, 1898. Hôtel Cosmopolitan, Menton, France.

Plate 20. Self-portrait, undated.
Pen and ink on off-white paper, 25.2 × 9.4 cms. The British Museum, London.

Mr. Aubrey Beardsley and his work
by Arthur H. Lawrence

There are widely divergent views entertained by the noble army of art critics as to the value of Mr. Aubrey Beardsley's black-and-white work. *L' Art decadent, c'est moi* is somewhere stated to have been Mr. Beardsley's own idea on the matter; but whether that utterance is to be taken as a proud boast, or a humble confession, there is no evidence to show. . . .

Although, according to medical opinion, he has not long to live, Mr. Aubrey Beardsley is yet but twenty-three years of age, and it is doubtful whether in such a short period of time as five years any artist has ever succeeded in obtaining so much public attention. Whether the public be a good, bad, or indifferent judge is a debatable matter, but certain it is that in no series of articles dealing with the black-and-white work of the past half-dozen years could Mr. Aubrey Beardsley's work be safely ignored. When an artist succeeds in an amazingly short space of time in catching the public eye, he is reckoned as having achieved something; and it may be safely assumed with regard to Mr. Beardsley's work that, even if it does not represent genius, it at least represents something more than the spoiling of paper; while, if it be true that imitation is the sincerest form of flattery, a walk down the street and a glance at the hoardings, or a cursory inspection of the illustrated periodical press will serve to convince one that—however unfortunate it may seem to us—Mr. Beardsley has founded a school, and has been blessed for some time by that superlative form of flattery which unoriginal artists are ever ready to supply.

Mr. Aubrey Beardsley is, at present, staying—his mother with him—at a south of England seaside resort. He has the young man's natural preference for life in London or Paris; but the air of these cities is not considered by the faculty as being conducive to the cure of haemorrhage of the lungs in an advanced stage, and in Mr. Beardsley's case medical orders are strict. Accordingly, it was on a cold and wet winter's afternoon that I presented myself at his house, and, after a tiring journey by train, I must admit that, even though an optimistic interviewer, I felt inclined to look on the bad side of everything. . . . When, however, I found myself sitting and chatting with the invalid in his combined sitting and workroom my spirits gradually rose, for although he looked haggard and pale, as victims of consumption generally do, I found in Mr. Beardsley an excellent talker, concise and to the point, interested in everything, listening eagerly, and, although his slight stoop and frail physique betrayed the invalid, entering into every point with considerable keenness.

Mr. Beardsley, when I saw him, was faultlessly dressed; and I suddenly remembered that a candid friend of his had told me that "Beardsley had two grand passions in life. One was for Wagner's music, and the other," which he thought surpassed in intensity his love for music, "was for fine raiment."

His charming study overlooks the sea. . . . "Yes, this is my studio," Mr. Beardsley explains. "It is made up of a table and those two old Empire ormolu candlesticks. Without those two candlesticks I never work, and they go with me everywhere."

"But is it true that you always work by candlelight?"

"I suppose I ought to express some apology for its being the truth; but I admit that I can't work by daylight. I am happiest when the lamps of the town have been lit, and I am so used to working by artificial light that if I want to work in the daytime I have to pull the blind down and get my candles in order before I begin.

"No, I had no idea of going in for black-and-white work professionally when I began studying the subject. It was on the recommendation of Sir Edward Burne-Jones, whose work has no more ardent admirer than myself, and of M. Puvis de Chavannes that I did so. That was five years ago, and since then I have turned out about a thousand sketches, drawings, posters, illustrations for various books, and the like. . . .

"This interviewing is a wonderful and terrible business," my host exclaims suddenly, "and I suppose I ought to make something in the nature of a confession. Well, I think I am about equally fond of good books, good furniture, and good claret. By-the-way, I have got hold of a claret which you must sample, and I think you will act on my advice and lay down a few dozen of it while there is a chance of getting hold of it," Mr. Beardsley interjects with a childlike heedlessness of the fact that interviewers do not, as a rule, receive princely salaries from publishers, while very often their credit is none of the best. But Mr. Beardsley is not to be denied on these matters, and refuses to say anything more about himself until I have sufficiently admired a goodly collection of Chippendale furniture—two rare old settees in particular, which he assures me are almost priceless—while he rapidly goes over the titles and dates of some of his rare editions, making up a collection sufficient to cause a bibliophile's eyes to bulge with envy.

"My opinion of my own work?" my host exclaims, as I bring him back to the main point of our chat. "Well, I don't know in what sort of way you want me to answer a question so inane—I mean so comprehensive. Of course, I think it's marvellously good; but, if you won't think me beating about the bush, I may claim it as a proud boast that, although I have had to earn my bread and cheese by my work"—("together with the Château Latour of 1865," I murmured)—"I have always done my sketches, as people would say, 'for the fun of the thing.' No one has prescribed the lines on which I should work, or set any sort of limits on what I should do. I have worked to amuse myself, and if it has amused the public as well, so much the better for me! Of course, I have one aim—the grotesque. If I am not grotesque I am nothing. . . ."

Then Mr. Beardsley goes on to tell me, amongst other things, how much he loves the big cities, and smilingly points out, that when a year ago his doctor ordered him to the Ardennes, he had obeyed his directions by going over to Brussels, following his

stay there by a sojourn in Paris. "How can a man die better than by doing just what he wants to do most!" he adds with a laugh. "It is bad enough to be an invalid, but to be a slave to one's lungs and to be found wintering in some unearthly place and sniffing sea-breezes or pine-breezes, with the mistaken idea that it will prolong one's threatened existence, seems to me utter foolishness."

A well known publisher having described Mr. Beardsley to me as "the most widely-read man" he had ever met, I questioned my host on the subject. "I am an omnivorous reader," he replies, modestly, "but I have no respect for the classics, as classics. My reading has been mainly confined to English, French, and Latin literature. I am very interested just now in the works of French Catholic divines, and have just received a copy of Bourdaloue's sermons from my publisher. I suppose my favourite authors are Balzac, Voltaire, and Beardsley. . . .

The interview continues.

From *The Idler*, edited by Jerome K. Jerome, Vol. XI, March 1897.

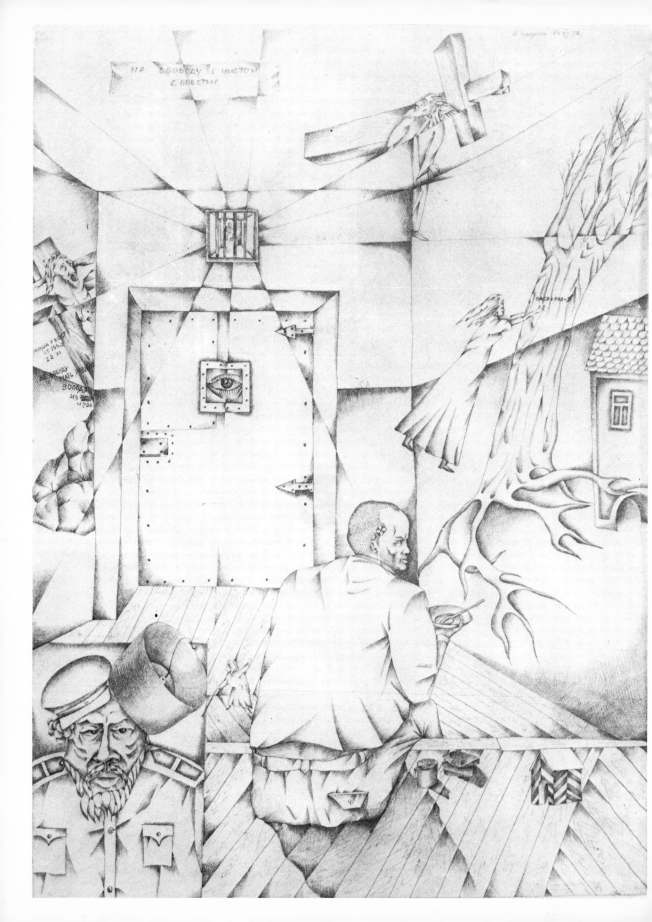

Alexander Kalugin

b. 1949. Moscow? Russia.

Plate 21. Self-portrait, *Freedom with a clear conscience*, 1974; age 24/25.
Pencil, 75 × 55 cms. Collection, Alexander Glezer, Russian Museum in Exile, Montgeron, France.

An interview with Alexander Kalugin obtained by a Moscow journalist in the summer of 1976.

Q: Information has recently filtered through to the West to the effect that the Soviet authorities are relaxing their policy towards representatives of unofficial art, so-called "avant-gardists". Do you share this opinion?
A: No, I do not, I cannot name a single well-known unofficial artist in our country whose position has changed for the better in the sense of his official social standing; that is to say, the overwhelming majority of such artists are still not members of the Artists' Union, and that means that they may at any moment be subjected to the cruellest repressions as "parasites" or "asocial elements". You do not have to look very far for examples. During the last year several exhibitions of unofficial art were held in Moscow. The authorities did not break up the exhibitions, but immediately after the first of them—the famous Izmailovsky Park exhibition—had closed, the repressions began. These hardly affected the "older generation" (as they are called) of "avant-gardists", artists like Rabin, Rukhin or Masterkova (perhaps because they are well known in the West). But the younger generation of artists (including myself) were the targets of the severest of measures: some were incarcerated in psychiatric hospitals, expelled from establishments of higher education, compulsorily recruited for army service or simply sacked from their jobs. As for myself, soon after the exhibition, the police came to my wife's apartment, where I live, threatened me and obtained a signed statement from me promising not to paint "abstract pictures" (although it is difficult to call my work abstract). Nevertheless, this does not surprise me: in a recent issue of the journal *Ogonyok*—"Spark"— an article by the Soviet artist Nalbandian, printed immediately after a poem by Yevtushenko about a progressive Japanese political lady artist, branded *all Soviet unofficial artists to a man* "abstractionists". If I disobeyed they threatened to have me put away in a psychiatric hospital. It was then announced to me that I was forbidden to live in my wife's apartment (!) since I was not registered to reside at that address.
Q: Nevertheless you went on exhibiting your work in people's homes after the Izmailovsky Park exhibition, did you not?
A: In the winter of 1974–75 I was put in a psychiatric hospital.[1] My work was taken to an exhibition while I was there without my knowledge. In the spring I was discharged, but I have continued exhibiting. One thing must be taken into account here. After the Ismailovsky Park exhibition, which was visited by many Western correspondents, a number of exhibitions were held in private apartments. Hardly

any Western correspondents came to these exhibitions, which therefore did not provoke what the authorities regarded as an "unhealthy fuss". The participants amounted to several dozen young artists. You can understand why the authorities nowadays are unwilling to use open repressions against several dozen relatively united people.

Perhaps it was the absence of open, mass repressions against artists that led Iosif Kiblitsky to announce that a new era in the authorities' attitude to unofficial artists had begun. In my opinion, there has been no change at all in their attitude. The repressions will continue; the KGB has not stopped compiling dossiers on us, and the authorities are not offering us premises to use for exhibitions.

Q: Your words about foreign correspondents not visiting recent exhibitions in private apartments may be taken as meaning that the exhibitions have not been enjoying very much success with the Western public.

A: That is true. Igor Golomshtok was right in what he said in his article in *Kontinent* about the Western public's attitude to our "avant-gardism" (which is the term the Soviet press uses when it talks about us). The exhibitions of our pictures Glezer has brought out of Russia to Western Europe have also demonstrated this attitude very clearly.

Q: Are private exhibitions by "avant-gardists" popular with Soviet citizens?

A: It is impossible to judge. The vast majority of Soviet citizens know absolutely nothing about the existence of such exhibitions. How can they possibly know? If Western radio stations are the only ones to report the fact. . . . And the majority of those who do know about them don't go to see them, fearing for their own personal safety: KGB men are constantly to be found on duty outside the apartments where these exhibitions take place. There remain the few dozen dissidents who make a habit of visiting such exhibitions. It is difficult, of course, to judge the real extent to which avante-garde art is popular from these few dozen people. The open-air exhibition at Izmailovsky Park was a pleasant exception; it was visited by enormous numbers of Muscovites. This was due to good advertising by Western radio stations broadcasting in Russian. However, the official reaction to that exhibition by the Moscow press was truly incredible. In an abusive review of the exhibition, the paper *Vechernyaya Moskva* incidentally described me as an imitator of Salvador Dali who painted in the "ancient Chinese manner" (in our country such absurdities in reviews by "plain-clothes art critics" are considered quite natural).

Q: Are private exhibitions in apartments the only opportunity for you and artists like you to show your work?

A: Yes, for the moment. So in this sense we are doomed to have no mass audience in our own country.

Q: How do you earn your living? How do you survive?

A: I refuse to get a job as a matter of principle. I am an artist and my business is painting. The authorities don't regard people like me as artists; they demand that we engage in "socially useful labour". Many of my friends who are unofficial artists or writers are forced to work as caretakers and nightwatchmen—anything to avoid giving the authorities any more grounds for repressions. But I do not wish to resort to a compromise of that kind. The only honest, acceptable source of income for

myself, in my opinion, is income derived from the sale of my pictures. Unfortunately, though, I have no permanent place of residence, and consequently I not only have nowhere to paint, I have nowhere even to show my work to prospective buyers. To a Western artist, even the least popular Western artist, such a situation may seem surrealistic, but, believe it or not, I make barely enough money from selling my pictures to keep me from starving to death—and I have a wife and daughter into the bargain. Even by the wretched, beggarly standard of living in the Soviet Union today I fall into the category of the lowest of beggars.

Q: Are you the rule or the exception?

A: I have, at least, some reputation in the West, and having a reputation in the West is a decisive factor when it comes to the matter of security. Most of the unofficial artists of my generation have no such reputation, and they live in even worse conditions and are victims of even greater persecution.

Q: Who buys your work?

A: Mainly foreigners, most of them Americans. I am grateful to fate that my work appeals to the Americans, the most culturally advanced people in the world, a nation with a subtle feeling for modern art.

Q: What are your average earnings from the sale of your pictures?

A: You had better address that question to my wife. For the reasons I have already mentioned my pictures sell in sporadic waves. It's either all or nothing. When it's "nothing" we get into debt. When we manage to sell some, all the money goes towards paying off the debts.

The interview continues.

From *Unofficial Art from the Soviet Union*, by Igor Golomshtok and Alexander Glezer, Secker & Warburg, 1977.

[1] The self-portrait drawing is from this period.

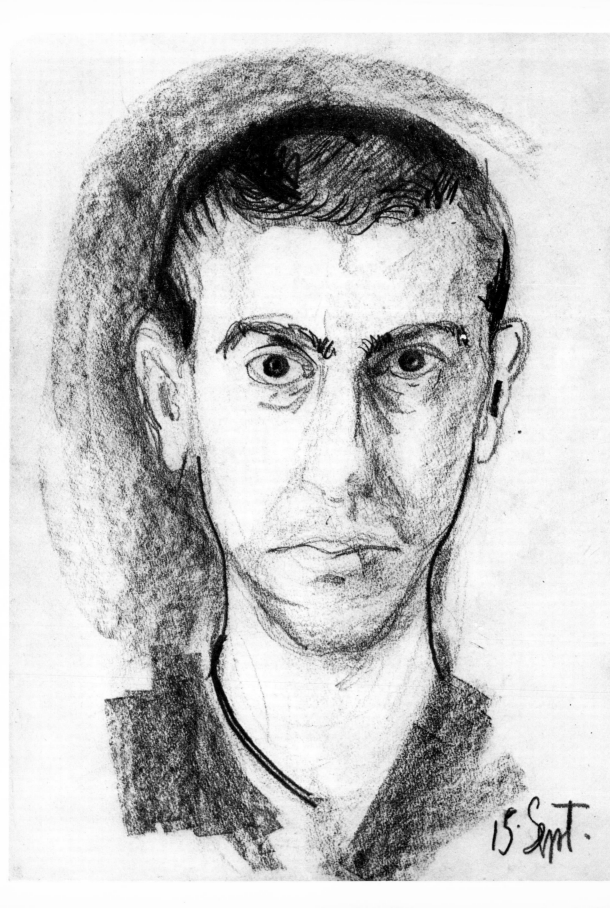

15. Sept.

Richard Gerstl

b. 14 September, 1883. Hungary.[1]
d. 4/5 November, 1908. Vienna, Austria.

Plate 22. Self-portrait 15th September, 1908; age 25 years and a day.
Thick black pencil, 40 × 29.9 cms. Historisches Museum der Stadt Wien.

Notice in Wiener Zeitung, *6 November, 1908.*

(Selbstmord) Heute wurde der Agent
Richard G. in seiner Wohnung erhangt
aufgefunden. Das Motiv des Selbstmordes
ist unbekannt.

(Suicide) Today the agent Richard G.
was found hanged in his apartment.
The motive for suicide is unknown.

The editor has so far been unable to find any more information relating to Richard Gerstl, or to
discover why the reporter chose to describe the painter as "agent". With his suicide at just
twenty-five a curtain was drawn on his life and work for about forty years. His name is now
linked with his contemporaries and fellow countrymen Kokoschka and Schiele, and it is
recognised that with his death Expressionist art lost one of its outstanding talents.

[1]According to his death certificate, Gerstl was born in Hungary.

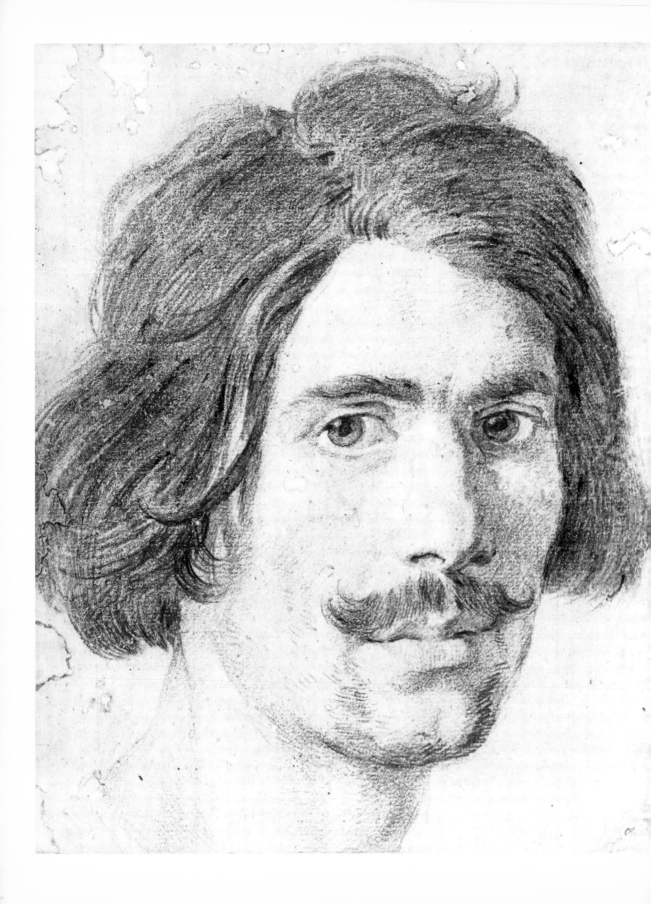

Gianlorenzo Bernini

b. 7 December, 1598. Naples, Italy.
d. 28 November, 1680. Rome, Italy.

Plate 23. Self-portrait, undated.
Black and red chalks, traces of white; 27.5 × 21.5 cms. Ashmolean Museum, Oxford.

Entry for 19 November, 1644, in the Diary of John Evelyn.[1]

(Rome) On the 19 I went to visite St. Pietro, that most stupendious & incomparable Basilicam, far surpassing any now extant in the World, & perhapps (Solomans Temple excepted) any that was ever built:

. . . Under the Cupola, and in the Center of the Church stands the high-Altar, consecrated first by Clement the 8th, adorn'd by Paulus V: and lately cover'd by Pope Urban the 8 with that stupendious Canopy of Corinthian brasse, which heretofore was brought from the Pantheon:[2] It consists of 4 Wreath'd Columns partly channeld & incircl'd with vines, upon which hang little Puti, Birds, & Bees (the Armes of the Barberini) sustaining a Baldachino of the same Mettal: The 4 Columns weigh an hundred & ten thousand pounds, all over gilted with rich gold; and indeede with the Pedistalls, Crowne, & statues about it, a thing of that Art, vastnesse & magnificence beyond all that ever mans industry has produced of this kind & worthy the Celebration, as it is the Worke of Cavaliero Bernini A Florentine Sculptor, Architect, Painter & Poet: who a little before my Comming to the Citty, gave a Publique Opera (for so they call those Shews of that kind) where in he painted the seanes, cut the Statues, invented the Engines, composed the Musique, writ the Comedy & built the Theater all himselfe.

[1]John Evelyn's diary is preserved in Christchurch, Oxford.
[2]Urban VIII had ordered the removal of the bronze from the trusses of the portico of the Pantheon in 1632, to provide material for the baldachin. Bernini, already knighted, was 25 when he embarked on this design of the High Altar of St Peter's—the Baldacchino— after Cardinal Barberini, his friend and patron, became Pope Urban VIII in 1623. The work took from 1624–33, but his involvement in the architecture and decoration of St. Peter's and the Vatican lasted his lifetime.

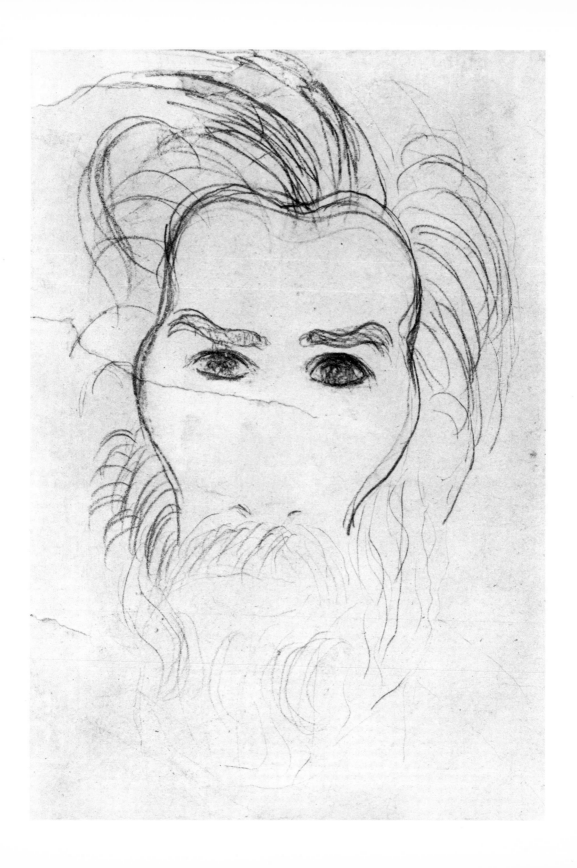

Constantin Brancusi

b. 1 February, 1876. Pestisani, near Turgu-Jiu, Roumania.
d. 16 March, 1957. Impasse Ronsin, Paris, France.

Plate 24. Presumed self-portrait, unsigned, undated.
Pencil on cream paper, 20.5 × 14 cms. Musée Nationale d'Art Moderne, Paris.

Sculptor of the famous Endless Column *in steel, 98 ft high, Brancusi is also remembered for this little fable he wrote in 1925, which has the enigmatic title,* Histoire de Brigands.[1]

Il y avait dans les temps très très très anciens temps quand les hommes ne savaient pas comment les bêtes viennent au monde . . . Un jour de ces temps là, un homme a trouvé une poule qui couvait ses œufs. Et comme en ces temps là bêtes et les hommes se comprenaient il lui demanda qu'est-ce qu'elle faisait.

Et comme la poule était gentille, car en ces temps là les bêtes avaient beaucoup de respect pour les hommes, Ah! beaucoup, beaucoup, beaucoup plus que maintenant elle se leva pour ne pas tenir un homme debout et s'en alla lui expliquer.

Et lui expliqua longtemps longtemps et tant que quand elle retourna à ses œufs, les œufs étaient gâtés. C'est pourquoi de nos jours les poules qui couvent les œufs se fâchent à nous crever les yeux quand nous nous approchons de leur nid!

One upon a long, long, long time ago, before man knew how the beasts came into the world . . . One day in those olden times, a man found a hen sitting on her eggs. And as in those olden times beasts and man spoke the same language, he asked the hen what she was doing.

And as the hen was polite, because in olden times animals held much respect for man, Ah! much, much, much more than they do to-day, and in order not to keep the gentleman standing she got up from her nest and went to explain things to him.

And she explained for a long, long time, so long that when she returned to her eggs they were no good. That is why, in our times, a sitting hen will make to peck our eyes out if we go near her nest!

[1] An edition of one hundred was published in 1969 by Galerie Daniel Gervis, Paris.

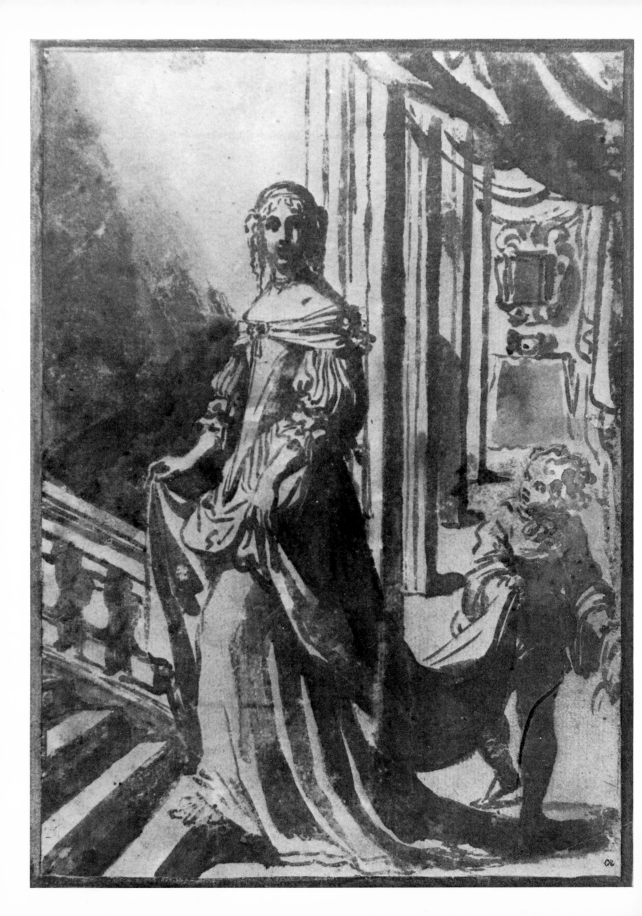

Elisabetta Sirani

b. 8 January, 1638. Bologna, Italy.
d. 27 August, 1665. Bologna, Italy.

Plate 25. Self-portrait, undated.
Brown wash-drawing on pale washed or off-white paper, 23.1 × 17.1 cms.
Ashmolean Museum, Oxford.

Notes on the paintings made by me Elisabetta Sirani

I, Elisabetta Sirani, was born on Friday the 8th of January 1638 between 6 and 7 in the morning, and was held in baptism by the Illustrious sig. Senatore Saulo Guidotti.

1655

A small canvas made for sig. Marchesa Spada which she donated to a congregation in Parma: showing Pope St. Gregorio, St. Ignazio, and St. Xaverio.

A small canvas with the Blessed Virgin, St. Martino, St. Bastiano, St. Rocco and St. Antonio of Padua, for the Municipality of Trassasso.

1656

A small canvas with the ten thousand crucified martyrs, for Madama di Mantova, who had it placed in the Cathedral.

An image of the Virgin Maria with St. Gioseffo and the Gesù Bambino supported in a sitting posture on a small table by the said Saint, with the Blessed Virgin indicating to him that she wants to put him in his cradle, causing him to draw back; in copper for a musician, or organist at San Petronio.

For Agnesino, the sculptor, a head and shoulders portrait, eight-sided, with a St. Agnese. And a copperplate with Delilah cutting Samson's hair.

The portrait of signora Ginevra Cantofoli, painter.

The head and shoulders portrait of my mother.

1657

The portrait of sig. Anna Maria Cagnuoli, wife of sig. Dottor Gallerati, my father's doctor.

A St. Bruno in the wilderness, for the Father Superior of the Certosa. A small canvas with the Blessed Virgin, St. Domenico and St. Caterina of Siena, and around them the fifteen mysteries of the Rosary for the villa Cosgono sul Modanese.

Various heads and shoulders, or heads, to wit a Samson, a Delilah, a Circe, and a Ulysses. A Diogenes, a Ptolemy, Honour, Fame, Virtue, Liberality, Philosophy, Astrology.

A small painting of the ten thousand crucified martyrs, for sig. Giacomo Maria Amodei, for the church of the Reverend Fathers of the Servi, facing the Holy Sacrament.

For Father Ettore Ghisilieri, priest of the Madonna di Galliera, a copper with the Blessed Virgin contemplating the crown of thorns, and diverse little angels contemplating the instruments of the Passion.

The above entries are the first to appear in the catologo *or work record book begun when Elisabetta Sirani was seventeen years old. It accounted for about 150 commissions. It was brought to an end in the summer of 1665 by her sensational death at the age of 27. Thirteen years later (1678) it was published, together with an account of her life and death, in* Felsina Pittrice, *by Count Carlo Cesario Malvasia, an intimate friend of the Sirani family. He ends with the following paragraph:*

But alas, old wounds bleed again when my thoughts return once more to the kindnesses which the deceived girl always extended to me so generously; nor does my habit or my profession allow me to address myself to the empious, abominable hands that planned the crime, with a thousand curses and portents, solemnly warning them of impending punishments from Heaven, of that just vengeance, the unjust desire for which is so little becoming to a true Christian and a Churchman.

Now here I realise with what curiosity the reader will be awaiting the name of the author of such a terrible and abominable misdeed; but who can know it, who can fathom it if the scrupulous researches of the Courts have been totally unable to elicit adequate and conclusive information? Certain it is that the servant (and perhaps she too may have been deceived in her turn, having been led to believe that the concoction given her to that end would have the power of making her loved by her mistress, who did in fact love her too much already) was taken prisoner, and did not deny having put a powder in her soup; she was unable to say otherwise, convicted as she was by another woman who very often came into the same house to perform domestic duties, and saw her putting it in:—indeed, because she ate a little of what remained in the plate she herself was extremely ill. But the servant girl persisted in saying that there was nothing in the screw of paper except sugar and cinnamon, and that she always put these in the food because her mistress was so fond of them. And it is also clear that since she could not be tortured (as Giuliano Lauretti[1] always maintained), the woman was at all events sent into exile, a slight punishment if she were guilty, but harsh and indeed uncalled for if she were innocent.

To this I would only add that those who say and believe that this death was dealt to her by a high and powerful hand whose proffered attentions she had rejected are very much deceived. And it is also false to say that it was ordered by some important gentleman who had taken offence at having been drawn from memory by her in a bizarre and ridiculous caricature. (It was her usual custom to draw anyone who came into that room.) But the poison, if it was poison, was certainly crude and coarse, such as caustic, commonly called *fuoco morto*, so that when the body was opened (as I have been told by those who saw it, since I could not bring myself to do so[2]) the stomach was found to have been eaten away, though the doctors, who at

first thought that this was what had happened, then changed their minds, and produced fanciful notions of how she had died not a violent death but a natural one, and if indeed of poison, of how the poison was born of itself therein; and that it was possible for such a thing to be generated of itself within a body, particularly that of a woman, because of the strange behaviour of the womb, especially in one as lively and spirited as she; in that she might have been concealing the desire for a husband, an opportunity having presented itself and been denied her by her father etc.

She was buried in the church of San Domenico, as we have said, in the very tomb belonging to the Signori Guidotti, where Sig. Senatore Saulo had earlier had the body of the great Guido[3] laid; to this Sig. Picinardi[4] himself alludes, and to the many other poetic compositions with which this book is adorned he adds this epitaph:

Elisabeth Siranae una cum Guidone Rheno
tumulatae

EPITAPHIUM

Siranae Tumulus Cineres hic claudit Elisae
Guidonis Rheni qui quoque busta tegit.
Sic duo Picturae, quae non Miracula iunxit
Vita, hoc in tumulo iungere Mors potuit.

From *Felsina Pittrice* by Count Carlo Cesario Mavasia, 1678. This translation is by Judith Landry.

[1]Giuliano Lauretti: a defence lawyer.
[2]Count Malvasia had known Elisabetta Sirani all her life.
[3]Guido Reni (1575–1642). Elisabetta's father was his friend and pupil.
[4]Picinardi wrote the funeral oration.

Masuo Ikeda

b. 23 February 1934. Mukuden, Manchuria; of Japanese parents.

Plate 26. Self-portrait, *Myself, staring at me*, 1964; age 29/30.
Etching, drypoint and roulette, printed in colour, 20 × 17.8 cms. Private Collection.

Masuo Ikeda, with his parents, was repatriated from China to Japan in late 1945, after Hiroshima, and lived in Nagano, a mountain area in the mid-west, from where he came to Tokyo as an aspiring artist to try to earning his living. The following is from his autobiography.

At the end of Chapter 2, I wrote about my going to Tokyo with 3000 Yen in my pocket. In fact, it was two days before the Bloody May Day[1] of 1952 in the Imperial Palace Plaza that I came to Tokyo. However, although those events were deeply shocking, the problem more on my mind was how to support myself in Tokyo. In my head, all congested with mere abstract aims, there was a total absence of any plan for a realistic life-style or for budgeting. You could say I was just the same as all boys who leave home. I just had to go to Tokyo, no matter what — that was all there was to it; it seemed to me that if I didn't do that there was no reason, or opportunity for living. From the start, for one thing, I did not have a single clue about living in Tokyo. I understood of course that going and living independently was not as simple as all that, but perhaps I realised too that whatever became of me, I wasn't going to die. When things got worse and worse, I would become boastful, but then there was always the expediency of running back home. . . . In fact, I frequently ran back home, but, whenever I did so, I would give very plausible reasons why, and never did anything to admit defeat in front of my parents. However, my feeling of hopelessness grew and grew as I made the return journey to Tokyo again and again.

During our first week in the capital, we—that is, H., with whom I came to Tokyo (he was also an aspiring artist) and I,—began living in a 4½-mat[2] room in Bunkyo-ku, Morikawa, together with a girl called Haruyo who was five years older than us, already working in Tokyo, and who had been in a hostel for Nagano repatriates.[3] We did this for economic reasons: that is, we pooled together 500 *Yen* each for the rent of the room. Despite this, however, the lodging was situated right in an alley that only one person at a time could walk down; the sun hardly ever reached it, and because of the damp, your feet sank in the horrible straw matting as you walked. At least there was the consolation that it was in Todai Mae,[4] and Takuboku Ishikawa[5] lived in that neighbourhood. The whole house leaned over to one side, and a strange, horrible smell drifted through the entire place; but inside still stranger people were living, and there was no end to the commotion surrounding each one. A woman who was a fanatical member of some type of new religion unknown to me, lived in a 2-mat room next door; every day she seemed to be haranguing her 6-year-old son until she came to blows with him. Her room was

buried under rags and useless bric-a-brac to an extent I have never seen in any room to this day; despite the presence of gas, she used to light a brazier and cook on it in this tiny space. Surprisingly, in a room such as that, a carpenter who seemed to be her lover often came to visit her, and violent arguments went on there time after time. Then again, her daughter was an extremely beautiful girl who worked in a bar on the Ginza;[6] but still she lived in a pitch-dark, 2-mat room on the first floor. During the day she would invade our room, wearing only a chemise, and chatter away about nothing; then at night, wearing an unusually splendid dress for those times, she would set off elegantly for work, emerging from that front door which brimmed over with nauseating smells.

In the room immediately above us lived a cook's family. Every night without fail the darker side of our imagination would be stirred by hearing a man's voice, groaning as if he were being hacked to pieces. However, despite all this, the most devastating aspect was the presence of the cook's utterly charming daughter, in her second year at primary school. She was unbelievably precocious, and would come to our room to play; but she completely dumbfounded me by saying such things as how she loved to peep at us through holes in the paper wall as we lay dishevelled in bed each morning, and how she liked Raymond Radiguet's *Le Diable au Corps*, which was a film showing at the time. Sometimes I was summoned, alone, by her mother. I was begged to teach her daughter to draw. I felt more angry than embarrassed by her explanation that her daughter wanted this because I was the most manly of her friends. However the little girl was so lovely that I wanted to hug her tightly, and I even used to day-dream of kidnapping her.

It was completely by chance that I came to draw portraits. From the beginning, despite the fact that even if I earned 100 *Yen* a day I ate in the most meagre way, I never felt that I should take a job anywhere, so this earning of 100 *Yen* would seem a ridiculously complex operation to me. If I could make do earning the smallest income, doing anything, in the shortest space of time, it was all right by me. One day, on an introduction from a friend, I met an artist called Saeki who was exhibiting in an open exhibition; with his encouragement, for the first time I found myself standing outside the PX[7] store, now "Matsuya", on the Ginza, sketchbook in hand. There was already a group of about 30 semi-professional artists making portraits of American soldiers. It seemed that in order to do this portrait business you had to possess some special skill, and from the start, I didn't have even the basics of what was required to set myself up to rival them. And so the soldiers always ousted me from my space, and to crown my misery, as a result of their discussions I was forbidden to have a plot on the Ginza, as if the newcomer was declared a rebel among the Ginza portrait painters, who must be thrown out. It was for that reason that I started to go round the bars, which were not the special province of anyone. I went round every single place where people congregated: Shinbashi, Ginza, Kanda, Shinjuku, Shibuya and all the other main places. On my luckiest day I would receive 1000 Yen from a single client, and the worst times were when I didn't make so much as 10 Yen after walking around for a week. As there were too many people working at the same thing as I was there, it was difficult to get three clients in one night. However fervently I drew, I could not make a resemblance on paper, and

there were always unending arguments with clients about whether it looked like them or not; to cap it all, there were many times when I didn't even get paid!

From *Masua Ikeda: My history, my technique*, published in Japanese by Bijutsu Shuppan-sha, Tokyo, 1968. This translation is by Evelyn Burges.

[1] Bloody May-day: student riots on 1 May, 1952.
[2] One mat = 6 ft × 3 ft.
[3] Families repatriated from China, who had no homes.
[4] Todai Mae: the student quarter, in front of Tokyo University.
[5] Takuboku Ishikawa was a well known poet, who died at an early age.
[6] Famous entertainment and commercial street in Tokyo, fashionable and popular.
[7] Store for American Army families.

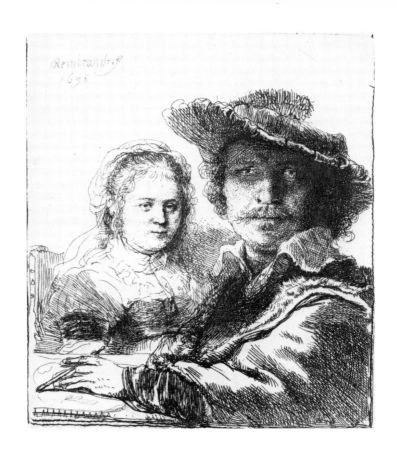

Rembrandt van Ryn

b. 15 July, 1606. Leiden, The Netherlands.
d. 4 October, 1669. Amsterdam, The Netherlands.

Plate 27. Self-portrait with his wife Saskia, 1636, age 29/30.
Etching, 10.4 × 9.5 cms. The British Museum, London.

Letter, c. February, 1639, from Rembrandt to Constantijn Huygens, a highly cultured man appreciative of Rembrandt's talent, who was in the service of His Highness Prince Frederick Hendrick of Orange.

My Lord,

My noble Lord, it is with hesitation that I come to trouble you with my letter and I am doing so because of what was told me by the collector Wttenboogaert to whom I complained about the delay of my payment and how the treasurer Volbergen denied that dues were claimed yearly. The collector Wttenboogaert now replied to this last Wednesday that Volbergen has claimed the same dues every half year up till now, and that more than 4000 carolus guilders were now again payable at the same office. And this being the true state of affairs, I pray you my kind lord that my warrant might now be prepared at once so that I may now at last receive my well-earned 1244 guilders[1] and I shall always seek to recompense your lordship for this with reverential service and proof of friendship. With this I cordially take leave of my lord and express the hope that God may long [keep] your lordship in good health and bless you. (Amen)

> Your lordship's humble and affectionate
> servant Rembrandt.

I live on the Binnen Amstel in the sugar bakery.

My Lord
My noble Lord van Suijlijkum
Councillor and secretary
of His Highness
 at The Hague.

Postage

From *Seven Letters by Rembrandt*, transcription by Isabella H. van Eeghen, translation by Yda D. Ovink, published by L. J. C. Boucher, The Hague, 1961. The original ms is in the British Museum, London, Add. Ms. 23744.

[1]The well-earned 1244 guilders were for two of the five Passion paintings Rembrandt had painted for the Prince: one of the *Entombment*, the other the *Resurrection* of Christ our Lord. The *Ascension*, and *Christ's Elevation and Descent from the Cross* were already finished by 1636. All five are now in the Alte Pinakothek, Munich.

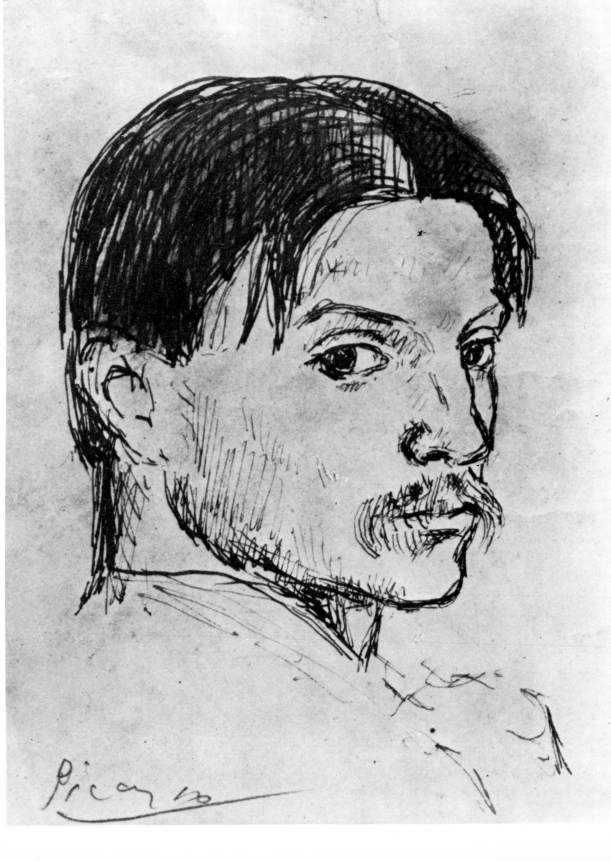

Pablo Picasso

b. 25 October, 1881. Malaga, Spain.
d. 8 April, 1973. Mougins, Provence, France.

Plate 28. Self-portrait, 1912; age 30 or 31.
Pen and ink, Private Collection.

Letter from Picasso to Daniel-Henry Kahnweiler.[1]

242, Boulevard Raspail
December 18, 1912

My dear friend

This letter confirms our agreement covering a period of three years beginning
December 2, 1912.

During this period I agree to sell nothing to anyone except you. The only
exceptions to this agreement are the old paintings and drawings that I still have.
I shall have the right to accept commissions for portraits and large decorations
intended for a particular location. It is understood that the right of reproduction
to all the paintings that I sell you belongs to you. I promise to sell you at fixed
prices my entire production of paintings, sculptures, drawings, and prints,
keeping for myself a maximum of five paintings a year. In addition, I shall have
the right to keep that number of drawings which I shall judge necessary for my
work. You will leave it to me to decide whether a painting is finished. It is
understood that during these three years I shall not have the right to sell the
paintings and drawings which I keep for myself.

During these three years you agree to buy at fixed prices my entire production
of paintings and gouaches, as well as at least twenty drawings a year. Here are
the prices which we have agreed on for the duration of our agreement.

drawings	100 francs
gouaches	200 ,,
paintings up to and including #6	250 francs
#8, 10, 12, 15, 20	500 ,,
#25	1000 ,,
#30, 40, 50,	1500 ,,
#60 up	3000 ,,

prices of sculptures and prints to be discussed.

Yours,
Picasso

[1] Daniel-Henry Kahnweiler, art historian and Gallery owner of Paris; (b. 1884) of
German nationality. A very influential figure in respect of *avant-garde* artists. The letter is
published in his book *My Galleries and Painters*, Thames & Hudson, Ltd, 1974.

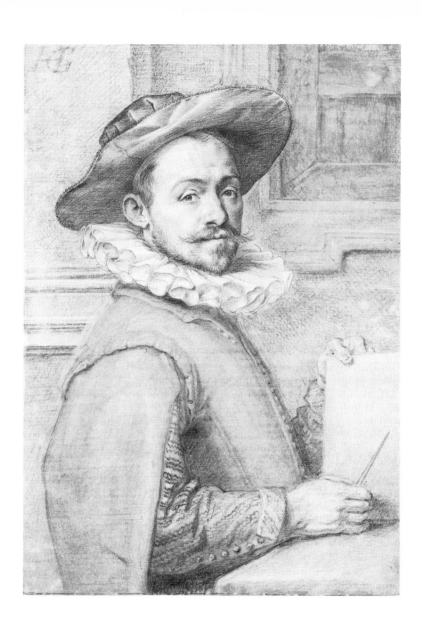

Hendrik Goltzius

b. 1558 Venlo, The Netherlands.
d. 1617 Haarlem, The Netherlands.

Plate 29. Self-portrait, *c.* 1589; age 30/31.
Black chalk on vellum, shadows strengthened with graphite, 14.6 × 10.3 cms. The
British Museum, London.

<div align="right">

Laus Deo 22 May, 1605

</div>

My good friend Mr. Weely,

My greetings to you and your wife. Yesterday I spoke to your servant and
should have given him a letter but that I was too busy to write at that moment;
therefore this reply is to let you know that I am working on the pen-drawing you
wish for. I work on it with delight and am spurred on all the more because of
the gossip. You may trust that I will hurry to finish it and with God's help by
the summer you will see more that you and others will like. You should have
made a wager with those who said it would not be finished! However there is
no need: I do not care what people say so long as my affairs are not dishonest or
corrupt. Those impudent busy-bodies do not understand me. They are not
worthy to understand. Those who speak out of stupidity or affectation can be
forgiven. They will learn the truth in time and be content.

I have no more to write except that I cannot be thankful enough to God that I
am so healthy and happy, when formerly I suffered through worry over things
of little importance. Now, on the contrary, I am always happy, deriving
pleasure through art and knowledge with no regard to what people say.

And now my dear good friend may the Almighty bless you.

<div align="right">

Your friend, H. Goltzius

</div>

<div align="right">

Laus Deo 10 June, 1605

</div>

My good friend Mr. Weely,

Nothing except my greetings and to inform you that intending to go out today
I discovered that I had your coat instead of my own. So I return it to you
herewith: if you will return mine then the exchange will be complete. For the
rest I hope that all goes well with you as it is with me, thanks to God. I shall
continue with your order. May the Lord protect you.

<div align="right">

Your friend, Goltzius

</div>

Postscript: Choose some Old Testament stories that are picturesque. . . .

From Vol. IV of *Oud Holland,* 1888. The letters have been translated into modern Dutch
by Dr. Karel Bostoen, and from modern Dutch into English by Elizabeth Yates.

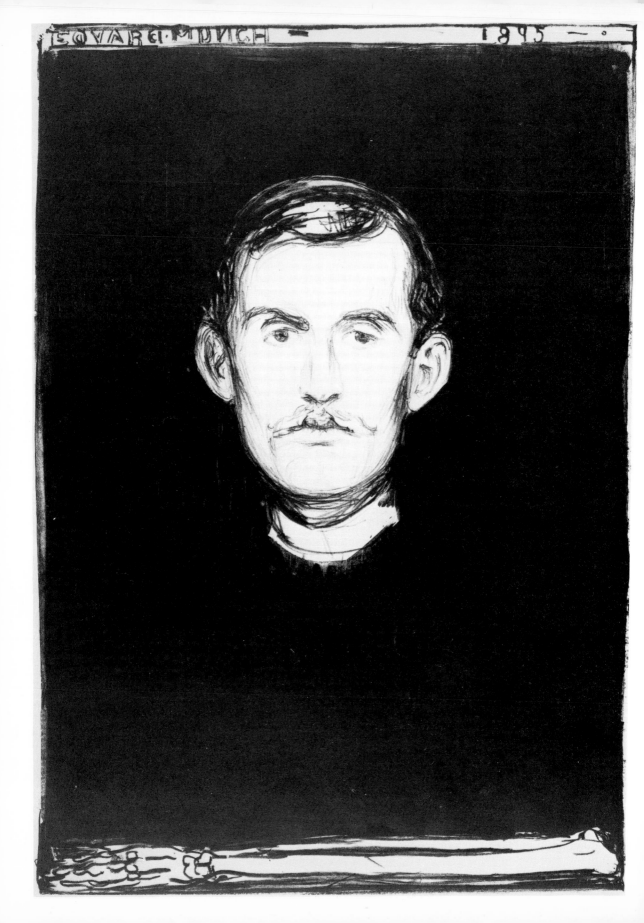

Edvard Munch

b. 12 December, 1863. Løyton, Hedmark County, Norway.
d. 23 January, 1944. Ekely, Norway.

Plate 30. Self-portrait, with skeleton arm, 1895; age 31.
Lithograph 45 × 31.5 cms. The British Museum, London

Letter from Edvard Munch to his friend, the writer and art critic, Jappe Nielsen, written during his stay at the psychiatric clinic of Professor Daniel Jacobsen.

<div style="text-align: right">

Kochsvei 21 [Copenhagen]
17.10.08

</div>

Dear Jappe,

A thousand thanks for your letter. Having as you know so many real and imaginary enemies, you will understand the happiness my real friends give me.

Do you remember—you could hardly have failed to notice—how that time at the Grand Café six years ago I was very deeply disturbed. And since then my life has been a constant build-up of tension and restlessness which in the end has to come to a head; there had to be a breaking point. I was struck violently after a journey in Sweden, which culminated in four days of alcoholic heaven in the company of Sigurd Mathiesen. I had a complete nervous breakdown, and possibly a minor stroke; a part of my brain had suffered such persistent battering from an obsessive idea.

I am having electric shock treatment and massage and now feel well and relaxed, surrounded by caring nuns and a good doctor. Had I not been forced to become an inmate of such an establishment, I would have gone under completely. I spend much of my time in bed. I want to make fully sure of healing my inner self.

I long to come home as I miss my friends, and I miss Norway.[1] I know now that I have more friends than I could have believed possible. But for the time-being I must protect the vulnerable part of my brain from stress. It would be nice to hear from you more often. Give my regards to Holmboe and his wife and thank them for their kind wishes. Goldstein comes to visit me a lot—he must be a true friend, even though I can't always understand him.

Write to me when you can, your old friend
 Edvard Munch

À-propos Mathiesen, don't you think he is a talented writer?

From *Edvard Munch's Kriseår—belyst i brever*, edited by Erna Holmboe Bang, Gyldendal, 1963. This translation is by Kjersti Kolstad.

[1]Munch had been away from Norway for a number of years. He returned home in 1909.

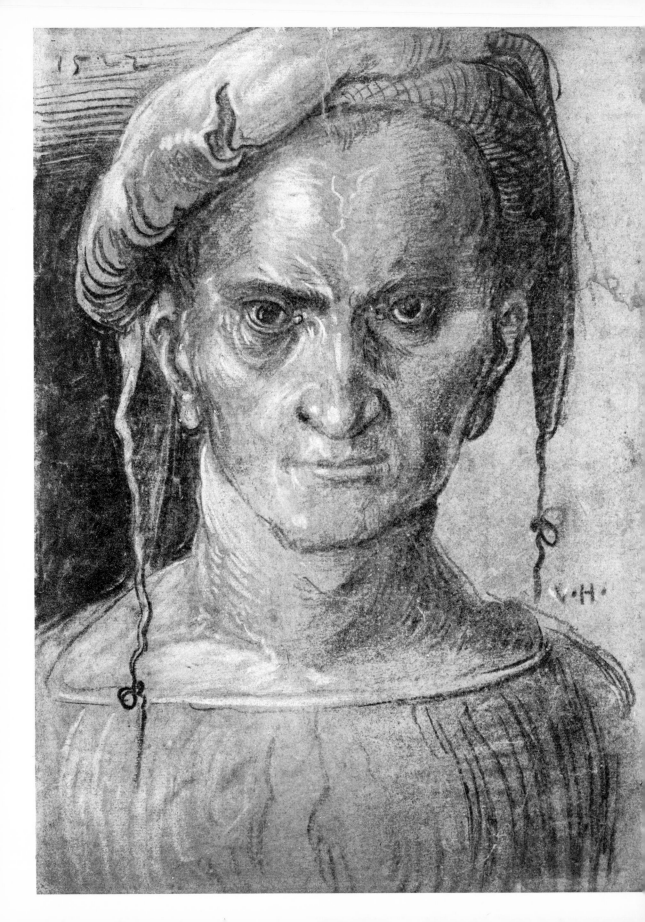

Wolf Huber

b. *c.* 1490. Feldkirch, Austria.
d. early July, 1553. Passau, Germany.

Plate 31. Self-portrait, 1522; aged about 32 yrs.
Black and white chalk on prepared rust-coloured ground, 27.5 × 20 cms. Staatliche
Museen Preussischer Kulturbesitz, Berlin-Dahlem.

The following is a scholarly article by Dr. Halm, published and very fully annotated in
Monatshefte für Kunstwissenschaft *December 1908. It tells us, I think, all that is known so
far about the life of this excellent early artist.*

Wolf Huber
by Philipp M. Halm

There is very little authentic information regarding the Passau painter Wolfgang
Huber. He has come more into the limelight and attracted more public interest
since Wilhelm Schmidt solved the identity of the monogrammist W. H., and Voss
and Riggenbach devoted works to him. Nevertheless, evidence remains scarce.

Riggenbach carefully collected the few known facts and supplemented them with
a short entry which he found in the Passau *Hofratsbüchl*[1] of 1542, preserved in the
Königliche Studienbibliothek, Passau. This entry refers to Wolf Huber's
appointment as Wolfgang I, Bishop of Passau's court-painter. As Voss proved by
comparing the style, and Stiassny confirmed by heraldic evidence, it was Huber
who painted the beautiful *Allegory of the Cross*, now in the Vienna Hofmuseum.

Apart from what is to be found written on Huber's paintings and graphics
themselves, the only other information has been the well-known note of contract,
of 1515, concerning the *Annabruderschaftsaltar* in Feldkirch (which Voss,
Riggenbach and Stiassny wrongly connected with the *Beweinungsbild* of 1521), and
W. M. Schmidt's publication referring to the "Petition of the corporate body of
painters, woodcutters and glaziers in Passau," 1542, which was directed against
Huber, who although not in possession of the freedom of the town, did work with
several apprentices and journeymen, and did infringe the guild regulations on
several counts.

To these scant archival records can now be added two further items: the first, a
hastily scribbled, illegible entry, antedates Huber's appointment as court-
painter—and also the petitions—by roughly two years, and can be read in the
Hofratsbüchl of 1540 (Königliches Kreisarchiv, Landshut), as follows:[2]

> February 13th. Town judge reports the case concerning Hans Schirlinger,
> painter, against Wolfgang Hueber. It is decided:—that if Hans Schirlinger can
> swear a holy oath to God and his saints that the said Hueber owes him his
> rightfully earned wages, the amount in question to be stated by him, then the

said Hueber is bound to pay him his debt, together with whatever other expenses the Court decides.

As nothing further can be gathered from the *Hofratsbüchl*, we can assume that Huber submitted to the verdict.

More important still is the second piece of information, as it indicates the year in which Huber died, which was hitherto unknown. We find it in the *Hofratsbüchl* for the year 1553 (Königliche Studienbibliothek, Passau), under Friday the 7th July, and it relates to the guardianship of Huber's children. It reads as follows:[2]

Concerning the children of the former court-painter Wolfgang Hueber deceased: To-day, summoned by H. Thamas von Preising and, on the order of my most benevolent Fürsten[3] and Lord through his court-council, did here present themselves the aforementioned Preising, the widow of the aforementioned Wolfgang Hueber, likewise M. Lucass Praitinger, carpenter, and M. Hans Stümpl, court-tailor, both citizens of this town, and both of whom, M. Lucass and M. Hans, were told why they had been summoned. Namely, it was by reason of obliging the above mentioned Preising who had nominated them both as guardians of the late Hueber's children,[4] that they might undertake this guardianship and fulfil the duties it entailed faithfully and trustworthily. Both men did acknowledge obedience, and willingly and under oath, did promise to honour the responsibilities they had undertaken; to be of help with regard to the interests and well-being of their foster-children, also giving support to their mother. Hueber's widow, and to the said Preising the executor. Moreover they were instructed that should they need help and advice in their guardianship in the future, that the toll-gatherer Hieronimus Sinzl, when approached, had willingly offered his services in an unofficial capacity. Thanks were then extended to all present, and the entire party was instructed to return on the early morrow, which was Saturday, to honour and make binding the agreement with a handshake. Gentlemen in session:—Herr Official Truebmpacher and Doctor Reichart.

According to this record one can assume that Wolfgang Huber died only shortly before this, probably during the first days of July 1553. Hitherto, it has always been assumed that 1542 must be the last certain time-limit for Huber, judging by his drawings in Wolfegg, Prague, and Budapest—and the convincingly supporting evidence of the record in the *Hofratsbüchl*, mentioned earlier, with which the date coincides. Recently however, Stiassny has drawn attention to a drawing of 1544, in the Albertina, Vienna.

Having established Huber's date of death, we must now accept that there are ten years of his working life which are so far unaccounted for.

We should first of all re-examine the three drawings dated after 1544—rejected by Riggenbach as being by Huber—and decide whether after all they should not be ascribed to the Passau painter. They are a landscape of 1548 in Erlangen, a gothic town with towers, of 1545, and a castle by a river, of 1549—both in Budapest.

Wilhelm Schmidt has long since considered the two latter to be Hubers.[5]

[1]*Hofratsbüchl* was a book of public records.

[2]This is a free translation from what was mediaeval German mixed with Bavarian dialect of the time.

[3]"Fürsten" means a sovereign or prince of one of the many small states of which the country was comprised.

[4]In the original, Huber's children are described as his *nachgelassne khinder,* his "left-behind" children.

[5]In Britain the best known pen-and-ink drawings by Huber are dated up to and including 1541. There are eleven in the Print Room of the British Museum (mainly landscapes, figures and portraits, dated between 1510 and 1541); one in the Print Room of University College, London (a rocky landscape); and one in the Ashmolean Museum, Oxford (*Landscape with Castle,* dated before 1510).

This translation is by Maria Saekel-Jelkmann.

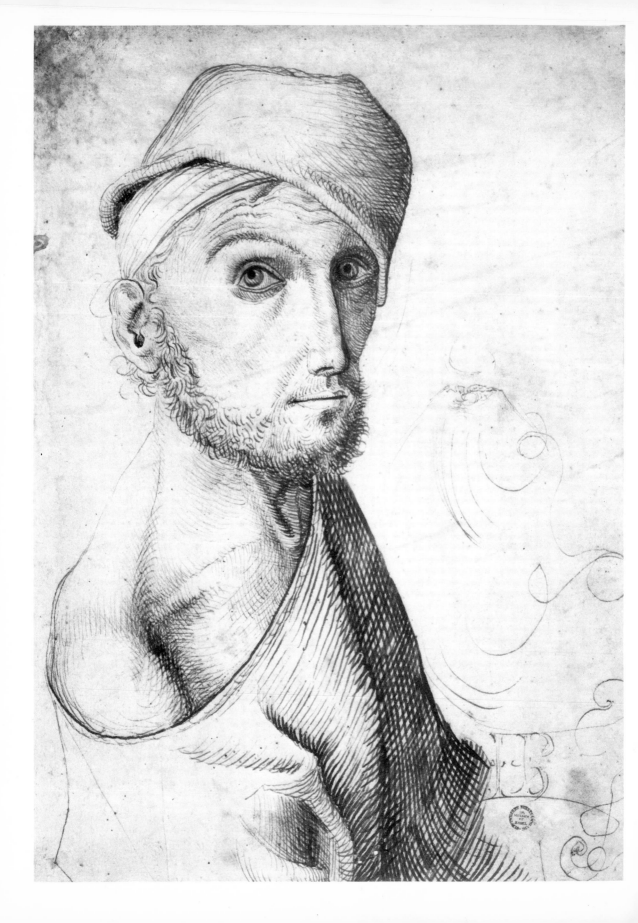

Monogrammist I.B. (Anonymous)

Plate 32. Portrait of a wounded man; undated.
Pen and brown ink, 26 × 18.2 cms. Kupferstichkabinett, Kunstmuseum, Basel.

Nothing is known about the anonymous Monogrammist I.B., and the only certain fact about the drawing is that it was given to the Kunstmuseum, Basel, by the art dealer Samuel Birmann (1793–1847). It is thought to originate in the lower Rhine area, some say Holland, about the late 15th or early 16th centuries. It cannot even be said that the drawing is a self-portrait; but to judge by the man's left eye with its riveting stare, as intense as that of Van Gogh (Plate 33), we can easily believe that it is.

With so much unknown, it is interesting to set down what *can* be said about the artist, assuming that the artist is also the man with the wound. His features alone place him as a European in his early thirties. His hat, according to paintings and drawings of the time, is typical of many worn in Germany in the late 15th century and would probably be made of felt—compressed and moulded fibre, wool, and other hair. The shirt or shift with the wide neck slipping off the wasted shoulder is likely to have been a hospital garment, easy to get on and off, and to launder. A beard at this period would have been unusual, but this could have been the growth of only a week or so while the patient was laid up after his accident. The wound showing below the bandage seems to have been extensive, perhaps the result of a sword fight.

The artist may have made the drawing through boredom, or curiosity about his condition and novel appearance, or to record the incident; but with events still fresh in his mind and the knowledge of what may have been a marginal escape from death, it seems likely that in making the drawing, I.B. also made a reappraisal of life and living. By his furrowed brow and the number of stitches in the wound he illustrates the ordeal of an operation with no anaesthetic. To add to this, nothing was sterilised; neither the needle, nor the thread or cat-gut which were used, nor yet the surgeon's hands. The chances are high that blood-poisoning developed and that the anonymous artist died young; otherwise we might have heard more of him.

This assessment of Monogrammist I.B. and his drawing was made through the help and interest of: Dr. Renate Burgess, Wellcome Museum of Medical History; Miss Jessie Dobson, Hunterian Museum, Royal College of Surgeons; Mrs. Madeline Ginsburg, Victoria and Albert Museum; Miss Powers, Natural History Museum; Dr. Dieter Koepplin, Kunstmuseum Basel, Kupferstichkabinett; Mr. John Rowlands, Department of Prints and Drawings, the British Museum.

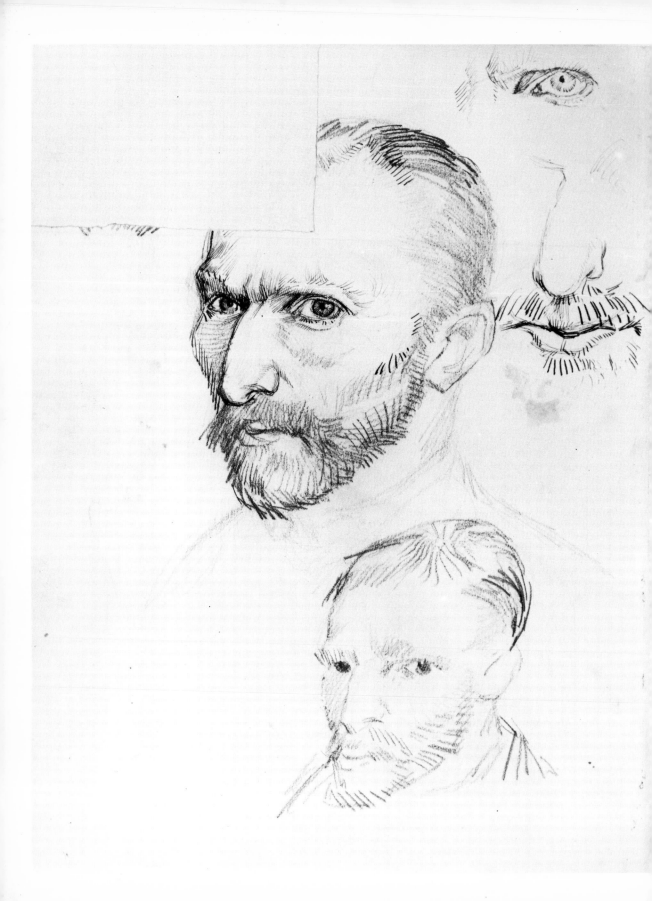

Vincent van Gogh

b. 30 March, 1853. Zundert, North Brabant.
d. 29 July, 1890. Auvers-sur-Oise, France.

Plate 33. Self-portraits, 1886; age 32/33.
Pencil and ink, 31.5 × 24.5 cms. Rijksmuseum Vincent van Gogh, Amsterdam.

Part of a long letter to his brother Theo, written in February 1886 from Antwerp, where Vincent had recently become a student at the Academy directed by Karel Verlat. The winter session was due to end on March 31 and Vincent had ideas of coming to Paris.

. . . But it has struck me forcibly that there are still other things that I absolutely must change. When I compare myself to other fellows, there is something stiff and awkward about me, as if I had been *in prison* for ten years. And the cause of this is that for about ten years I have had a difficult and harassed life, much care and sorrow and no friends. But that will change as my work gets better, and I shall know something and be able to do something.

And I repeat, we are on the right track to accomplishing this. But do not doubt it, the way to succeed is to keep courage and patience and to work on energetically. And it is a fact that I must change my outward appearance somewhat. Perhaps you will say that has nothing to do with art, but on the other hand, perhaps you will agree with me! I am having my teeth seen to, for instance, there are no less than ten teeth that I have either lost or may lose, and that is too many and too troublesome, and besides, it makes me look over forty, which is not to my advantage. So I have decided to have that taken care of. It will cost me 100 fr., but it can be done better now while I am drawing than at any other time, and I have had the bad teeth cut off and have just paid half the money in advance.

They told me at the same time that I ought to take care of my stomach, for it's in a bad state. And since I have been here this has far from improved. But if one knows where the fault lies, that is something gained, and with some energy much can be redressed. It is not at all pleasant, but necessity knows no law, and if one wants to paint pictures, one must try and stay alive and keep one's strength. . . .

You see I am not stronger than other people in that if I neglected myself too much, it would be the same with me as with so *many* painters (so *very many* if one thinks it over), I should drop dead, or worse still—become insane or an idiot. This is a fact, and the question is to steer a clear course between the various cliffs, and even if one gets damaged, to try to keep the ship afloat. . . .

So do not be angry with me because of the expense. I shall try to economize, but things were getting too bad and I had to remedy them. . . . More and more I believe that *l'art pour l'art*, to work for work's sake, *l'énergie pour l'énergie*—is after all the principle of all great artists, for in the case of the de Goncourts one

sees how necessary obstinacy is, for society will not thank them for it. . . .

 Not to be discouraged, even though one is almost starving, and though one feels one has to say farewell to all material comfort in life! So much for that. I wish you would write a little more, now that we are discussing a change. Founding a studio together would perhaps be a *good thing*. . . . And such a studio—in starting it one must know that it will be a battle and that people in general will be absolutely indifferent, so one ought to begin it feeling confident of some power—wanting to be somebody, wanting to be active—so that when one dies one can think, I go where all those who have dared something go—well, we shall see.

<div style="text-align: center">

Ever yours, with a handshake,

Vincent

</div>

 That impression I can't help getting of myself when comparing myself to others, namely that I look as if I had been in prison for ten years, is not exaggerated; but to change it—and I will change it—I must primarily not get too far out of the art world, but stay some time longer in a studio or at an academy. Then it will disappear.

From *The Complete Letters of Vincent van Gogh*, Vol. 2, No. 448, translated by Johanna van Gogh Bonger and C. de Dood, Thames and Hudson, and Little, Brown & Co., 1958.

Anthonie van Dyck

b. 22 March, 1599. Antwerp, The Netherlands.
d. 9 December, 1641. London, England.

Plate 34. Self-portrait, undated.
Etching, approximately 23.5 × 15.8 cms. The British Museum, London.

Van Dyck's Studio Procedure

. . . The writer De Piles relates in his treatise on painting, which appeared at Paris at 1708: ". . . the celebrated Jabach (of Cologne), well known to all lovers of the fine arts, who was on friendly terms with Van Dyck and had had his portrait painted by him three times, informed me that he spoke to that painter one day of the short time which the latter spent on his portraits, whereupon the painter replied that at first he used to exert himself severely, and take very great pains with his portraits for the sake of his reputation and in order to learn to do them quickly, at a time when he

was working for his daily bread. Then he gave me the following particulars of Van Dyck's customary procedure.

He appointed a day and hour for the person whom he was to paint, and did not work longer than one hour at a time on each portrait, whether at the commencement or at the finish; as soon as his clock pointed to the hour, he rose and made a reverence to his sitter, as much to say that this was enough for the day, and then he made an appointment for another day and hour; thereupon his serving-man would come to clean his brushes and prepare a fresh palette, while he received another person who had made an appointment for this hour. Thus he worked at several portraits on the same day, and worked, too, with astonishing rapidity. After he had just begun a portrait and grounded it, he made the sitter assume the pose which he had determined for himself beforehand, and made a sketch of the figure and costume on grey paper with black and white chalk, arranging the drapery in a grand style and with the finest taste. He gave this drawing afterwards to skilled assistants whom he kept employed, in order to transfer it to the picture, working from the actual clothes, which were sent to Van Dyck at his request for this purpose. When the pupils had carried out the drapery, as far as they could, from nature, he went over it lightly and introduced into it by his skill in a very short time the art and truth which we admire. For the hands he employed hired models of both sexes.

. . . We are further informed that Van Dyck was fond, at the end of his day's work, of inviting the persons whom he was painting to dine with him, and that at these repasts the style of entertainment was no less sumptuous than that adopted by the highest classes of society in England. After his work was done, Van Dyck lived like a prince. His earnings were immense, and he spent them freely. It is said that once Charles I, while sitting for his portrait, was talking to the Earl of Arundel about the bad state of his finances, and addressed to the painter incidentally the playful question whether he, too, knew what it meant to be short of money.

'Yes, Sire,' Van Dyck is said to have answered, 'when one keeps an open table for his friends and an open purse for his mistresses, he soon reaches the bottom of his money-chest.' "

From *Van Dyck*, by H. Knackfuss, translated from German by Campbell Dodgson, H. Grevel & Co., 1899.

Caspar David Friedrich

b. 5 September, 1774. Greifswald, Germany.
d. 7 May, 1840. Dresden, Saxony.

Plate 35. Self-portrait, undated, *c.* 1810; age 35/36.
Black chalk, 22.9 × 18.2 cms. Kupferstichkabinett, Staatliche Museen, East Berlin.

Letter from Caspar David Friedrich to his relatives in Greifswald.

Dresden; 28 January 1818

Herewith I inform my brothers, relatives and acquaintances, that on the 21st
January at six o'clock in the local Kreuzkirche, I was married to Caroline
Bommer; thus I have been a married man for eight days. A few hours after the
wedding I went home with the intention of writing to you, but I was prevented
from doing so. And thus eight days passed and it has not been done yet.
Although ever since the day of my wedding I have felt the obligation of writing
to you and informing you of it, we nevertheless have been expecting letters
from you long since, and my wife is beginning to be agitated and has reminded
me several times to write; for she wishes to write too, in order to become better
acquainted with her new brothers.

It is a satisfying thing having a wife; it is satisfying to have a household
however small; it is satisfying when, at noon, my wife invites me to come and
have dinner. And finally it is satisfying when in the evening I now stay nicely at
home, instead of running all over the place as before. Also I feel it satisfying that
everything I now undertake is done, and must be done, with consideration for
my wife. If I only hammer a nail into the wall, it must not be so that I can reach
it, but only as high as my wife can reach it comfortably.

In short, since I have changed the I into We, many a thing has changed. There
is more eating, drinking, sleeping, laughter, joking, chatting. We also spend
more money, and maybe in the future we shall not lack cares. But may it be as
the Lord pleases, His will be done. Many things have changed, since I have had a
wife. In many respects my old simple home can no longer be recognised, and it
pleases me that now it looks cleaner and nicer. Only the room where I work
remains as of old. By the way, curtains in front of the windows have become
necessary. Likewise necessary have become: coffee tin, coffee-mill, coffee funnel,
coffee bag, coffee pot, coffee cups; all, all has become necessary. Big pots and
little pots, big and little dishes, big and little saucepans; everything, everything
has become necessary. Everything has changed; formerly my spitoon was
anywhere in my room, now I have my orders to spit into little dishes meant for
this purpose; my love for cleanliness and neatness gladly submits to this.

The desk ordered long ago is finished and executed with the greatest possible
neatness; it cost 56 Taler, and the very same day that I received it I sold two
pictures. For one, shown to the buyer as being bad and spoilt, I received 19

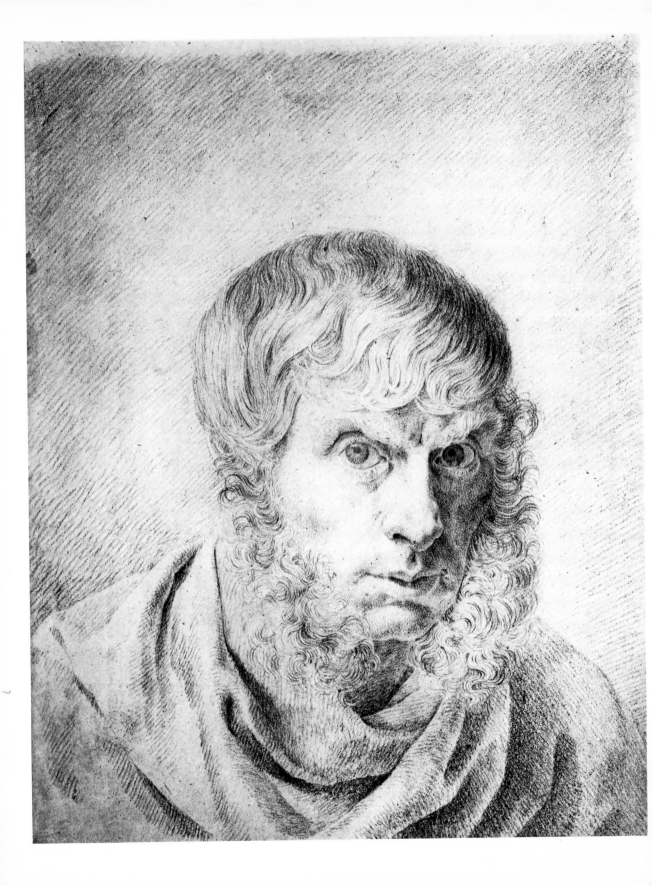

Louisdor; an income which pleases me the more as the expense of 56 now seemed to me unnecessary, for I had ordered the desk before I thought of my present wife.

God be with you, dear brothers, and your wives and children and the entire family and all acquaintances.

<div align="right">

Your brother

C. D. Friedrich

</div>

Letter from Friedrich to his brothers Christian and Adolf.

<div align="center">

(*Dresden 1819*) 30 August, $\frac{1}{4}$ to 12 at night.

</div>

At last the longed-for day has come; tonight at a $\frac{1}{4}$ to 10 o'clock my Lina has borne a little well-made girl. The child seems to be healthy, for it has already sneezed a dozen times. The mother is well. This very evening at seven o'clock she was still knitting. The labour pains followed in quick succession, and must have been violent, for a few times she cried out so loudly that people may easily have heard in the street. In spite of that she smiled at me in the intervals and wanted to comfort me instead of my comforting her. If the child would sleep all the time and not cry, the mother would no doubt sleep too. Three times the child has been given drink. Three times the little thing has freed itself with its tiny arms from its wrappings.

So far the life-story of the little girl.

You, my *dear brother Adolf*, herewith have been invited by me and my wife to be God-father, and my brother-in-law will represent you here. The other God-parents are: my mother-in-law, and the wife of the uncle of my Caroline. Everything will be done quite simply and after half an hour, I think, the God-parents should be out of the house again.

God be with you all and in you all.

<div align="right">

Your brother C.

</div>

From *Caspar David Friedrich in Briefen und Bekenntnissen*, Rogner & Bernhard, 1974. This translation is by Gertrude Cuthbertson.

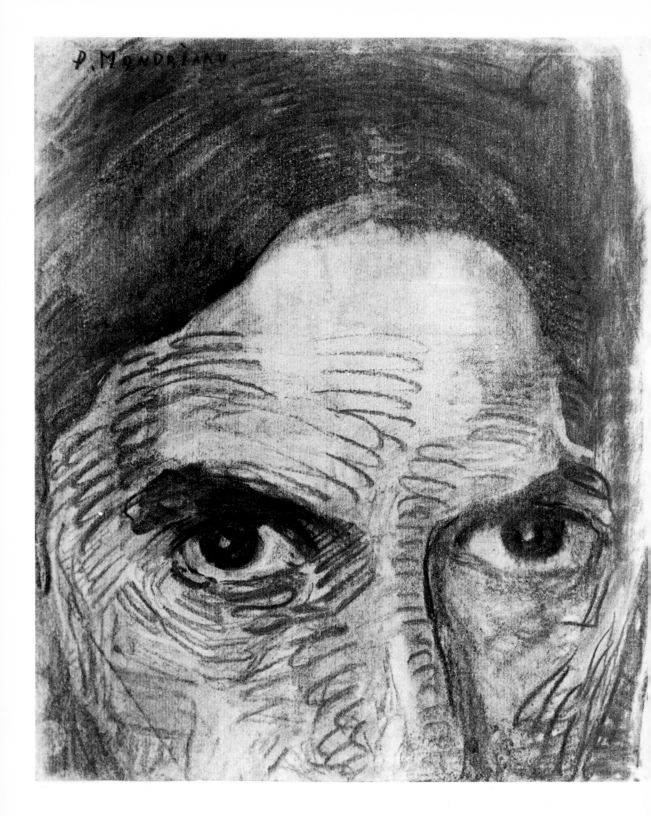

Pieter Cornelis Mondrian

b. 7 March, 1872. Amersfoort, Holland.
d. 1 February, 1944. New York, USA.

Plate 36. Self-portrait, undated, 1908/09; age *c*.36.
Charcoal, 30.0 × 25.5 cms. Haags Gemeentemuseum, The Hague.

Some Memories of Mondrian
by Nelly, wife of Theo van Doesburg with whom Mondrian collaborated over the founding of the De Stijl movement.

... Contrary to the general impression he gave casual acquaintances, Mondrian was not without a sense of humor and a capacity to enjoy the ordinary pleasures of life. In short, these years[1] represented a period of close personal and professional association between Mondrian and Van Doesburg, which, although differing little on the surface from the artistic life of the times in Paris, naturally brought out many aspects of Mondrian's character—some already legendary, others less well-known—which deserve to be recorded. First, there is the question of Mondrian's many personal mannerisms. Although in my opinion he remained throughout his life typically Dutch in his behavior and thinking about life, he nonetheless made a personal fetish about the adoption of French customs. He rarely missed an opportunity to proclaim the superiority of French culture to all others, especially the German—and this despite the continuing indifference of France to his own painting. He made a ritual of rolling his cigarettes like the average French worker. Although his own cooking remained basically Dutch, he vocally proclaimed the superiority of French *cuisine* and made a point of teaching me to cut potatoes in the French instead of the Dutch manner.... Typically, when I later visited him in England, Mondrian had adopted the English cigarette and other national habits with the same dedication previously shown toward France. I suppose the same thing happened when he moved to the United States. Whatever its deeper psychological motivation, this habit reflected Mondrian's great wish to be a part of the social environment in which he was living. ...

As is well known, Mondrian was a great devotee of social dancing. By the time I met him in Paris, he had already given up the waltz, and, if I remember correctly, he took lessons in such modern steps as the fox-trot, tango, etc. Whatever music was being played, however, he carried out his steps in such a personally stylised fashion that the results were frequently awkward and rarely very satisfactory to his partners. Yet, this form of social intercourse meant much to Mondrian, and, though undertaken with his usual seriousness, afforded him much pleasure, especially whenever he had found a sufficiently attractive, which is to say young and pretty, partner....

From the catalogue of the 1971 Mondrian Exhibition, by the Solomon R. Guggenheim Museum, New York.
[1] The mid-twenties in Paris.

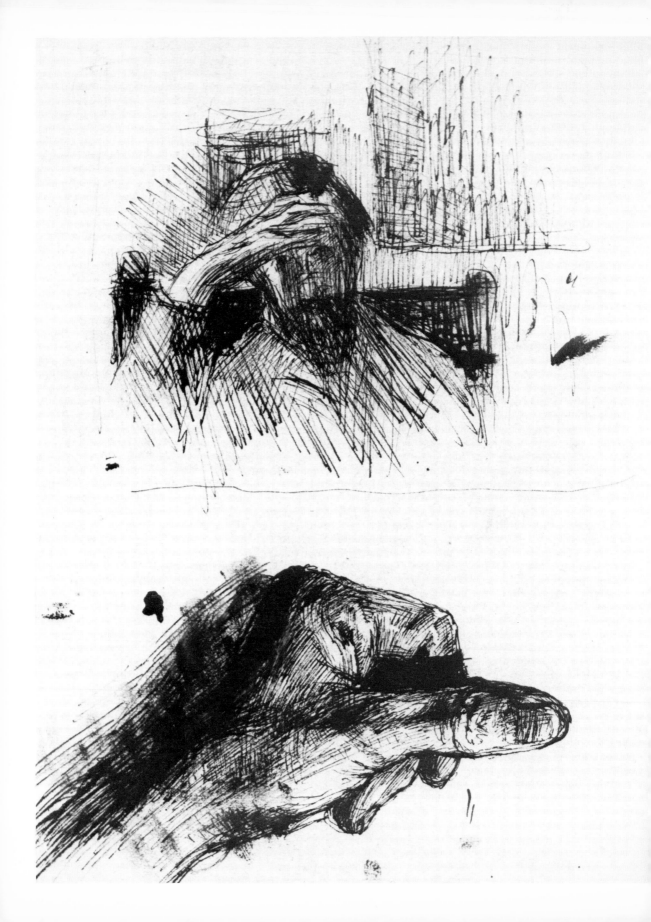

Aristide Maillol

b. 8 December, 1861. Banyuls-sur-Mer, France.
d. 27 September, 1944. Banyuls-sur-Mer, France.

Plate 37. Self-portrait, 1898; age 36.
Pen drawing on grey-green sugar-paper, 29 × 22 cms. Collection Galerie Dina Vierny, Paris.

Aristide Maillol
by Octave Mirbeau

... At that period[1] Aristide Maillol had tried his hand at most things but not really specialised in anything. It was the difficult period of indecision. He had so much choice besides, being passionately interested in everything, and already inferior in nothing. He could paint, do modelling, cut marble, carve wood, chase bronze, forge steel, cast in metal, turn and ornament a pot and bake and glaze it in the kiln, and practice the methods of lithography, wood-engraving and etching.

Ill equipped, almost penniless, ignorant of the various techniques of these various processes, he proceeded by intuition, or with scant knowledge, to reconstruct, and so to speak, invent them. Nothing stopped him, he must get the better of things, and that without ever complaining or getting cross, but always with courage and gaiety.

Before his arrival in Paris Maillol had undertaken a considerable work, a large tapestry, *La Musique*. Knowing he could not depend on commercial wool, which is faulty and unreliable, he had prepared and dyed his own by means of materials he got himself, and which he had tested for permanence.[2] I mention this is order to demonstrate just how far Maillol drives his conscience. This tapestry, which they could hardly refuse at the Salon du Champ-de-Mars, was acquired by Mme la princesse Brancovan. The subject is simple and infinitely graceful. In a wonderfully flowery garden, under the rhythmical branches of trees, there are women, women—not muses—playing the viol, the zither and the harp. This little Pyrenean peasant is already a great charmer; one cannot imagine a décor more elegant, more serene in attitude and form—a more delightful atmosphere of joy and peace, or a delicacy of tone with more piquant and harmonious lightness.[3]

The public did not understand it, and the critics naturally passed by without seeing this exquisite work, which by chance however stimulated the interest of a lady of sensibility. At the same time some young painters fascinated by the composition and execution, revealing a remarkable temperament and fresh grace, were anxious to know who had done it. And that is how Maillol joined a coterie of select artists, the Vuillards, Bonnards, Roussels, the Valtats, the Maurice Denis's, who, like himself—despising easy success or cheap publicity, with the same ardent beliefs, deep and thoughtful, but with different sensibilities—are renewing art in our time and adding to its glories.

Today[4] Aristide Maillol is thirty-five. And these thirty-five years have in no way encroached on or sapped his youth. With his fine features, his eye never still, his nose pointed and sensitive, his supple bearing, easy and controlled, he resembles a young wolf.

Descended directly from the people, he has never disclaimed his peasant origin. On the contrary, he boasts of it; from them he gets his native vigour, his tenacity, naïve confidence, his physical skill, and temperate and clean living. He is poor, proud and happy. His welcome expresses a frank cordiality, an assured hospitality, a charm at the same time rough and gentle which is overwhelming. He has the light heart which comes of an easy conscience; he speaks with a southern accent, picturesque and beautiful, and what he says is simple, right, strong, descriptive and from the heart. I have certainly never met in a man less affectation or artifice, or more natural and true grace.

Through his personality, unconsciously, and by the overriding force of his character, he exercises great authority over his friends. Sometimes he has a naïvety, a singular and unworldly enthusiasm which is enchanting in its delightful spontaneity. One day in Edouard Vuillard's studio he admired a canvas which the latter was finishing. "I will take it to the Louvre at once," said Maillol. He was very disappointed and angry when he learned of all the rigmarole which accompanies the acceptance of a work of art; and that the Louvre doesn't belong to artists, but to the civil servants of the Arts. He was scandalised. One loves him at first sight; one values and admires him on better acquaintance.

"When I have spent a couple of hours with Maillol," an anxious painter told me, "I go away entirely reassured, I feel a security and a serenity which stays with me for days." . . .

From *Aristide Maillol* by Octave Mirbeau, Paris 1921.

[1] About 1895, on his arrival in Paris with his wife, Clothilde Narcisse, and son, Lucien, when they lived in Rue-Saint-Jacques.
[2] Maillol got the wool and gathered the plants himself in the Pyrenees to make his own dyes.
[3] During the period in which he was working on the tapestry, Maillol's eyesight was threatened. It was then that he turned seriously to sculpture.
[4] In 1897, the year before he drew this self-portrait.

Marc Chagall

b. 7 July, 1887. Vitebsk, Russia.

Plate 38. Self-portrait with Grimace, 1924/25; age *c.* 37.
Etching and aquatint, printed in black, 37.4 × 27.5 cms. Stedelijk Museum,
Amsterdam.

My Life, by Marc Chagall.

... "Jew or not?" For a second, I hesitate. It is dark. My pockets are empty, my fingers sensitive, my legs weak, and they are out for blood. My death would be futile. I so much wanted to live.

"All right! Get along!" they shout. Without further delay I hurried towards the centre where the pogrom had broken out.

Gunshots. Bodies fall into the water. I run home.

I prayed: "Wilhelm, be satisfied with Warsaw, with Kowno, don't enter Dwinsk! And whatever you do, don't touch Witebsk! That's where I am, painting my pictures."

But luckily for Wilhelm, the Russians fought badly. Although they fought furiously, they could not drive the enemy back. Our men excel only in the attack. Every defeat of the army was an excuse for its leader, Grand Duke Nicholas Nicolaewitch, to blame the Jews.

"Get them all out within twenty-four hours. Or have them shot. Or both at once!"

The army advanced, and as they advanced, the Jewish population retreated, abandoning towns and villages. I felt like having them all put on to my canvases, to keep them safe.

Fists were being shaken at the sky. Soldiers fled the front. The war, ammunitions, fleas, everything was left behind in the trenches. Panic-stricken soldiers broke carriage windows, commandeered wrecked trains and, packed like herrings, bolted towards the towns, towards the capitals. Freedom roared on their lips. Oaths hissed.

I don't stay put either. I desert the office, the inkwells, and all the records. Goodbye! I also leave the front, with the others. Freedom and the end of the war. Freedom. Absolute freedom.

And the February Revolution breaks out.

My first feeling—is that I won't have to have any more dealings with the "passportist".

The Volunsky regiment was the first to mutiny. I ran to Znamensky Square, from there to Liteynay, to Nevsky, and back. Gunfire everywhere. The cannon were being mounted. They were laying out the arms.

"Three cheers for the Duma! Three cheers for the provisional government!"

The gunners voted for the people. After limbering up their cannons, they left.

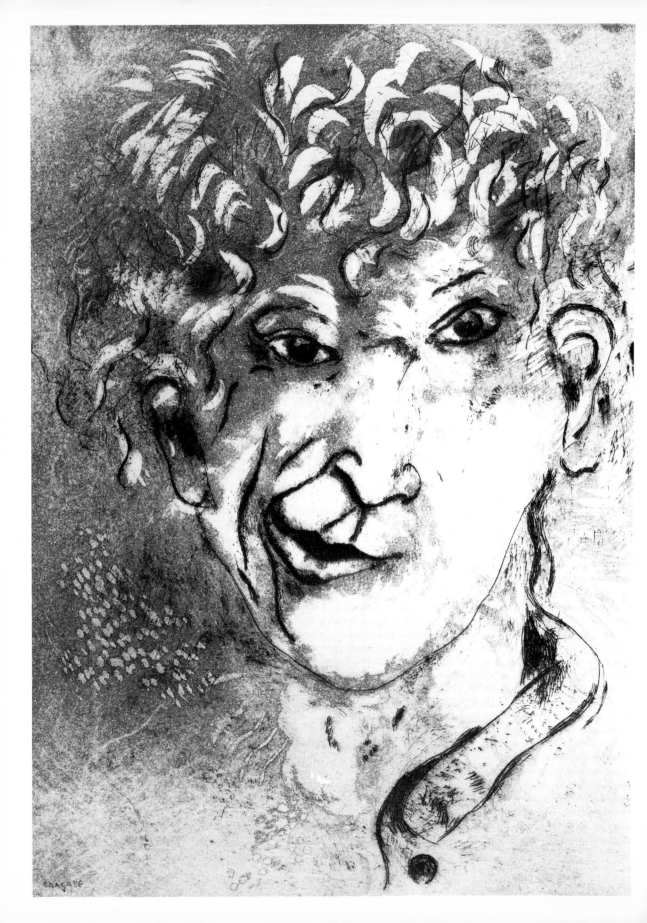

The other corps swear allegiance, one after the other. After them, the officers, the sailors.

In front of the Duma, President Rodzianko thunders:

"Don't forget, brothers, the enemy is still at our gates. Swear allegiance! Swear!"

"We swear! Hurrah!" They shouted themselves hoarse.

Something was about to be born. I was living in a kind of coma.

I never even heard Kerensky. He was at the height of his fame. Hand on chest, like Napoleon, his glance too. He sleeps in the Imperial bed.

The Constitutional Democratic ministry is succeeded by the ministry of the semi-Democrats. Then the Democrats. They joined forces. Checkmate.

After that, General Korniloff tried to save Russia. The deserters attacked the whole railway system.

"Back to our homes!"

That was in the month of June. The R.S. party was in favour. Tchernoff was making speeches in the amphitheatre.

"Constituent assembly, constituent assembly!"

In Znamensky Square in front of the great monument of Alexander III, people were beginning to whisper:

"Lenin's arrived."

"Who's he?"

"Lenin from Geneva?"

"Himself."

"He's here."

"Not really?"

"Down with him! Drive him out! Three cheers for the provisional government! All power to the constituent assembly!"

"Is it true he came from Germany in an armoured carriage?"

The actors and painters have gathered in the Michailowsky Theatre. They mean to found a Ministry of Arts. I attend as an onlooker. Suddenly I hear my own name proposed for minister by the young artists.

I leave Petrograd and return to my Witebsk. I still prefer my home town to being a minister.

Seeing me neglect painting, my wife wept. She warned me that it would all end in insults, in snubs. It was so. Unfortunately, she is always right. When will I learn to take her advice?

Russia was covered with ice. Lenin turned her upside down the way I turn my pictures.

Madame Kchessinsky has left. Lenin is making a speech from his balcony. Everyone is there. The letters R.S.F.S.R. were already turning red. The factories were stopping. The horizons opened. Space and emptiness.

No more bread. The black lettering on the morning posters made me sick at heart. . . .

From *My Life* by Marc Chagall, first published in Russian in 1947. The French edition, translated by Bella Chagall, was published in 1957, and from this the English version, translated by Dorothy Williams, was published by Peter Owen in 1957, 1965.

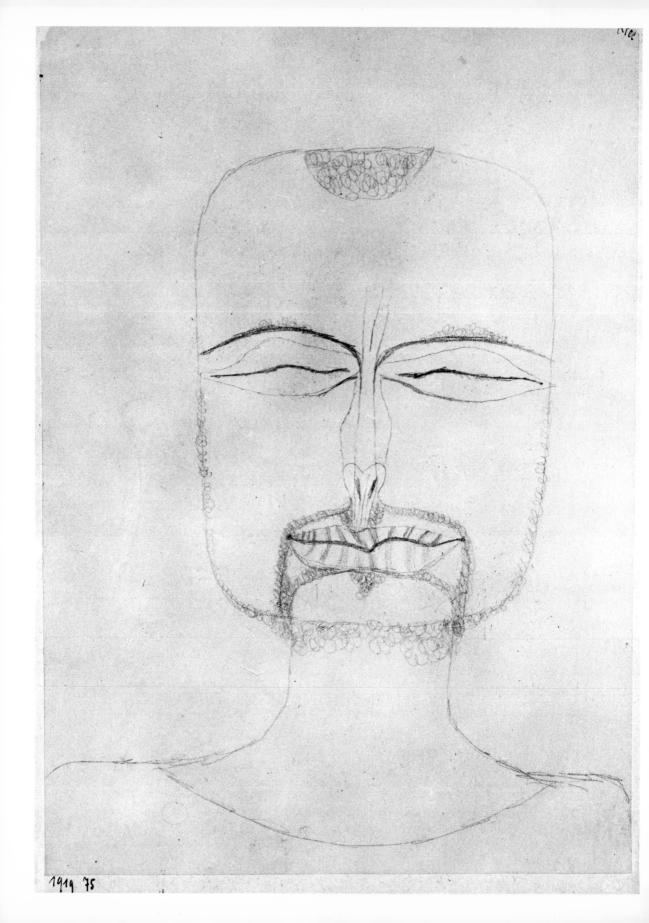

Paul Klee

b. 18 December, 1879. Münchenbuchsee, near Bern, Switzerland.
d. 29 June, 1940. Sanatorium in Ticino, Switzerland.

Plate 39. Self-portrait, 1919; age 39.
Pencil, 27 × 19.5 cms. The Blue Four—Galka Scheyer Collection, Norton Simon Museum of Art at Pasadena, California.

On Modern Art

Paul Klee explains, in a lecture delivered at the opening of an exhibition at the museum in Jena in 1924.

. . . I now come to the first construction using the three categories[1] of elements which have just been enumerated. This is the climax of our conscious creative effort. This is the essence of our craft. This is critical. From this point, given mastery of the medium, the structure can be assured foundations of such strength that it is able to reach out into dimensions far removed from conscious endeavour.

This phase of formation has the same critical importance in the negative sense. It is the point where one can miss the greatest and most important aspects of content and thus fail, although possibly possessing the most exquisite talent. For one may simply lose one's bearings on the formal plane. Speaking from my own experience, it depends on the mood of the artist at the time which of the many elements are brought out of their general order, out of their appointed array, to be raised together to a new order and form an image which is normally called the subject. This choice of formal elements and the form of their mutual relationships is, within narrow limits, analogous to the idea of motif and theme in musical thought.

With the gradual growth of such an image before the eyes an association of ideas gradually insinuates itself which may tempt one to a material interpretation. For any image of complex structure can, with some effort of imagination, be compared with familiar pictures from nature. These associative properties of the structure, once exposed and labelled, no longer correspond wholly to the direct will of the artist (at least not to his most intensive will) and just these associative properties have been the source of passionate misunderstandings between artist and layman. While the artist is still exerting all his efforts to group the formal elements purely and logically so that each in its place is right and none clashes with the other, a layman, watching from behind, pronounces the devastating words, "But that isn't a bit like uncle". The artist, if his nerve is disciplined, thinks to himself, "To hell with uncle! I must get on with my building. . . . This new brick is a little too heavy and to my mind puts too much weight on the left; I must add a good-sized counterweight on the right to restore the equilibrium." . . .

From *On Modern Art*, translated into English by Paul Findlay, first published by Faber and Faber Ltd in 1948. This extract is taken from pages 29 and 31 of the 1974 edition.

[1] The "formal elements" Klee describes are line, tone value, and colour; or measure, weight, and quality.

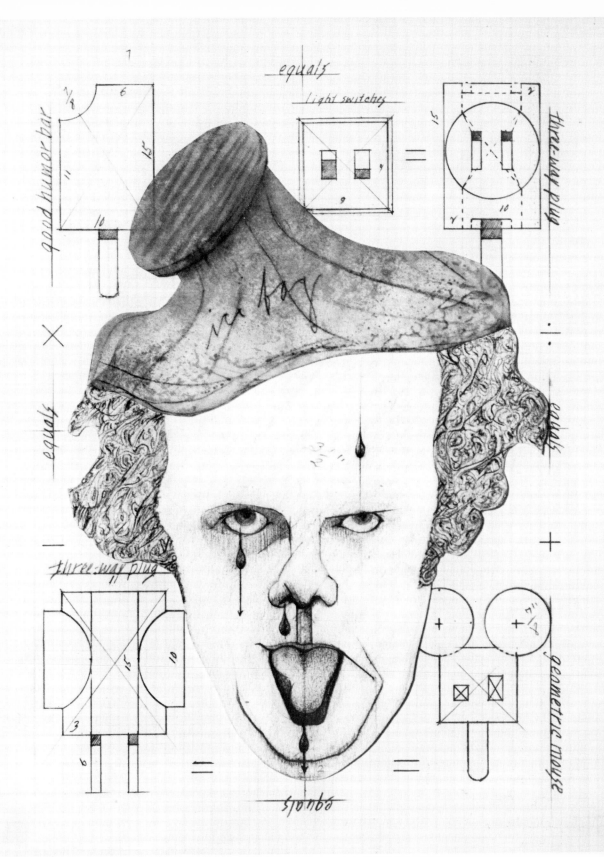

Claes Oldenburg

b. 28 January, 1929. Stockholm, Sweden.

Plate 40. Symbolic Self-portrait with Equals, 1969; age 40.
Pencil and other mixed media in colour, 27.9 × 21 cms. The Moderna Museet,
Stockholm, Sweden.

The Self-portrait[1]

The face is a cutout, like a mask, which is pasted on the diagram of the objects.
The ice bag is also a cutout of different paper, pasted on. The face is divided in
half vertically. One side shows the kindly aspect of the artist; the other, his
brutal one. The body is introduced in the image of the face via the
representation of the body's juices—the tongue (bringing out the insides)—
which doubles as a heart and foot. The stare is partly the result of the working
conditions of making a self-portrait—one hangs up a mirror and stares into it—
but also emphasises the artist's reliance on the eyes. The "$3\frac{1}{2}$" on the forehead is
left on as a reminder of my concern at the time with measurements of patterns.
The Ice Bag on the head signifies that subject was on my mind. It doubles as a
beret—attribute of the artist.

 The objects are shown in the order in which they were made, reading left to
right from the Good Humor Bar of 1963 through the Geometric Mouse of
1969. They circulate about the artist's head like the representation of
unconsciousness in the comics, or the astrological signs on the hat of Merlin the
Magician—deflated to an Ice Bag.

 I alternated between the image of a magician and that of a clown, trying to
make a combination of the two. Two clown representations, I recall, which
contributed are the "Joker" from the BATMAN comic strip and the laughing face
that used to be on Tilyou's Amusement Park, "The Funny Place", at Coney
Island. I remembered, also the self-portraits (in agony) of Messerschmidt, which
were analysed by Ernst Kris.

Oldenburg's Crē'dō, May–June 1961[2]

I am for an art that is political-erotical-mystical, that does something other than
sit on its ass in a museum.

 I am for an art that grows up not knowing it is art at all, an art given the
chance of having a starting point of zero.

 I am for an art that embroils itself with the everyday crap & still comes out on
top.

 I am for an art that imitates the human, that is comic, if necessary, or violent,
or whatever is necessary.

 I am for an art that takes its form from the lines of life itself, that twists and

extends and accumulates and spits and drips, and is heavy and coarse and blunt and sweet and stupid as life itself.

I am for an artist who vanishes, turning up in a white cap painting signs or hallways.

I am for art that comes out of a chimney like black hair and scatters in the sky.
I am for art that spills out of an old man's purse when he is bounced off a passing fender.
I am for the art out of a doggy's mouth, falling five stories from the roof.
I am for the art that a kid likes, after peeling away the wrapper.
I am for an art that joggles like everyones knees, when the bus traverses an excavation.
I am for art that is smoked, like a cigarette, smells, like a pair of shoes.
I am for art that flaps like a flag, or helps blow noses, like a handkerchief.
I am for art that is put on and taken off, like pants, which develops holes, like socks, which is eaten, like a piece of pie, or abandoned with great contempt, like a piece of shit.

I am for art covered with bandages, I am for art that limps and rolls and runs and jumps. I am for art that comes in a can or washes up on the shore.
I am for art that coils and grunts like a wrestler. I am for art that sheds hair.
I am for art you can sit on. I am for art you can pick your nose with or stub your toes on.
I am for art from a pocket, from deep channels of the ear, from the edge of a knife, from the corners of the mouth, stuck in the eye or worn on the wrist.
I am for art under the skirts, and the art of pinching cockroaches.

I am for the art of conversation between the sidewalk and a blind man's metal stick.
I am for the art that grows in a pot, that comes down out of the skies at night, like lightning, that hides in the clouds and growls. . . .

[1] Written by Oldenburg for the catalogue of the Pasadena Museum circulating exhibition of 1971.
[2] Extract from the *Crē'dō*, written for the catalogue of the exhibition *Environments, Situations, Spaces* at the Martha Jackson Gallery, New York, 23 May–23 June 1961. Reprinted in the catalogue of the Claes Oldenburg exhibition, Tate Gallery, Arts Council of Great Britain, 1970. Oldenburg's statement contains 27 more items.

Wenceslaus Hollar

b. 13 July, 1607. Prague, Bohemia.
d. 25 March, 1677. Gardiner's Lane, Westminster, London, England.

Plate 41. Self-portrait, *c.* 1647; age 40.
Etching, 13.2 × 11.1 cms. National Gallery, Prague.

Amongst the biographical material on English artists, collected by George Vertue,[1] was the following letter from Francis Place, written from York, 20 May, 1716.

Coppy

Sr. By my neighbour Mr Lumley I had the favour of yours in which you are desirous to know some passages concerning Mr Hollar. he was a person I was intimately acquainted withal. but never his disciple nor any bodys else. which was my misfortune

Mr Winceslaus Hollar was born at Prague in Bohemia but I know not the year. he was bred a clarck in some of the offices of that country, which he left when the unfortunate troubles brake out there, seconded by Gustavus Adolphus. after he left his native country he came into flanders. & setled some years at antwerp. where he did several plates as you may see by the date of his Works. he was a General Master. so did not confine himself to any one Studie. but did everything not ill but his most excellent performances are views, churches & c. & rarities of the Arundellian Collection; he studied with one Mesian,[2] an Artist of that country, who has likewise etch the most prints of views of places in Germany of any man that ever was. but Mr Hollar exceeded his master. he was the most indefatigable man that has been in any Age as his works will testifie, he had a defect in one of his Eyes, which was the left, so that he always held his hand before it when he wrought. he never us'd spectacles. he was sent over by K. Charles ye 2d to Tanger to make designs of the town & mole. I have I believe 15 or 16 drawings he made of that place. he publish'd I remember a book of Views of Tangier which may be had at Overtons for his father bought the Plates. the King gave him but a 100 pound, for all the trouble & hazard he run. for in their passage they were attack'd by 3 Turkish rovers which after an obstanate fight they were forct to shere off. there is a print with the relation of his own doing in one part of Ogilbys Atlas as I remember it in that of Africk.

He lived in Bloomsbury all the time of the Plague but sufferd extreamly for want of Business. which old Peter Plent made an advantage of, purchasing several of his plates for a trifle. he told me he gave him but 30 shill. for the Long view of Greenwich which very well deservd 10 or fifteen pounds. he was always indigent & had a method of Working not common. he did all by the hour in which he was very exact for if any body came in that kep him from his business he always laid ye hour glass on one side, till they were gone. he always record

12d an hour. he carried arms in the Militia in Germany but was soon tir'd out. I beleve his first comeing into England was with the Lord Arrondel who was sent ambassador to the Emperor. & he lighting of Mr Hollar as they came down the Rhyne. took him into the boat. he drew several designs for his Lordship who was the first nobleman that ever pretended to a Collection in England. Mr Hollar was a very passionate man easily moved. he has often told me he was always uneasie if not at work. he was one of great temperance I don't think he in all his lifetime was ever seen in drink but would eat very heartily. he was near 70 when he died, about 36 or forty years ago at a house he had in Gardeners Lane King street Westminster[3] of a Parraletick fitt. & before his departure the Bayliffs came & siez'd all he had, which gave him a great disturbance & he was heard to say they might have stayd till I (he) was dead.

he left a widow & two daughters & had a son which was very promising in his way. He died young.

<div align="right">Yrs F Place</div>

There is three Prints of Hollars own picture etch'd by himself. one in debyes[4] lives of Painters. two others alike only one less than the other. the biggest of two has etchd on it Æta 40 1647. whereby he must be 71 years old if he died in 1678 as is said.

[1]After Vertue's death in 1756, Horace Walpole bought the note-books from his widow, and compiled from them his *Anecdotes of Painting in England*. A copy of this letter is in the Manuscript Department, the British Museum, London; Add. 21111, p. 15. Francis Place (1647–1728) was a topographical artist and friend of Hollar.
[2]"one Mesian" was Jan Meyssens of Antwerp, 1612–70.
[3]Hollar was buried on 28 March 1677 at St Margaret's, Westminster, London.
[4]Cornelis de Bie who wrote *Het Gulden Cabinet* which was published by J. Meyssens, Antwerp, 1661.

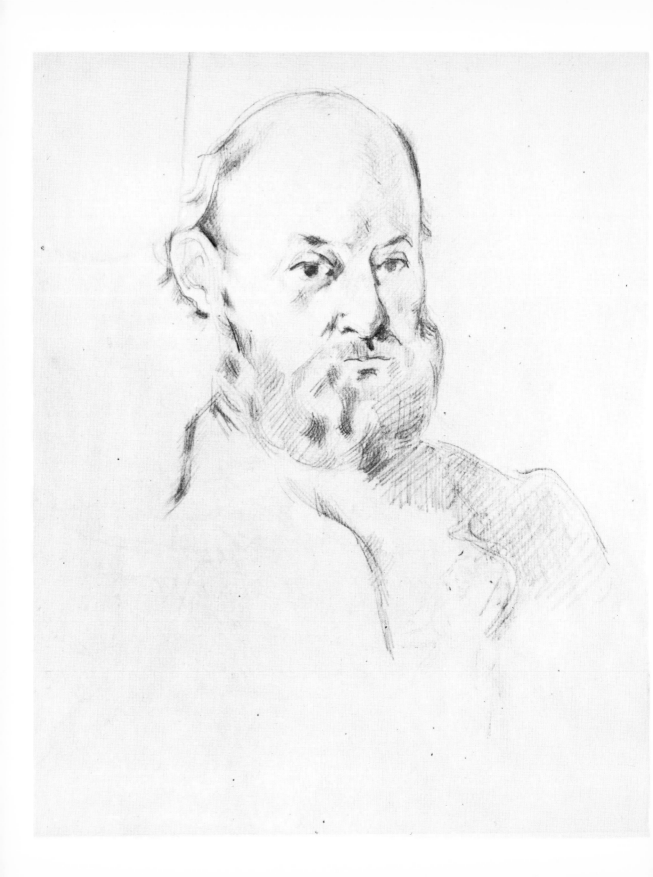

Paul Cézanne

b. 19 January, 1839. 28 rue de l'Opéra, Aix-en-Provence, France.
d. 22 October, 1906. 23 rue Boulegon, Aix-en-Provence, France.

Plate 42. Self-portrait, undated, *c.* 1878–85.
Pencil on off-white paper; 30.3 × 25 cms. Szépmüvészeti Muzeum, Budapest.

Letter[1] from Cézanne to his old school-friend Émile Zola. Written from Aix in 1878, it is one of many which show to what an extent Cézanne depended on and was supported by the successful Zola.

28 March [Aix, 1878]

My dear Émile,

I agree with you that I shouldn't renounce the paternal allowance[2] too readily. But by the snares which are laid for me and which so far I have escaped, I foresee that the big issue will be that of money, and of the use which I should make of it. It is more than probable that I shall only receive 100fr from my father although he promised me 200 when I was in Paris. I should then have to accept your benevolence, all the more because my little boy has been ill for two weeks with a mucous fever. I take every precaution that my father should not get definite proof.

Forgive me for mentioning it, but your writing paper and envelopes must be heavy; they made me pay 25ᶜ for insufficient postage, and your letter was only one double sheet; would you, when you write, put in only one single sheet folded in two.

If it turns out that my father does not give me enough I shall apply to you in the first week of next month, and will give you Hortense's address so that you can kindly send it to her.

I wish Madame Zola *bonjour, et je te serre la main,*

Paul Cézanne

There will probably be an impressionist exhibition; if there is I will ask you to send the still-life that you have in your dining-room. I received a letter about a meeting for the 25th of this month, rue Lafitte, to discuss the matter. Naturally I did not go. Has *Une Page d'Amour*[3] come out yet?

[1]Preserved in the Département des Manuscrits, Bibliothèque Nationale, Paris.
[2]Although Cézanne was thirty-nine at this time, he lived on an allowance from his banker father who, becoming suspicious that his son was keeping a woman in Paris, and had a son, must have threatened to withdraw it. The woman was Hortense Fiquet, whom Cézanne married on 28 April, 1886. The child was Paul, born 4 January, 1872.
[3]*Une Page d'Amour* was the eighth volume of Zola's *Rougon-Macquart* series.

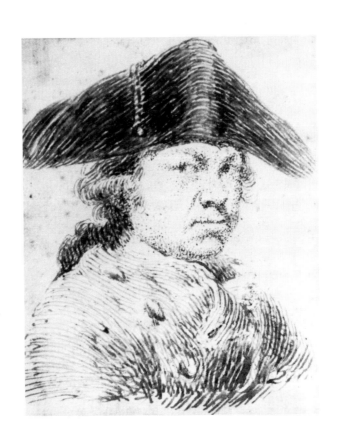

Francisco de Goya y Lucientes

b. 30 March 1746. Fuendetodos, near Saragossa, Aragon.
d. 16 April 1828. Bordeaux, France.

Plate 43. Self-portrait, undated.
Pen and brown ink. 10.4 × 8.6 cm. The Metropolitan Museum of Art, Robert
Lehman Collection, 1975, New York.

*Letters of 1786/87 from Goya to his old schoolfriend, Martin Zapater, boasting of his new
affluence and life at court on his appointment as* pintor de cámara, *or Painter to the King,
Charles III.*

<div align="right">(July 7, 1786)</div>

Dear Martin,

I am now Painter to the King, with 15,000 reales! Though I'm rushed for time, I
must tell you how it was that the King ordered Bayeu and Maella[1] to find the
two best possible painters so that they should paint samples for tapestries, and
anything else they wished either in fresco or oils. Bayeu proposed his brother
and Maella me.

 A consultation was made with the King, and the honour was bestowed upon
me without my knowledge. Afterwards, however, I thanked the King, Prince,
and the rest of the company, also Bayeu who claims he was responsible for
Maella proposing me, and Maella for doing so. I swear by God I will write to
you soon.

 Yours and yours again, Goya

<div align="right">(August 1, 1786)</div>

Dear Martin,

As I've said before, I shall attempt to write to you at length, seeing that I am
lame from a spill we had in the chaise.[2] At 90 doubloons it was rather expensive,
but a jewel nevertheless (there are only three others like it in Madrid). It's
English-made, and so light, its metalwork so beautifully polished, that
everybody stops to look at it.

 We sallied forth to try it out with a very high-spirited horse. The owner and I
were going splendidly, and once we had left Madrid we got up speed. I was
holding the reins, when he said, "Would you like me to make the animal do a
Neapolitan Turn?" (he was Neapolitan). I handed him the reins, always ready
to learn something new. We were galloping, and even though the road was
wide enough, the turn sent horse, chaise and ourselves into a spin. Thank God it
was not serious; in fact I was the worst off, and have been in this condition since
St. Iago's day. I hope the court surgeon will allow me to ride; apart from my
heel, my right leg is sore, but neither broken nor dislocated.

I have been leading an enviable way of life. No one waiting in my ante-room can hope to see me; anyone wanting me had to look for me, I play hard to get, and if he is not someone important, or has not come to me through a friend, I can't do anything for him. Even so, I am never left alone, nor am I now. I don't know how I can comply with all the requests, nor how I could have been so thoughtless in neglecting you for so long. I knew there were many applicants for the job at the tapestry factory. I was only glad to hear that other professionals should aspire to the post as well.

One day Bayeu sent for me (we had not been in touch for some time), and I was very surprised when he started by saying that to be in the King's service was very pleasant, and that he himself had started with 12,000 reales, which he received from Mengs,[3] and only for being his assistant. Now, he said, the time had come for me to enter the King's service with Ramón.[4] This had come about because the King had ordered both him (Bayeu) and Maella to seek the best painters in Spain and propose one each. He had put forward his brother's name, and had seen to it that Maella put mine. We were to paint samples for the tapestry works, and any other painting for the King, with a fee of 15,000 reales a year. I thanked him, still not understanding what was going on, and two days later we received the official document from the King, Princes and the rest; and now you find me completely baffled as to how I managed it.

With what I had before I now possess 28,000 reales,[5] thank God—I could not wish for more—which of course is at your disposal should you ever need it. It is unnecessary to remark that I am talkative today! Please remember me to Don Juan Martin, and hand the enclosed letter over to my sister.

Yours and yours again,

Francisco de Goya.

Goya writes to Zapater again (April 17, 1786?87):
. . . I no longer want a chaise on two wheels: the other day it turned over and I nearly killed a man who was walking down the street. As for myself, I had to have myself bled, so I'm writing to my brother Thomas to ask him to buy me a couple of mules.

April 25, 1786?87

. . . I am glad you agree with me, and let us make it quite clear that life is too short not to be enjoyed to the full.
. . . I very much appreciate your offer of two mules. I would prefer them to be well trained, and of good stock, even for 10 doubloons extra. Please let Thomas know and he will do whatever you say.

With reference to what you say about my "flowering doubloons"—all the ones I possess are at your disposal. I live very pleasantly with the money I have,

and generally find myself with one or two hundred to spare, without counting the three or four hundred owed to me. Anyway, if I work for the general public I can afford to keep my four-wheeled chaise ("berlina"). You are welcome to anything I have, as one man to another, and you and I are very alike. God has distinguished us from other people, for which we thank Him to Whom all is possible. . . .

(May 4, 1787)

Friend,

I don't know what people will think when they find out the mules are for me; I don't want them to get the wrong impression. I suspect that at the Bayeus they already know about it from my having written about it from there, though we haven't spoken about it and I will be careful not to—they'll find out in time. I am sure other people will be pleased to hear about it because many of them have advised this move (that is, those who have them). Anyway, I'm tired of writing all these idiocies; let's change the subject. I shall make your Virgen del Carmen beautiful in my painting. God grant us life to serve Him.

Your Paco.

From *Epistolario de Goya*, edited by G. Diaz-Plaja, 1928. This translation is by Caroline Bridger.

[1] Francisco Bayeu: Spanish painter (1734–95), brother-in-law to Goya, and first Court painter at that time. Mariano Salvador de Maella: Spanish painter (1739–1819).
[2] Editor's note: The translator Caroline Bridger and I, ignorant as to what type of vehicle Goya could have bought, asked the help of the expert Donald J. Smith. It is tempting to think it was the "suicide gig", very smart and sporting and unreliable, but Mr. Smith makes clear that this came later, in the 1790s. Therefore it was probably the English two-wheeled chaise, originally made in France, a refined and elaborate version of the "Wonderful One-Hoss Chaise" about which O. W. Holmes wrote in *The Poet at the Breakfast Table*.
[3] Anton Rafael Mengs: (1728–79), worked several years as Court painter in Spain.
[4] Ramón Bayeu, brother of Francisco Bayeu.
[5] A contrast to the extreme poverty of Goya's childhood when he first knew Zapater in Saragossa.

Graham Sutherland

b. 24 August, 1903. London, England.

Plate 44. Self-portrait with mumps, *c.* 1945; age 41/42.
Pencil, 32.4 × 20.3 cms. Collection, Mrs. K. Sutherland.

Letter from the artist to Canon Walter Hussey, later Dean of Chichester Cathedral, whose perception, and faith in contemporary artists, brought about the two works referred to below: Henry Moore's Madonna and Child,[1] *and Sutherland's* Crucifixion[2] *in St. Matthew's Church, Northampton, which was unveiled on November 16th, 1946.*

<div align="right">

White House Trottiscliffe West Malling Kent
30.V.45

</div>

Dear Mr. Hussey,

Many thanks for your letter; I think the whole thing is a splendid idea of yours & my wife & I will eagerly look forward to seeing you & the Moores at the opera[3]—& before at the National Gallery & for tea, as you suggest.

I'm glad that Henry is pleased on seeing his work again; such a re-union, after a lapse of time is always significant for the artist, because he sees his work for the first time with almost complete detachment & the seeing can bring the most tense kind of pleasure—or—disgust!

As for my painting: I'm still very absorbed by the idea of a Crucifixion. The very difficulties are fascinating. The very shape of the Cross has become a symbol so familiar that the Act it stands for must have become to many almost unreal. I would still like to try it; if my powers prove insufficient,—& I can assure you that of all critics I shall be the most careful & severe,—then, perhaps, I could fall back on the less difficult & less complex "Way of the Cross" or Agony in the Garden.

Much looking forward to ~~the~~ [sic] seeing you on the 20th. & to the opera (please let me know what I owe you for so kindly getting the tickets)

<div align="right">

With kindest regards
Yours sincerely
Graham Sutherland

</div>

[1]Henry Moore's *Madonna and Child*, Hornton stone, height 4 ft 11 ins was unveiled in September 1944.
[2]Sutherland's *Crucifixion*, oil on hardboard, 8 ft × 7 ft 6 ins.
[3]The opera was the fifth performance of Benjamin Britten's *Peter Grimes*, with Peter Pears who created the title role, and Reginald Goodall conducting. The first performance had been on June 7th 1945.

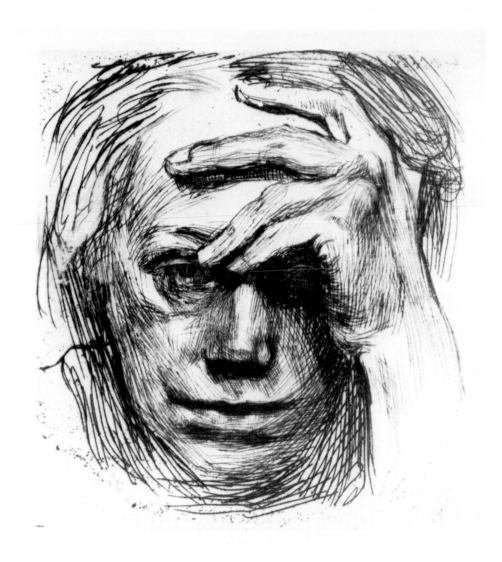

Käthe Kollwitz

b. 8 July, 1867. Königsberg, Germany.
d. 22 April, 1945. Moritzburg, near Dresden.

Plate 45. Self-portrait with hand on her forehead, 1910; age 42/43.
Etching, 144.4 × 12.8 cms. Kupferstichkabinett, Staatliche Kunstsammlungen,
Dresden.

Aus Meinem Leben.

11 October, 1916

Still everything remains obscure to me; why is it? The youth of our country—the youth of all nations goes voluntarily and joyfully to war; and young men who might otherwise live in understanding and friendship, face one another in enmity.

Is youth really without judgement, ready to fight as soon as summoned, without questioning? Does it accept blindly whatever is given as a reason for war, because fighting is in its blood? Does youth want war? and is it only in old age it will have done with it? What terrible stupidity, the youth of Europe in conflict with itself! When I seek to confirm the senselessness of war, I ask myself again—according to what laws should mankind live? Surely not only for happiness. That life must serve an idea is surely an eternal truth. But what happens then? Peter,[1] Erich, Richard, gave their lives for the idea of love of the Fatherland. The youth of England, Russia, France, did the same, and in consequence Europe lost the best it had.

Have, therefore, the young been deceived? Have they been exploited because of their capacity for utter devotion? Where are the culprits?—do they exist? has everybody been deceived, was it mass-madness, and when and where will be the awakening?

I shall never see it; only the fact that the young, that our Peter, two years ago, went dutifully to war, proving a willingness to die for Germany. And they did die, almost all. In Germany and the enemy countries millions died. When the priest blessed the volunteers he spoke of the Roman youth who jumped into the abyss in order to close it. Each of these young men felt it was required of him to do the same. But the result was different; quite different. The abyss was not closed up, it devoured millions and is still gaping.

And Europe, the whole of Europe goes on sacrificing, like Rome, its most beautiful and precious possessions. But it benefits nobody. Am I disloyal to you Peter, that all I can see is the madness of war? You died believing. But did Erich, Walter Meier, Gottfried, Richard Noll? Or were they disillusioned, but still had to jump into the abyss? Had to—wanted to—or had to?

When I think of Richard's poem—

> Now, not later—
> Take me from this place.
> I have had my fill of blood today;—
> It is enough.[2]

From *Aus Meinem Leben* by Käthe Kollwitz, Paul List Verlag, 1957. This translation was done by Gertrude Cuthbertson.

[1]Peter was the second son of Käthe and Dr. Karl Kollwitz. He was born in 1896 and killed at Flanders in October 1914. Their elder son Hans was born in 1892, and came to edit his mother's writings.
[2]Richard's poem reads:

> *Drum lieber heute noch als dann*
> *Hol mich von dieser Statt!*
> *Denn nie als heut und je und wann*
> *Bin ich des Bluts mehr satt.*

Mauritz Cornelis Escher

b. 17 June, 1898. Leeuwarden, The Netherlands.
d. 27 March, 1972. Laren, The Netherlands.

Plate 46. Self-portrait in shaving mirror, 1943; age 44/45.
"Scratch" drawing, brown lithographic crayon, 24.9 × 25.6 cms. Haags
Gemeentemuseum, The Hague.

*The following statement was written by Escher on the back of a print made by Samuel
Jesserun de Mesquita, his friend and former teacher in the art of wood-cut. They had met in
1919 when Escher went to Haarlem to study at the School of Architecture and Decorative
Arts.*

Found at the end of February, 1944, at the home of S. Jesserun de Mesquita,
immediately behind the front door, and trampled on by German hob-nailed boots.
Some four weeks previously, during the night of January 31st to February 1st, 1944,
the Mesquita family had been hauled out of bed and taken away. The front door
was standing open when I arrived at the end of February. I went upstairs to the
studio; the windows had been smashed and the wind was blowing through the
house. Hundreds of graphic prints lay spread about the floor in utter confusion. In
five minutes I gathered together as many as I could carry, using some pieces of
cardboard to make a kind of portfolio. I took them over to Baarn. In all there turned
out to be about 160 prints, nearly all graphic, signed and dated. In November, 1945, I
transferred them all to the Municipal Museum in Amsterdam, where I plan to
organise an exhibition of them, along with such works of De Mesquita as are already
being kept there, and those in the care of D. Bouvy in Bussum.

It must now be regarded as practically certain that S. Jesserun de Mesquita, his
wife and their son Jaap all perished in a German Camp.

November 1, 1945. M. C. Escher.[1]

M. C. Escher Baarn 3–IX–1951
Heemstralaan 56 De Heer Dr. A. W. M. Pompen
BAARN—HOLLAND Specialist for internal diseases
telef. 2926—Giro 409390 St. Jozef Hospital
COPY DEVENTER

Dear Dr. Pompen,

Many thanks for your letter of August 30th and for the prompt return of my
photograph. I was very pleased to hear about the things you "see" in the print,[2]

149

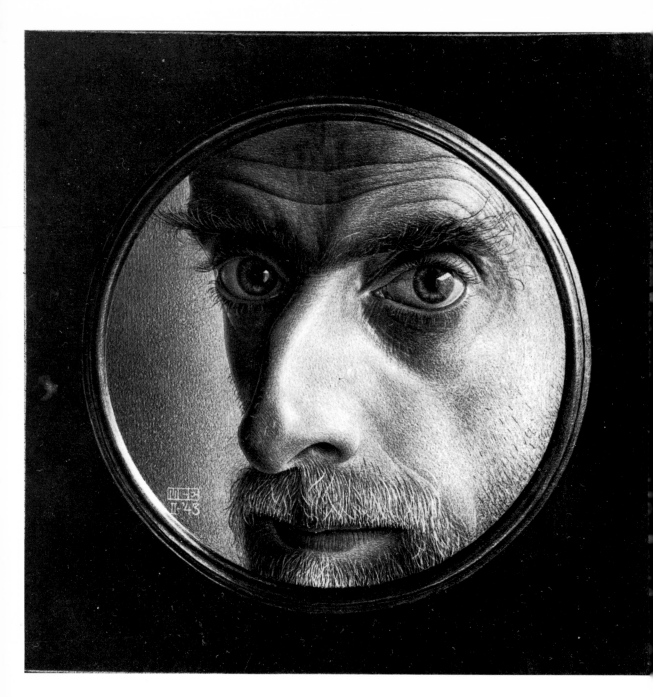

and feel honoured by your intention to project it as a lantern-slide during your talk.

I hope you will accept my efforts to give a short answer to the question which you mentioned you had put to my niece Mevr. van Bolhuis. I will send her a copy also of this letter as you did of yours.

It is very intriguing to hear the interpretation of my work by others, especially as the meaning or symbolism sometimes seen in it is completely non-existent for me, consciously at any rate. I do not think I have ever aimed to render any symbolic expression in my work—but the fact that this is the way that others sometimes see it or understand it is very valuable to me, because then I can accept more easily the incomprehension of my hobbies which haunt me.[3]

The systematic division of an area into congruent shapes which evoke associations with some familiar recognisable natural object is one of these hobbies or problems. This is really all that can be said with regard to *Day and Night*. Over the years I have taken up this geometrical problem again and again, and every time I try to throw light on different aspects of it. I cannot contemplate what life would be for me if I had never been confronted with the problem; I am desperately in love with it, in a manner of speaking, and I still do not know why.

It is not my only hobby. There are various others which direct me and sometimes pull me from the flat surface into space. A conscious awareness of the three dimensions, a grasp of form, is, to my great surprise, not as general as could be expected of us spatial beings. Comprehension of the relationship between surface and infinity is a source of emotion for me, and emotion gives a strong impulse, or at least a stimulus, to create an image.

Yes, indeed, "now we know in part"—but how very small a part.[4]

With kind regards, yours sincerely,

This letter to Dr. Pompen was very kindly provided by J. R. Kist, and translated by Eveline Vaane.

[1] This statement is translated and published in *The Magic Mirror of M. C. Escher* by Bruno Ernst, translation from the Dutch by John E. Brigham, Random House, 1976.
[2] The print was *Day and Night*.
[3] Escher is persistent in his use of the word "hobby", which is a curious understatement, and describes most inadequately what really amounted to an obsession.
[4] Using the plural "we", Escher quotes from the new translation of Corinthians in his original letter. I have taken the liberty of using the old authorised version of the Bible in order that the sentence should read more smoothly.

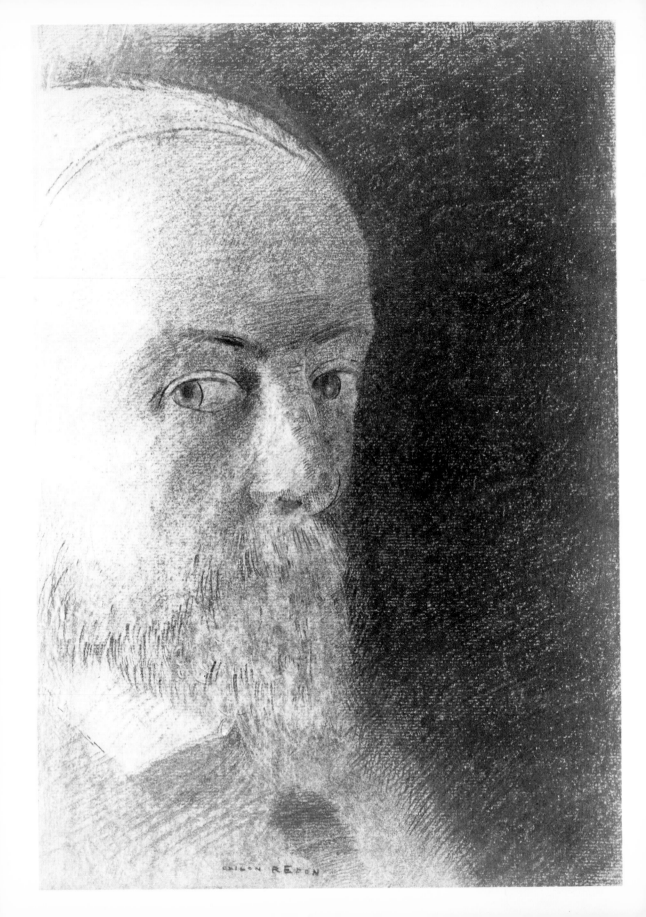

Odilon Redon

b. 20 April, 1840. Bordeaux, France.
d. 6 July, 1916. Paris, France.

Plate 47. Self-portrait, undated, *c.* 1888; age *c.* 47/48.
Charcoal and black crayon, 34.3 × 23.5 cms. Haags Gemeentemuseum, The Hague.

Written by Redon for a conference in Holland on the occasion of an exhibition of his work, January 1913.[1]

. . . All is not vanity for him who accepts his own gifts with grateful curiosity: he applies himself with humility to the cultivation of his faculties for the pleasure of gathering its fruit, and sharing it with those who love and await it. I pursue the course of this thesis for them, the ones who will commend me in the task and appreciate the necessity for me to do it.

Formerly, when I have produced and published drawings and lithographs I have sometimes received letters from unknown people telling me of their feeling for this medium; one of them vowed to have received faith through them. I do not know if art has such powers, but I have felt bound since then to regard with more respect certain of my works, particularly those done lately during a time of sadness and suffering, which are doubtless for that reason more expressive.

I have therefore examined and scrutinised my blacks, and it is above all in the lithographs that they have their full lustre, their unalloyed sparkle, because the charcoal drawings which I made before them and since have been done on tinted paper—rose, yellow, blue, heralding the trend towards colour which I later came to indulge and delight in.

Black is the most essential colour. It takes above all its exuberance and its life, dare I say, from the deep and subtle sources of our well-being; on good diet and sleep, or better still on supreme good health depends the piercing vital intensity which charcoal gives. That is to say, it will appear in its full and greatest beauty at the zenith of our career, short or long; it exhausts us in old age, when we assimilate less food: We can still cover a surface with black but the charcoal will remain charcoal, the lithographic chalk will transmit nothing; whereas in the ardour and strength of our youth, it is the very vitality of a being which bursts out—its energy, its spirit, sometimes of its soul.

We must respect black. . . .

[1]Published in *À Soie-Même* by Odilon Redon, Floury, 1922.

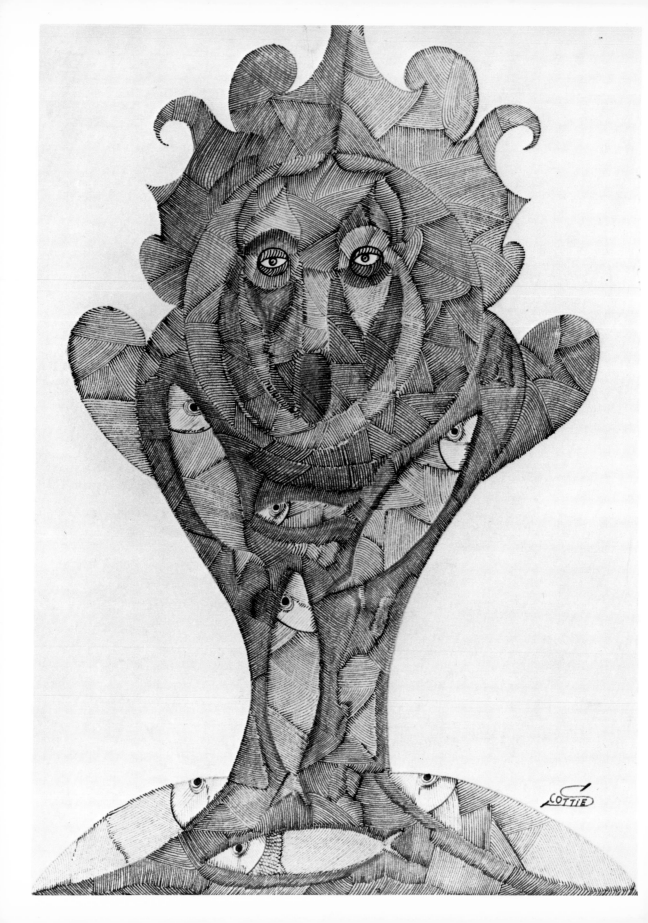

Scottie Wilson[1]

b. 28 February, 1891. 24 Rope Work Lane, Glasgow, Scotland.
d. 26 March, 1972. Kilburn, London, England.

Plate 48. Self-portrait, undated, *c.* 1940; age 49.
Pen and blue-black ink, with green, blue, yellow, pink and red crayon, 37.9 × 27.5 cms. Private Collection.

Recollections of Scottie Wilson by his landlord and friend for seventeen years, Wieslaw Czyzynski. The spelling and punctuation are as in the original.

Scottie Wilson was a very ordinary old man to me when I met him first sometime in 1955. We were tennants in the same house No. 37, Lynton Road NW6.

He was a short little man with a big nose, always wore cloth cap and was rather shabbily dressed, he wore glasses and spoke with strong Scottish accent. But there was something in his face especialy eyes that one could not help noticing. When I got to know him better and learn that he is an artist, I took a closer interest in him and admired his works from first sight.

He loved his pictures and would not part with them, of course he was compeled by necessity of life to sell some from time to time. He would talk about his works and the only artists he admired were William Blake and Michaelangelo. He occupied one small upstairs room (12 × 10 ft) which served him as a bed-sitter, kitchen, studio. It was furnished, the only piece of furniture he owned was large table, 2 or 3 wooden hand made boxes with padlocks, where he kept his best works, and an alarm clock. His room was untidy, he would not like to be disturbed for such a trivial matter like cleaning.

He done his own cooking, did his own washing-up made his own bed, he ate lot of tin fish, kippers (the smell!)—and lots of oranges. I remember him going for his daily shopping no matter what weather pulling his little trolley behind. He went to Sainsbury's in Kilburn High Rd. At W. H. Smith's he bought the ordinary steel pen-nibs he used for his drawing. His daily routine was shopping in the morning he read the *Daily Telegraph* later, little snack and cup of tea, nap in the afternoon, then work sometime till early hours in the morning, his radio on full blast; he was a little deaf, he liked classical music he would turn off pop.

He told me that he taught himself to read but could not write, never read books, he liked a glass of whisky or beer occasionally. He was sort of hermit, had few friends who visited him (and) looked after him and his affairs. He hated people running after his work for a few pounds. He was talkative, reminiscing about his youth, army life, Canada where he started to paint. He did talk about his hard working parents, especially mother, his many brothers and sisters.

He was temperamental, but easy to go with if he liked someone, he had a great sense of humour & was always ready for a joke.[2] He loved children and would seldom come home without bringing something for our son Mark, a banana or

something. He said many times if he was borne again, he would get married and have plenty of children. He had an elder brother somewhere and used to send him money regularly.[3]

He always walked or used public transport, he wore boots which were very costly as he had them specialy made; never had a holiday, sometime in the summer he would take a train to Brighton and return same day. Christmas he spent with two of his closest friends. He never complained about his health until last few months before he died.

My wife Beata and myself looked after him until his doctor arranged for day and night nurses. He died quietly before Easter 1972. Many people from world of art and press and his closest friends were present at his funeral. We miss him very much, he was very lovable somehow he was part of our life, and such a people can not pass away unnoticed.

<div style="text-align: right">

W. Czyzynski
24 February, 1974

</div>

[1]Scottie Wilson, otherwise Louis, or Lewis, Freeman came of an orthodox Russian Jewish family. His father, Julius Freeman, a fur skin dresser—who signed his name with a cross—his mother, Esther, his elder brother Philip, and his grandmother all emigrated to Scotland from Riga, Russia.

[2]Mr Czyzynski relates how one day as Scottie was preparing to go out, a lady present reminded him to behave himself and not to do anything she wouldn't do. "Don't worry," Scottie said, "I'm on the Pill".

[3]The money, to Philip who had become blind, was a regular monthly pound note which Scottie despatched in an envelope containing also another envelope stamped and addressed to himself. Philip had only to post it, and Scottie knew he was all right.

Percy Wyndham Lewis

b. 18 November, 1882, on his father's yacht *Wanda*, at Amhurst, Nova Scotia, Canada.
d. 7 March, 1957. Westminster Hospital, London, England.

Plate 49. Self-portrait, 1932; age 49/50.
Pen and wash, 25.3 × 19.5 cms. National Portrait Gallery, London.

The Sea-Mists of the Winter
by Wyndham Lewis

It became evident quite early that it was going to be a deplorable winter. The cold was unvarying, it had purpose it seemed. Usually in a London winter it forgets to be cold half the time; it strays back to autumn or wanders dreamily forward to spring, after a brief attempt at winter toughness, perhaps squeezing out a few flakes of snow. But *this* winter though it experienced its usual difficulty in producing anything but a contemptible snowfall there has been an un-British quality, an unseemly continuity.

Speaking for myself what struck me most was the veil of moisture, like a sea-mist which never left my part of the town. I remember first remarking this just before Christmas. I said to Scott, my journalist-newsagent-friend, that these perpetual mists must slow him down in the morning; he drives up to business in his car, from his home in the outer suburbs. He did not seem to mind a light sea-mist, for he shook his head absent-mindedly. Another time I was talking to him over the magazine counter of the shop and indicating the street outside, with its transparent film of blue-grey. I protested, "Another mist!" He looked out and said, a little sharply, "There is no mist". I did not argue, I supposed that he meant it was not up to the specification of what *he* called "a mist".

But you may have seen through my innocent device. The truth is that there was *no* mist. The mist was in my eyes: there was no sea-mist in nature. In spite of conditions which, one would have supposed, would have made it quite clear what these atmospheric opacities were, it took me a considerable time to understand. It was not, you see, like this that I had imagined my sight would finally fade out. "You have been going blind for a long time", said the neuro-surgeon. And I had imagined that I should go on going blind for a long time yet: just gradually losing the power of vision. I had never visualised mentally, a sea-mist.

In such cases as mine there always arrives a time when normal existence becomes impossible, and you have to turn towards the consultant who has made a specialty of your kind of misfortune. When I started my second portrait of T. S. Eliot, which now hangs in Magdalene College, Cambridge, in the early summer of 1949, I had to draw up very close to the sitter to see exactly how the hair sprouted out of the forehead, and how the curl of the nostril wound up into the dark interior of the nose. There was no question of my not succeeding, my sight was still adequate. But I had to move too close to the forms I was studying. Some months later, when I

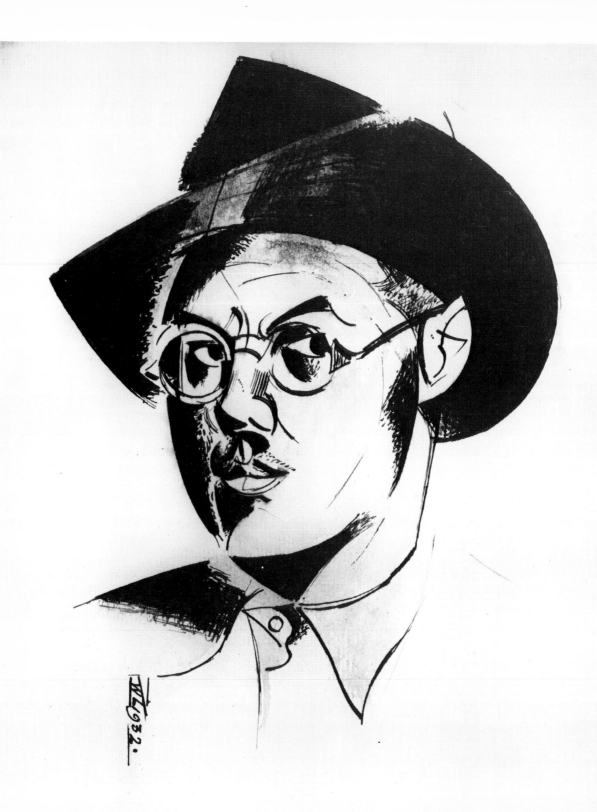

started a portrait of Stella Newton, I had to draw still closer and even then I could not quite see. So I had to have my eyes examined. This was the turning-point, the date, December 1949. What, in brief, is my problem, is that the optic nerves, at their chiasma, or crossing, are pressed upon by something with the pleasing name of craniopharyngioma. It is therefore a more implacable order of misfortune than if I had a jolly little cataract. There has been a great acceleration of failure of vision during the last seven months or so. Of course I was told that I should first lose my "central vision" which would mean that I should no longer be able to read or write. Already I was obliged to read with a magnifying glass. Then I found that I could no longer read the names of streets, see the numbers on houses, or see what station I was passing through on the railway. About that time everything except banner headlines was invisible: then I found I could no longer read the letters inside the finger-holes of a telephone-dial. At present, if I wish to dial a number, I count the holes with my fingertips until I reach the opening where I know the letter I have to locate is situated. Thus seven is P.R.S., five is J.K.L. I know what letters the holes near the beginning and end of the half-circle contain, and what the figures are as well.

As to typing, it is some time ago now that I ceased to see distinctly the letters on the keys. I still write a certain amount with a pen or pencil; but I write blind. However much I write on it, the page before me is still an unsullied white; and sometimes the lines I have written distressingly amalgamate. The two books on which I am at present working, one a novel, the other an art book, will proceed quite smoothly, but the method of their production will be changed. A dictaphone, or "recorder" as the Americans call it, will supersede the pen or the typewriter, at least as far as the first stages of composition are concerned. Many American writers I am informed employ the recorder, although possessing ordinary visionary powers.

As to the sea-mist, that is now too pretty a name for it. Five or six weeks ago I still went to my newsagent to have a talk with Scott and make some purchases. He of course would move about as a fresh customer would come in and demand attention. At any given time I found it extremely difficult to decide whether he was there before me or not, for he would come back and stand silently near me, and often it was only because of the tobacco he was smoking, and a slight movement in the mist before me, or at my side, that I knew that he had returned. Recently he has told me that he realised that half the time I did not know he was there. I went to other shops as well, as long as it was possible: but when for me the butcher became nothing but a white apron, and the skinned back of a bullock protruding, as it hung, seemed to me a fleshly housewife, I ceased to be a shopper. Now I take my exercise arm-in-arm with some pleasant companion, and it is surprising how easily one can thread one's way in and out of the shadowy pedestrians, very slightly steered by another but sharp-eyed person.

Sometimes I am still at large solo, though increasingly rarely. I may go out, for instance, and some twenty yards away look for a taxicab. In these cases I will stand upon the edge of the pavement, calling imperiously "Are you *free*?" to owner-drivers, who probably observe me coldly from behind their steering wheels as if I were the Yonghi-Bonghi-Bo. I signal small vans, I peer hopefully at baby-trucks.

At length I get a response. It *is* a taxi! But I assure you that it is one thing to hail a taxi-cab, another to get into it. This is quite extraordinarily difficult. I try to force my way in beside the indignant driver. He or I will open the door. But as I see everything so indistinctly I attempt to effect a passage through the wood of the door itself, in Alice Through the Looking Glass fashion, rather than take advantage of the gaping hole in the side of the taxi produced by the opening of the door. It is with a sigh of relief that I at last find my way in, after vainly assaulting the stationary vehicle in two or three places. This I realise must be extremely difficult to understand for a person with rude eyesight and piercing vision.

The failure of sight which is already so far advanced, will of course become worse from week to week, until in the end I shall be able to see the external world only through little patches in the midst of a blacked-out tissue. On the other hand, instead of little patches, the last stage may be the absolute black-out. Pushed into an unlighted room the door banged and locked for ever, I shall then have to light a lamp of aggressive voltage in my mind to keep at bay the night.

New as I am to the land of blind-man's-buff I can only register the novel sensations, and not deny myself the enjoyment of this curious experience. It amuses me to collide with a walking belly; I quite enjoy being treated as a lay-figure, seized by the elbows and heaved up in the air as I approach a kerb, or flung into a car. I relish the absurdity of gossiping with somebody the other side of the partition. And everyone is at the other side of the partition. I am not allowed to see them. I am like a prisoner condemned to invisibility, although permitted an unrestricted number of visitors. Well, Milton had his daughters, I have my dictaphone.

This short story of mine has the drawback of having its tragedy to some extent sublimated. Also, we have no ending. Were I a dentist, or an attorney, I should probably be weighing the respective advantages of the sleek luminol or the noisy revolver. For there is no such thing as a blind dentist or a blind lawyer. But as a writer, I merely change from pen to dictaphone. If you ask, "And as an *artist* what about that?" I should perhaps answer, "Ah, sir, as to the artist in England! I have often thought that it would solve a great many problems if English painters were born blind".

And finally, which is the main reason for this unseemly autobiographical outburst, my articles on contemporary art exhibitions necessarily end, for I can no longer see a picture.

From the *Listener*, 10 May, 1951

Hans Holbein the Elder

b. *c.* 1465. Augsburg, Germany.
d. 1524. Isenheim, Alsace.

Plate 50. Self-portrait, *c.* 1516.[1]
Silverpoint, touched with red and white, 13 × 10 cms. Musée Condé de Chantilly, Paris.

In the late Middle Ages artists' studios were often the common workshops of single families; a painter's brothers and sons worked under his direction—each according to his capabilities. While the more modest talents fulfilled whatever task was set them, clinging as closely as possible to the familiar style of the studio, the more independent spirits strove towards unrestrained and individual activity.

The history of Hans Holbein the Elder and his sons, occurring in the transition period from Gothic to Renaissance, is readily accessible to us, for a lucky fate has preserved a large quantity of records, paintings and drawings.

Hans Holbein the Elder was born in Augsburg between 1460 and 1470. After travels which took him to the Netherlands by way of Ulm, he settled in Augsburg in 1493.

The artist must soon have found recognition. It was at the beginning of the sixteenth century that he painted most of those panels which are to be found today in public collections, great series of pictures from the Passion, the lives of the Virgin and of the Saints: in 1501 the High Altar of the Dominican Church at Frankfurt on the Main (Städelsches Kunstinstitut); in 1502 the Kaisheim Altarpiece (Munich, Alte Pinakothek); in 1504 the *Basilica of St. Paul* and, in 1512, the St. Catherine Altarpiece (Augsburg, Städtische Kunstsammlungen). We know from sketches and documentary evidence that the number of commissions actually executed by him must have been far greater. In order to deal with all the commissions a big workshop organization must have been needed. Holbein's brother Sigmund and Leonard Beck, an artist with a reputation of his own, were called in as assistants. Then suddenly there came a pause in production, perhaps caused by economic difficulties. Very few masterpieces have come down to us from the second decade of the sixteenth century and the years up to Holbein's death in 1524—some portraits, and the St. Sebastian Altarpiece of 1516 (Munich, Alte Pinakothek). His last great work, the *Fountain of Life* (Lisbon), was not painted in Augsburg. He had left that town in 1517 and ended his days at Isenheim where, in the Antonine Church, Grünewald's mighty altarpiece then stood.

The conception that we form of Holbein's activities as an artist is enhanced by the extensive number of his drawings, which may be divided into two main groups: drawings in pen and wash which were closely connected with the paintings, and sketch-books drawn in silverpoint technique filled chiefly with portraits of his contemporaries. This surviving material is distributed today principally among the museums of Basle, Berlin, Copenhagen and Bamberg; a single sketch-book is preserved quite intact in the Printroom (Kupferstichkabinett) at Basle. . . .

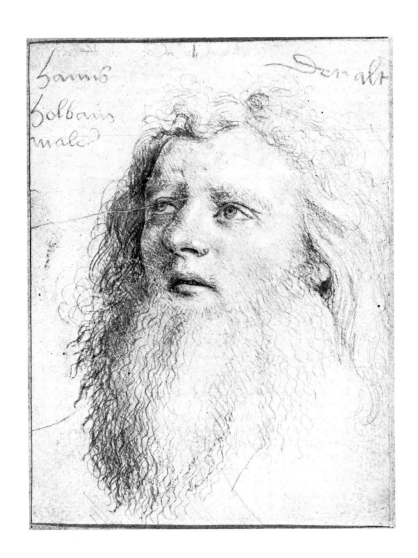

Anyone who studies the elder Holbein's altarpieces attentively will note that individual portraits are painted as well as types: that among the Bible figures there are contemporaries of the artist. These portraits are a link with his sketch-books which revealed so much of his personality. In these small volumes, drawn in silverpoint on grey prepared paper, he has left us a vast collection of portraits of the men with whom he came into contact in Augsburg and on his travels. We possess no comparable picture chronicle from the hand of any other German artist. Holbein characterises without reserve the rich merchant, the clever monk, the prosperous citizen's wife, the Emperor Maximilian I and his trusted servant and "merry counsellor" Kunz von der Rosen, his friends and, finally, his brother, his children, and even himself.

Holbein's style of portrait painting derives from the great Dutch artists of the school of Van Eyck. It is unpretentious, without ornamental linear flourishes and untouched by the far-reaching influence of Dürer. Holbein starts with the contour, and shadows are evolved by means of thicker or more open parallel strokes. Cross-hatching occurs less often. He was fond of reworking his silverpoint portraits with red chalk on the cheeks and mouths, and of emphasising fine shading by drawing with the pen or with the pointed brush, adding highlights in white.

Holbein used the portraits from his sketch-books for the first time in the panels of the Frankfurt Dominican Altar; the latest known studies of this sort belong to the St. Sebastian Altar of 1516. Apart from the many heads, the sketch-books contain a number of other interesting documents—workshop accounts, undeciphered notes, studies of the nude and of hands for the pictures, armorial shields, animals and utensils; also drawings of Roman remains, a Renaissance medal and drawings of classical capitals and ornaments.

From the introduction to *Drawings by the Holbein Family*, selected and with an introduction by Edmund Schilling; translated by Eveline Winkworth, The Macmillan Co., New York, 1955.

[1]This silverpoint self-portrait at Chantilly is a study for Holbein's painted self-portrait which appears in his St. Sebastian Altar of 1516, now in the Alte Pinakothek, Munich. He is to be seen on the outer right wing of the altarpiece behind the beggar and the leper, looking up at St. Elizabeth of Hungary.

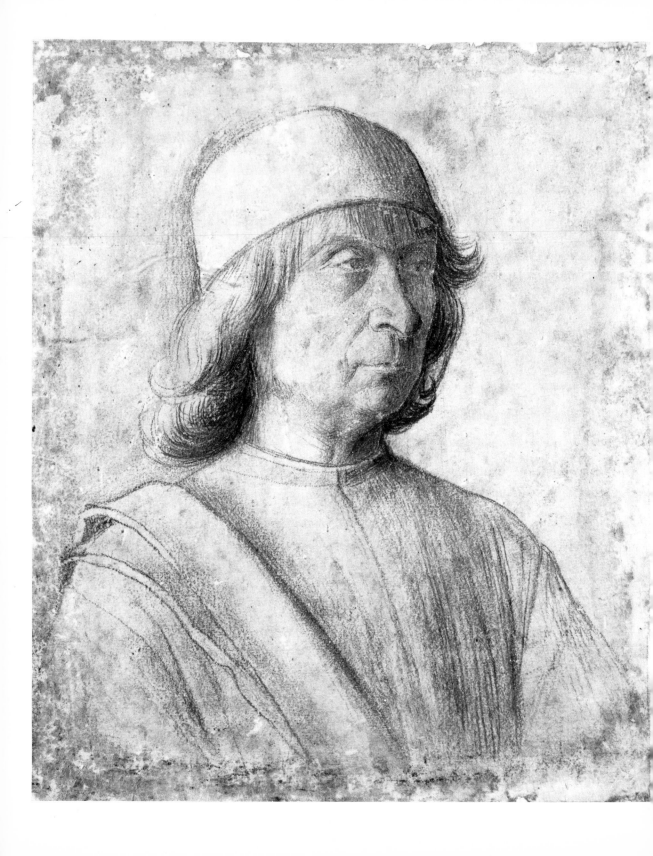

Gentile Bellini

b. *c.* 1429. Venice.
d. 23 February, 1507. Venice.

Plate 51. Self-Portrait, undated.[1]
Drawing in black chalk on prepared paper, yellow with age, 23 × 19.5 cms.
Kupferstichkabinett, Staatliche Museen Preussischer Kulturbesitz, Berlin-Dahlem.

In 1479 a peace treaty was signed between the Venetian government and Sultan Mohammed II, "the Conqueror". Among the celebrations of friendship came a request to the Grand Council of Venice, from the Sultan, for an accomplished portrait painter to be sent to him. The Grand Council proposed Gentile Bellini, who set sail for Constantinople on September 3rd, in the same year. The historian Gio Maria Angiolello made his acquaintance at the Sultan's court, and his writings[2] and those of Vasari provided the evidence for later biographers.

It was at the court of Mohammed that he came to meet Gentile Bellini about whom he has left us only a few lines, but these are priceless with regard to the understanding of the artist's character, of which frankness, independence of spirit, dignity, and selflessness were the outstanding traits. Gentile, in his fifty-third[3] year at the time, was in the fulness of manhood and at the height of his powers.

On arrival at Constantinople, Gentile was presented by the bayle of the Venetian court to Sultan Mohammed who welcomed him warmly, and during the length of his stay gave him marks of the particular esteem in which he held him. The Sultan, whether out of curiosity, or whether in order to flatter the patriotic sentiments of Bellini, requested him to paint his native city. He then requested him to paint his portrait, and the likeness was so striking that it was extraordinary. Bellini also did portraits for the Sultan of the principal personages of his court. He painted also numerous amatory subjects in the private apartments of His Highness who had need of this erotica to stimulate his wearying and enfeebled senses.

As if to test how faithfully the artist reproduced the characteristics of his sitters, Sultan Mohammed sent him sometimes men who had been recommended to him for their excellent beauty: the Sultan looked first at the portrait, then sent for the models to come before him in order to compare the originals with the paintings.

One day he called Gentile and told him; "A Holy-man is being sent to you; paint his portrait." Gentile obeyed, and as soon as the work was finished he took it to the Sultan. The Sultan had learned that in Bezestein (a district of Constantinople) this derviche, mounted on a bench, had been singing of the great exploits of the emperor: he had ordered him to stop; then he had had the idea to have him painted by Gentile Bellini. The artist presented the portrait to the Sultan who considered it attentively; then, "Gentile" he said, "you know I have always said that you may speak with me provided you always speak the truth—tell me, what do you think of this man?" "Seigneur," replied Gentile, "since you ask me to speak freely, I must tell you that to my thinking this man is a madman."

"You speak rightly," replied Sultan Mohammed, "look at his staring eyes, which denote madness."

"Seigneur," said Gentile, "in my country also there are men who like this derviche stand on some bench and proclaim the greatness of this person or that; furthermore I am surprised that your Highness—who is so sublime, whose exploits have surpassed those of Alexander—does not wish to be praised."

"If this man were sound in spirit, I would consent to be praised by him, but I do not at all want the praises of a fool." And the shrewd Venetian rejoined: "Let Your Lordship consent to make him chief of the derviches"; and the Sultan acceded to Gentile's request.

Another time (this is Vasari who reports), the Sultan demanded of Bellini whether he could paint his own portrait. The latter replied that it was simple, and getting to work in front of a mirror, he took, several days later, his portrait to the Sultan. Marvelling at the perfect likeness the Sultan said that to produce something so prodigious, there "must be some magic somewhere".

Honoured by the Sultan's friendship, the object of the favours and attentions of the top dignitaries of the court, Gentile divided his time between the works executed at the harem, and his studies of Byzantine art of which there were such remarkable examples to hand.

But political events cut short his stay, and hastened his return to Venice. Irritated by the repulse of his troops, Sultan Mohammed resolved to renew in person the siege of Rhodes; and to that end, he rounded up more than three hundred thousand men, and had founded in his arsenals cannon of enormous size with which to breach the city walls. It was then that, understandably, he thought to return Gentile Bellini to his own country. To this effect he sent for him towards the end of November, and told him that he authorised him to return to Venice. With flattering praise for his zeal and for his talent, the Sultan promised him any favour he desired. Gentile, as ungrasping as he was modest, thanked the Sultan and asked to be given a letter of recommendation to the Senate and the Illustrious Seigneurie of Venice. Sultan Mohammed acquiesced, and sent him on his way with rich presents; he bestowed on him the title of *bey*, and of *comte palatin*, and put round his neck a gold chain, embossed in Turkish fashion and weighing 250 gold crowns, which was still to be seen in Venice in the possession of his descendants at the time of Vasari.

Gentile Bellini was at this moment engaged on the finishing touches to the magnificent portrait of the Sultan, now in the Layard collection.[4] On right and left of the frame are to be seen the crowns of the three empires of Constantinople, Iconium, and of Trebizonde, and in the tablets at each side, the inscription of Bellini with the date 25 November, 1480. Without doubt it must only have been a few days before his departure, after his farewell audience with the Sultan, that Bellini signed his last work, certainly the most interesting of those accomplished in Constantinople.

To return to Gentile Bellini, after having taken leave of the Sultan as described, he left Constantinople in the last days of the year 1480; and after a pleasant voyage he disembarked at Venice where he received from his brother, and "almost the whole town" which was waiting for the galley, a most warm welcome. Called

before the Doge and the Council to render account of his mission, Gentile Bellini was complimented on the manner in which he had fulfilled it; and the Seigneurie, in response to the Sultan's favourable letter, assigned to him a pension of two hundred gold crowns to be payable during his lifetime.

From *Notes sur le séjour du Peintre à Constantinople*, by L. Thuasne, Paris, 1888.

[1] The drawing, pricked for transfer, is a study used for the small self-portrait in Bellini's *Procession before St. Mark's*, part of the decoration of the Grand Council Chamber, dated 1496. It is now in the Venice Academy.
[2] *Historia Turchesca di Gio Maria Angiolello schiavo et altri schiavi dall'anno 1429 sin al 1513.* Edited Dr. I. Ursu, Bucharest, 1909.
[3] Bellini was not in his 53rd year. He was 50 or 51 during his stay in Constantinople.
[4] The National Gallery, London.

William Blake

b. 28 November, 1757. 28 Broad Street, Golden Square, Soho, London, England.
d. 12 August, 1827. 3 Fountain Court, Strand, London, England.

Plate 52. Self-portrait, undated, from a page in his note-book—the "Rossetti Ms". Pencil, page size 19.6 × 15.7 cms. The British Museum, London.

Letter from William Blake addressed to "Mr. Butts,[1] Gr Marlborough St. London".

Felpham August 16. 1803

Dear Sir,

I send 7 Drawings, which I hope will please you. this I believe about balances our account—Our return to London draws on apace our Expectation of meeting again with you is one of our greatest pleasures. Pray tell me how your Eyes do. I never sit down to work but I think of you & feel anxious for the sight of that friend whose Eyes have done me so much good—I omitted (very unaccountably) to copy out in my last Letter that passage in my rough sketch which related to your kindness in offering to Exhibit my 2 last Pictures in the Gallery in Berners Street it was in these Words. "I sincerely thank you for your kind offer of Exhibiting my 2 Pictures, the trouble you take on my account I trust will be recompensed to you by him who seeth in secret: if you should find it convenient to do so it will be gratefully remember'd by me among the other numerous kindnesses I have reciev'd from you"—

I go on with the remaining Subjects which you gave me commission to Execute for you, but shall not be able to send any more before my return tho perhaps I may bring some with me finish'd. I am at Present in a Bustle to defend myself against a very unwarrantable warrant from a Justice of Peace in

23 May 1810 found in the Word Gotten

A Man sets himself down with Colours & with all the Article
of Painting he puts a Model before him & he Copies that so neat
as to make a Deception now Let any Man of sense ask himself
one Question Is this Art can it be worthy of admiration to any
body of Understanding Who would not do this what man who has eyes
and an ordinary share of reason cannot do this neatly. Is this Art
Or is it glorious to a Nation to produce such wretched Copies
Englishmen Consider this do not suffer yourselves to be Persuaded

No Man of Sense can think that an Imitation of the Objects
of Nature is The Art of Painting or that such Imitation which
any one may easily perform is worthy of Notice much less
that such an Art should be the Glory & Pride of a
Nation & ~~that is~~ The Italians
laugh at English Connoisseurs who are most of them ~~all~~ such silly
Fellows as to believe this

Chichester, which was taken out against me by a Private in Capt[n] Leathes's troop of 1st or Royal Dragoons, for an assault & Seditious words. The wretched Man has terribly Perjur'd himself as has his Comrade for as to Sedition not one Word relating to the King or Goverment was spoken by either him or me. His Enmity arises from my having turned him out of my Garden into which he was invited as an assistant by a Gardener at work therein, without my knowledge that he was so invited. I desired him as politely as was possible to go out of the Garden, he made me an Impertinent answer I insisted on his leaving the Garden he refused I still persisted in desiring his departure he then threaten'd to knock out my Eyes with many abominable imprecations & with some contempt for my Person it affronted my foolish Pride. I therefore took him by the Elbows & pushed him before me till I had got him out. There I intended to have left him, but he turning about put himself into a Posture of Defiance threatening & swearing at me. I perhaps foolishly & perhaps not, stepped out at the Gate, & putting aside his blows took him again by the Elbows & keeping his back to me pushed him forward, down the road about fifty yards—he all the while endeavouring to turn round & strike me & raging & cursing which drew out several neighbours. at length when I had got him to where he was Quarter'd, which was very quickly done, we were met at the Gate by the Master of the house, The Fox Inn (who is the proprietor of my Cottage), & his wife & Daughter & the Man's Comrade & several other people. My landlord compell'd the Soldiers to go in doors, after many abusive threats against me & my wife from the two Soldiers; but not one word of threat on account of Sedition was utter'd at that time. This method of Revenge was Plann'd between them after they had got together into the Stable. This is the whole outline. . . .

I have been before a Bench of Justices at Chichester this morning. but they as the Lawyer who wrote down the Accusation told me in private are compell'd by the Military to suffer a prosecution to be enter'd into altho' they must know & it is manifest that the whole is a Fabricated Perjury. I have been forced to find Bail. Mr Hayley[2] was kind enough to come forwards and Mr Seagrave Printer at Chichester. Mr H. in 100£ & Mr S in 50£; & myself am bound in 100£ for my appearance at the Quarter Sessions which is after Michaelmass.[3] So I shall have the Satisfaction to see my friends in Town before this Contemptible business comes on. I say Contemptible for it must be manifest to every one that the whole accusation is a wilful Perjury. Thus you see my dear Friend that I cannot leave this place without some adventure. it has struck a consternation thro' all the villages round. Every Man is now afraid of speaking to or looking at a Soldier; for the peaceable Villagers have always been forward in expressing their kindness for us & they express their sorrow at our departure as soon as they hear of it. Every one here is my Evidence for Peace & Good Neighbourhood, & yet such is the present state of things this foolish accusation must be tried in Public. Well I am content, I murmur not & doubt not that I shall recieve Justice & am only sorry for the trouble & expense. I have heard that my Accuser is a disgraced Sergeant his name is John Scholfield. perhaps it will be in your power to learn something about the Man.[4] I am very ignorant of what I am requesting

of you. I only suggest what I know you will be kind enough to Excuse if you can learn nothing about him & what I as well know if it is possible you will be kind enough to do in this matter.

Dear Sir This perhaps was suffer'd to Clear up some doubts & to give opportunity to those whom I doubted to clear themselves of all imputation. If a Man offends me ignorantly & not designedly surely I ought to consider him with favour and affection. Perhaps the simplicity of myself is the origin of all offences committed against me. If I have found this I shall have learned a most valuable thing well worth three years perseverence. I have found it! It is certain! that a too passive manner, inconsistent with my active physiognomy had done me much mischief I must now express to you my conviction that all is come from the spiritual World for Good & not for Evil.

Give me your advice in my perilous adventure. burn what I have peevishly written about any friend.[5] I have been very much degraded & injuriously treated. but if it all arise from my own fault I ought to blame myself.

> O why was I born with a different face
> Why was I not born like the rest of my race
> When I look, each one starts! when I speak, I offend
> Then I'm silent & passive & lose every Friend
>
> Then my verse I dishonour, My pictures despise,
> My person degrade & my temper chastise;
> And pen is my terror, the pencil my shame
> All my Talents I bury, and dead is my Fame.
>
> I am either too low or too highly priz'd;
> When Elate I am Envy'd, when Meek I'm despis'd.

This is but too just a Picture of my Present state. I pray God to keep you & all men from it, & to deliver me in his own good time. Pray write to me & tell me how you & your family enjoy health. My much terrified Wife joins me in love to you & Mrs Butts & all your family. I again take the liberty to beg of you to cause the Enclos'd Letter to be deliver'd to my Brother & remain Sincerely & Affectionately

Yours William Blake.

The letter is preserved in the Preston Blake Library, Westminster Central Reference Library, London.

[1] Thomas Butts was a patron of Blake and the two families had become good friends.
[2] The poet William Hayley lived at Felpham. He had given Blake big commissions and, for convenience, Blake and his wife had moved to Felpham three years previously.
[3] Blake went back to stand trial for high treason at Chichester Quarter Sessions on 11 January 1804.
[4] Butts worked at the War Office. So Blake thought he might get help from him.
[5] The personal relationship between Hayley and Blake had become strained; but with Blake's present difficulty there seems to have been forgiveness on both sides.

Matthias Grünewald

b. 1470(?) Würzburg, W. Germany.
d. August 1528, Halle, E. Germany.

Plate 53. Self-portrait,[1] erroneously dated, and retouched by a later hand, *c.* 1514–15. Fine chalk overworked in pen, on sepia/grey wash, 20.8 × 15.0 cms. Graphische Sammlung der Universität Erlangen.

Life of Matthias Grünewald
by Joachim von Sandrart

Matthaeus Grünewald, also know as Matthaeus of Aschaffenburg, is second to none among the greatest of the old German masters in the arts of drawing and painting: on the contrary, he must be regarded as an equal, if not superior, to the very best of them. It is regrettable that the works of this outstanding man have fallen into oblivion to such a degree that I do not know of a single living person who could offer any information whatsoever, be it written or oral, about the activities of the master. I shall, therefore, compile with special care everything that I know about him, in order that his worth may be brought to light. Otherwise, I believe his memory might be lost completely a few years hence.

Already fifty years have passed since the time when there was in Frankfurt a very old but skilful painter by the name of Philipp Uffenbach who had once been an apprentice to the famous German painter Grimer. This Grimer was a pupil of Matthaeus of Aschaffenburg and had carefully collected everything by him that he could lay his hands on. In particular he had received from his master's widow all manner of wonderful drawings, most of them done in black chalk and in part almost life-size. After the death of Grimer, all of these were acquired by Philipp Uffenbach, who was a famous and thoughtful man. At that time I went to school at Frankfurt not far from Uffenbach's house, and often did him small service; whereupon, if he was in a good mood, he would show me these beautiful drawings of Matthaeus of Aschaffenburg, which had been assembled into a book. He himself was an ardent follower of this master's manner, and would expound to me the particular merits of those designs. After the death of Uffenbach, his widow sold the entire volume for a good deal of money to the famous amateur, Herr Abraham Schelkens of Frankfurt, who placed it in his renowned collection so that the genius of its author might be remembered for all time to come. There the drawings repose among many other magnificent works of art, such as the best of ancient and modern paintings, rare books, and engravings, which it would take too long to enumerate in detail. I would like to refer the reader to this collection, where every art lover may inspect and enjoy the drawings.

This excellent artist lived in the time of Albrecht Dürer, around the year 1505, a fact that can be inferred from the altar of the *Assumption of the Virgin* in the monastery of the Predicants (Dominicans) at Frankfurt. The altar itself is the work of Albrecht Dürer, but the four outer wings, painted in *grisaille*, were done by

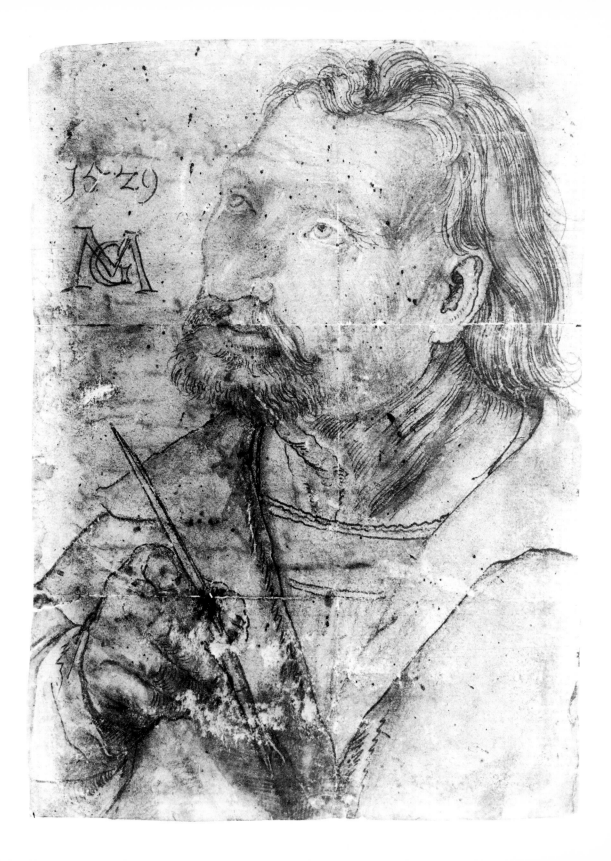

Matthaeus of Aschaffenburg. On them are shown St. Lawrence with the grill, St. Elizabeth, St. Stephen, and another subject that escapes me. They can still be seen in their original place at Frankfurt, and are painted with the greatest delicacy. Especially praiseworthy, however, is the *Transfiguration of Christ on Mount Tabor*, painted in water colors; this scene contains an exquisitely beautiful cloud in which appear Moses and Elijah, as well as the disciples kneeling on the ground. The design, the coloring, and every detail of the panel are so excellently handled that there is nothing to equal it anywhere, in fact, its manner and character are entirely beyond compare, so that the picture is a never-ending source of enchantment.

The same distinguished author produced further three altar panels, each having two wings painted on either side, which used to stand in three separate chapels on the left-hand side of the choir of Mayence Cathedral. The first of these showed the Madonna with the Christ Child on a cloud, attended by a large number of saints standing on the ground, including St. Katherine, St. Barbara, St. Cecilia, St. Elizabeth, St. Apollonia, and St. Ursula, all of them drawn so nobly, naturally, charmingly, and correctly, and so beautifully colored, that they appeared to be in heaven rather than on earth. The second panel showed a blind hermit walking across the frozen Rhine river with the aid of a boy; he is being killed by two assassins and has fallen on top of the screaming child. This picture was so rich in expression and detail that it seemed to contain a greater wealth of true observations and ideas than its area could hold. The third panel was slightly less perfect than the other two. All three of them were taken away in 1631 or 1632 during the ferocious war that was raging at the time, and dispatched to Sweden by boat, but unfortunately they were lost in a shipwreck, along with many other works of art. . . .

This, then, is everything that I have been able to find out about the works of this excellent German master, apart from the fact that he stayed mostly at Mayence, that he led a secluded and melancholy existence, and that his marriage was far from happy. I do not know where or when he died, but I believe it was around 1510.

From *The Academy of the Arts of Architecture, Sculpture, and Painting* by Joachim von Sandrart, 1675–79.[1]

[1]Joachim von Sandrart (1606–88): painter and art historian, was Grünewald's first biographer. Although there are omissions and mistakes, this work has formed the basis for subsequent research. This drawing must have been known to Sandrart as a self-portrait, as he copied it for use as an engraving in his *Academy of the Arts of Architecture, Sculpture, and Painting* Nuremberg, 1675, to illustrate the life of Grünewald. But he did not know that Grünewald had used it as a study for St. Paul the Hermit, shown with St. Anthony in a panel of the famous Isenheim Altar, now in the Musée d'Unterlinden in Colmar. This work must have been unknown to Sandrart. The text above is taken from *A Life of Matthias Grünewald*, in *Literary Sources of Art History* by Elizabeth Gilmore Holt © 1947 (© 1975) by Princeton University Press, pp. 312–15.

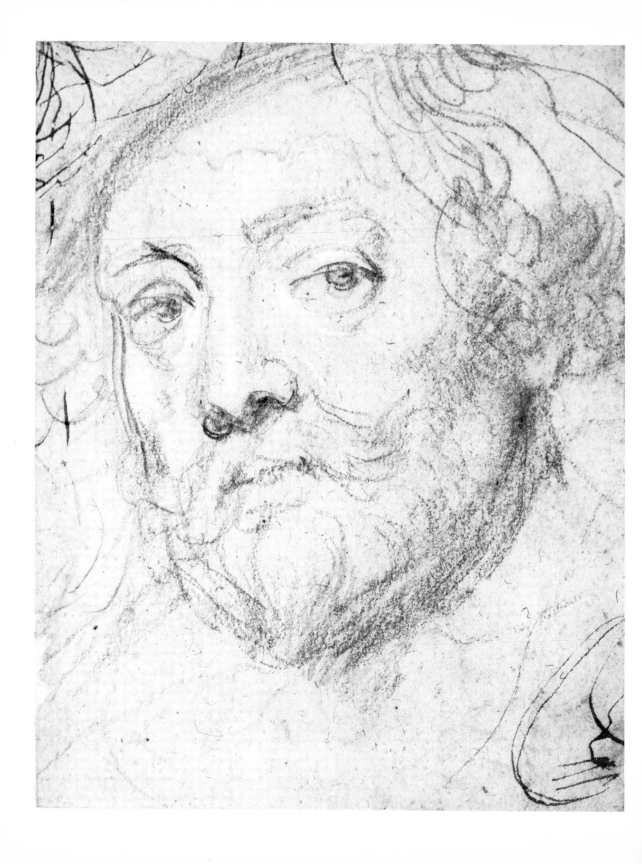

Peter Paul Rubens

b. 28 June, 1577. Siegen, Westphalia.
d. 30 May, 1640. Antwerp.

Plate 54. Self-portrait,[1] undated; age *c.* 53.
Black chalk, 20.3 × 15.9 cms. Royal Library, Windsor.

Letter from Rubens to Monsieur N. C. Fabri de Peiresc.[2]

Antwerp, December 18, 1634

Monsieur:

Your most welcome letter of the 24th. of last month, delivered to me by my
brother-in-law, M. Picquery, was a favor so unexpected that I first felt
astonishment mingled with incredible joy, and then an extreme desire to read it.
I see that you continue with more ardor than ever your investigation into the
mysteries of Roman Antiquity. Your excuses for your silence are superfluous; I
had already imagined that the essential reason for it was the unfortunate haven
given to certain foreigners who had retired to this country.[3] To tell the truth,
when I consider the dangers to which the suspicions and the malice of this
century expose us, and the important part which I had in this affair, I do not feel
that you could have done otherwise. Now, for three years, by divine grace, I
have found peace of mind, having renounced every sort of employment outside
of my beloved profession. *Experti sumus invicem fortuna et ego.*[4] To Fortune I owe
great obligation, for I can say without conceit that my missions and journeys
in Spain and England succeeded most favorably. I carried out negotiations of the
gravest importance, to the complete satisfaction of those who sent me and also
of the other parties. And in order that you may know all, they then entrusted to
me, and to me alone, all the secret affairs of France regarding the flight of the
Queen Mother and the Duke of Orléans from the kingdom of France, as well as
the permission granted them to seek asylum with us. Thus I could provide an
historian with much material, and the pure truth of the case, very different from
that which is generally believed.

When I found myself in that labyrinth, beset night and day by a succession of
urgent duties; away from my home for nine months, and obliged to be present
continually at Court; having reached the height of favor with the Most Serene
Infanta (may she rest in glory) and with the first ministers of the King; and
having given every satisfaction to the parties abroad, I made the decision to force
myself to cut this golden knot of ambition, in order to recover my liberty.
Realizing that a retirement of this sort must be made while one is rising and not
falling; that one must leave Fortune while she is still favorable, and not wait
until she has turned her back, I seized the occasion of a short, secret journey to
throw myself at Her Highness' feet and beg, as the sole reward for so many

efforts, exemption from such assignments and permission to serve her in my own home. This favor I obtained with more difficulty than any other she ever granted me. In fact, there were still a few secret negotiations and state matters reserved for me, but these I was able to carry out with little inconvenience. Since that time I have no longer taken any part in the affairs of France, and I have never regretted this decision. Now, by God's grace, as you have learned from M. Picquery, I am leading a quiet life with my wife and children, and have no pretension in the world other than to live in peace.

I made up my mind to marry again, since I was not yet inclined to live the abstinent life of the celibate, thinking that, if we must give the first place to continence, *fruimur licita voluptate cum gratiarum actione.*[5] I have taken a young wife of honest but middle-class family,[6] although everyone tried to persuade me to make a Court marriage. But I feared *commune illud nobilitatis malum superbiam praesertim in illo sexu,*[7] and that is why I chose one who would not blush to see me take my brushes in hand. And to tell the truth, it would have been hard for me to exchange the priceless treasure of liberty for the embraces of an old woman.

That is the story of my life since the interruption of our correspondence. I see that you have been informed by M. Picquery about the children of my present marriage, and therefore I shall only tell you that my Albert is now in Venice. He will devote all this year to a tour of Italy, and on his return, please God, will go to pay his respects to you.[8] But we shall discuss this more in detail when the time comes. Today I am so overburdened with the preparations for the triumphal entry of the Cardinal Infante (which takes place at the end of this month), that I have time neither to live nor to write. I am therefore cheating my art by stealing a few evening hours to write this most inadequate and negligent reply to the courteous and elegant letter of yours. . . . All these occupations force me to ask you for a truce, for it is really impossible for me, in these circumstances, to make the necessary effort to satisfy my obligation to you and to answer the questions in your letter. . . .

I cannot, however, help refreshing your memory on the subject of certain special and very ingenious methods of weighing which, as I think I once told you I observed in Spain on my first journey to that Court, thirty years ago. . . .

With this I shall put an end to bothering you and fatiguing myself in this limited time at my disposal. And kissing your hands a million times, I remain ever, with all my heart.

Your most humble and affectionate servant

Peter Paul Rubens

Just as I thought I had finished, it came to my mind that . . . [*Rubens here begins the first of two very long post-scripts to what is already an extremely long letter, only a portion of which could be reprinted here.*]

From *The Letters of Peter Paul Rubens*, translated and edited by Ruth Saunders Magurn, Harvard University Press, and Oxford University Press, 1955.

[1]This self-portrait could have been drawn at the time of his painting, *c.* 1631 (Älte Pinakothek, Munich), of himself and Helena in their garden in Antwerp.
[2]Original in the Bibliothèque Nationale, Paris. Written in Italian. No address. Rubens dates this letter 1635, but this is incorrect. On the back, in Peiresc's hand: "18 dec. 1634. Ancient spoon or porringer. Most exact method of weighing."
[3]Rubens refers to Marie de' Medici and Gaston, Duke of Orléans.
[4]Fortune and I have come to know each other (Tacitus, *Historiae* 2.47).
[5]We may enjoy licit pleasures with thankfulness.
[6]Rubens' second wife, whom he married on December 6, 1630, was the sixteen-year-old Helena Fourment, youngest daughter of Daniel Fourment, a silk merchant of Antwerp.
[7]Pride, that inherent vice of the nobility, particularly in that sex (cf. Sallust, *Jugurtha*, 68).
[8]This is Rubens' only reference to his son's visit to Italy. Albert did not visit Peiresc, and Peiresc's letter of Frebruary 26, 1635, to Jacques Dupuy expresses a certain resentment at this lack of courtesy, but excuses it because of Albert's youth.

John Ruskin

b. 8 February, 1819. 54 Hunter Street, Brunswick Square, London, England.
d. 20 January, 1900. Brantwood, Coniston, Lancashire, England.

Plate 55. Self-portrait, *c.* 1873; age 53 or 54.
Pencil, 24.8 × 20 cms. The Brantwood Trust, Coniston.

Letter from John Ruskin to Miss Susie Beever.[1]

<div align="right">

Hotel Meurice Paris
4th Sept '80

</div>

Darling Susie

It is such pain to you when people say what they ought not to say about *me*?— But when do they say what they ought to say about anything? Nearly everything I have ever done, or said, is as much above the present level of public understanding as the Old Man is above the Waterhead.[2]

We have had the most marvellous weather thus far—and have seen Paris better than ever I've seen it yet; and today at the Louvre, we saw the Cassette de St. Louis, the coffre of Anne of Austria—the porphyry vase made into an eagle, of an old Abbé Segur or some such name. All these you can see also you know in those lovely photographs of Miss Rigbye's—if you can only make out in this vile writing of mine what I mean!

But it is so hot. I can scarcely sit up or hold the pen,—but tumble back into the chair every half minute and unbutton another button of waistcoat, and gasp

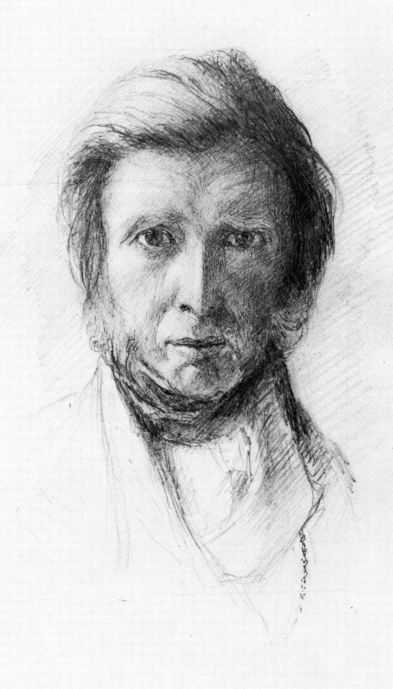

J. Ruskin (se ipsum)
del.

a little, and nod a little, and wink a little,—and sprinkle some Eau de Cologne a little, and try a little to write a little—and forget what I had to say, and where I was, and whether it's Susie or Joan[3] I'm writing to; and then I see some letters I've never opened that came by this morning's post, and think I'd better open them perhaps; and here I find in one of them a delightful account of the quarrel that goes on in this weather between the nicest elephant in the Zoo and his keeper, because he won't come out of his bath! I saw them at it myself, when I was in London, and saw the elephant take up a stone and throw it hard against a door which the keeper was behind; but my friend writes, "I *must* believe from what I saw that the elephant knows he would injure the man with the stones for he threw them hard to the *side* of him, and then stood his ground; when, however, he threw water and wetted the man, he plunged into the bath to avoid the whip; not fearing punishment when he merely showed what he could do, and did not." The throwing the stones hard at the door when the keeper was on the other side of it must have been great fun for him!

I'm so sorry to have crushed the enclosed scrawl, it has been carried about in my pocket, to be finished—and I see there's no room for the least bit of love at the bottom. So here's a leaf full, from the Bois de Boulogne which is very lovely; and we drive about by night or day as if all the sky were only the roof of a sapphire palace, set with *warm* stars.

<div align="right">Ever your loving Cat.</div>

[1]Miss Susie Beever, in her 70s at this time, was the middle sister of three maiden ladies who lived at Thwaite, on the north-west shore of Lake Coniston. Some of the hundreds of letters Ruskin wrote to them were published in 1887 under the title:—*Hortus Inclusus or Messages from the Wood to the Garden*, sent in happy days to the sister ladies of the Thwaite, Coniston, by their thankful friend J. Ruskin. This letter is in the Guild of St. George Collection, Reading University Library.
[2]Coniston Old Man, the highest of the Coniston fells, looks down on the Waterhead which is the north point of the lake.
[3]Joan, or Joanie, was Ruskin's cousin, Mrs. Arthur Severn. She and her family lived with Ruskin at Brantwood and kept house for him.

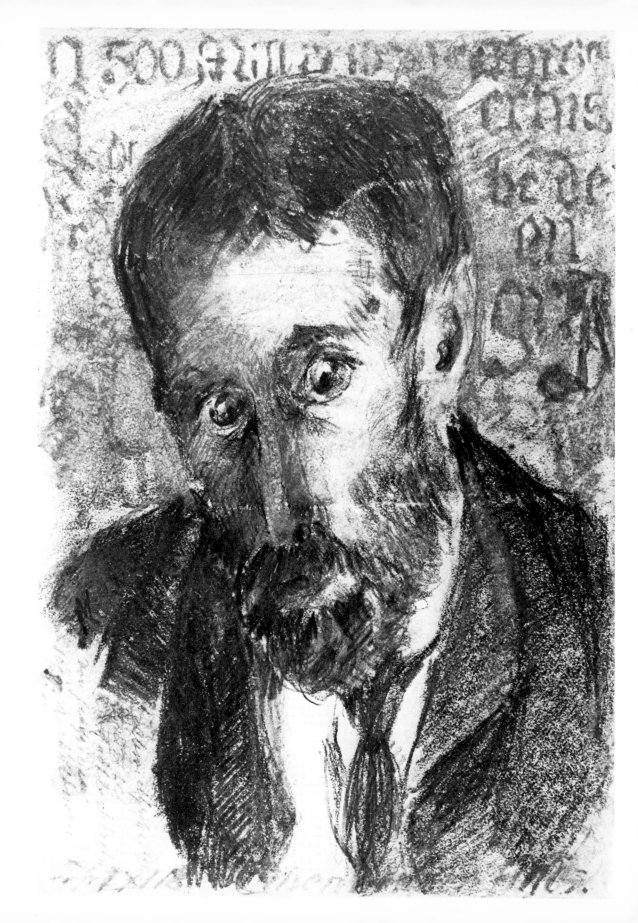

Franz Pohl

b. 1864, Upper Rhine, Germany.
d. 1920? Psychiatric hospital.

Plate 56. Self-portrait, 1918; age 53/54.
Coloured crayon, primarily blue, with dull light brown, 28 × 19 cms. Prinzhorn
Collection, University-klinik, Heidelberg.

Case 244. Schizophrenic. Part of the case-history[1] of Franz Pohl, locksmith.

. . . During the 22 years of his stay in the asylum Pohl consistently developed along
the direction which he had apparently entered on earlier. His autism did not result
from battles with his environment and with hallucinations; instead he slid ever
more deeply into it. He hardly experienced states of excitement as such. . . .

A conversation with him is of course no longer possible. Even the stimulus of a
visit from the outside, which would produce some little sign of vitality in many
other patients in their terminal stages, no longer works with him. Pohl looked
distrustfully at us with his lively, mousey eyes and cleverly tried to thwart our desire
to view his pictures by constantly finding new reasons to postpone untying the
strings of the newspaper bundle containing his treasures. He would murmur
something about "unready things", turn the bundle from side to side, or run to the
window and signal outside. At the sight of a physician he withdrew to a corner with
a warning call to us and followed the physician's movements from there with a
fascinated expression and magically conjuring gestures accompanied by steady
mumbling. Afterward he checked the door meticulously, listened for a long time in
all directions—and again began to turn the bundle over while shrugging his
shoulders thoughtfully and casting shy glances to the side without ever responding
to the words addressed to him. When he had finally loosened the string and taken out a
sheet he suddenly reached for his head as if in recognition, repacked the bundle
carefully and began to search in his vest pockets while declining to answer all
questions with small gestures of the hands. From the small package wrapped in
newspaper which he finally found, he took a cigarette butt which he looked at
lovingly, sniffed, and lit thoughtfully. Then he walked back and forth with dignified
short steps, always bidding the visitor to be quiet with small motions of the hands
and a clever and sly expression. After he had smoked perhaps a third of the butt he
carefully stubbed it out, painstakingly wrapped it up again, put it into his vest
pocket, and returned to the table with a friendly smile. After a prolonged struggle
with such whims we finally succeeded in seeing a few drawings but we could not
start a conversation. Only when we found a picture beautiful in color and form did
Pohl answer, as painters usually do, "Yes, that's quite good; there should be more red
in it. . . ."

[1] This report is published in *Artistry of the mentally ill*, by Hans Prinzhorn, translated by
E. von Brockdorff, Springer Verlag, Berlin, Heidelberg, New York, 1972.

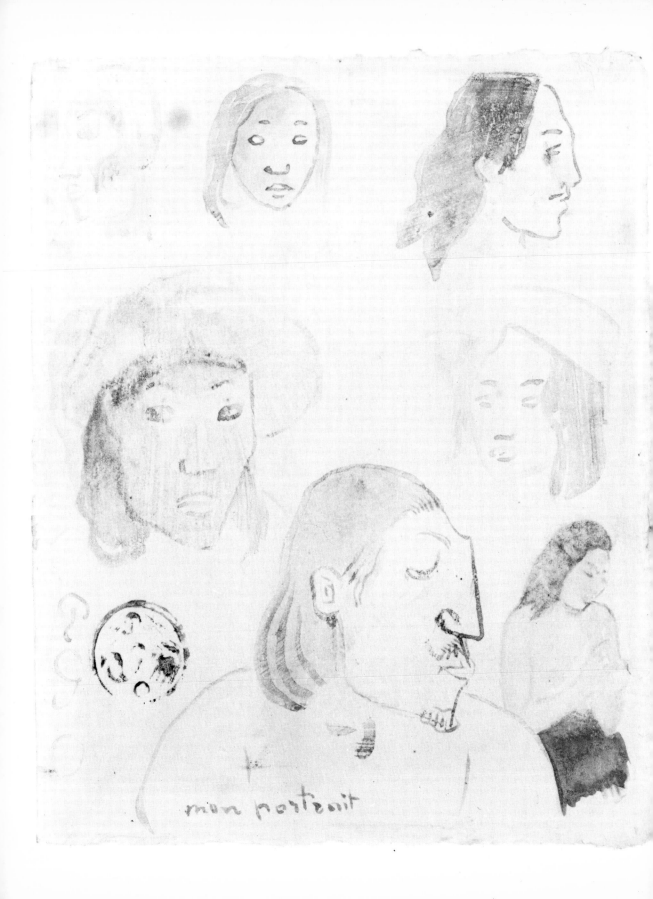

mon portrait

Paul Gauguin

b. 7 June, 1848. Paris, France.
d. 8 May, 1903. Atuana, Marquesas.

Plate 57. Self-portrait, *Mon portrait*, undated.
Coloured wood-cut with touches of water-colour, 24 × 20 cms. The British Museum, London.

Part of the preface by Gauguin's son, Émile, to The Intimate Journals of Paul Gauguin.

. . . For to me, at least, these journals are an illuminating self-portrait of a unique personality. They transfigure and make vivid my recollections of my father, recollections all too dim and few. They bring sharply into focus for me his goodness, his humour, his insurgent spirit, his clarity of vision, his inordinate hatred of hypocrisy and sham.

What others will make of him I do not know, and do not greatly care. All his life my father shocked smugly respectable people, shocked them deliberately and for the same impish reason that impelled him to hang on his wall that obscene picture he tells about in these journals. What is more fitting than that he should continue to shock them after his death?

The other sort of people will not misunderstand. They will not fail to perceive that these journals are the spontaneous expression of the same free, fearless, sensitive spirit that speaks in the canvases of Paul Gauguin.

Émile Gauguin, Philadelphia, May 1921

Extract from The Intimate Journals *dated January/February 1903, Atuana, Marquesas (shortly before Gauguin's death).*

. . . You wish to teach me what is within myself? Learn first what is within you. You have solved the problem, I could not solve it for you. It is the task of all of us to solve it. Toil endlessly. Otherwise, what would life be worth? We are what we have been from the beginning; and we are what we shall be always, ships tossed about by every wind.

Shrewd, far-sighted sailors avoid dangers to which others succumb, partly, however, thanks to an indefinable something that permits one to live under the same circumstances in which another, acting in the same manner, would die. The few use their wills, the rest resign themselves without a struggle.

I believe that life has no meaning unless one lives it with a will, at least to the limit of one's will. Virtue, good, evil are nothing but words, unless one takes them apart in order to build something with them; they do not win their true meaning until one knows how to apply them. To surrender oneself to the hands of one's Creator is to annul oneself and to die.

St. Augustine and Fortunatus the Manichaean, face to face, are each of them right and wrong, for here nothing can be proved. To surrender oneself either to the power of good or to the power of evil is a dangerous and far from creditable business. It is the excuse. . . .

No one is good; no one is evil; everyone is both, in the same way and in different ways. It would be needless to point this out if the unscrupulous were not always saying the opposite. It is so small a thing, the life of a man, and yet there is time to do great things, fragments of the common task.

I wish to love, and I cannot.

I wish not to love, and I cannot.

You drag your double along with you, and yet the two contrive to get on together. I have been good sometimes; I do not congratulate myself because of it. I have been evil often; I do not repent it.

A sceptic, I look at all these saints, but to me they are not alive. In the niches of a cathedral they have meaning, there only. The gargoyles, too, unforgettable monsters. My eye is not terrified by these childish grotesqueries.

The graceful ogive lightens the heaviness of the structure; the wide steps invite the curious passer-by to investigate the interior. The belfry—the cross above—the great transept—the cross within. In his pulpit the priest babbles about Hell; in their seats these ladies talk about the fashions. I like this better.

As you see, everything is serious and ridiculous also. Some weep, others laugh. The feudal castle, the thatched cottage, the cathedral, the brothel.

What is one to do about it?

Nothing.

All this must be; and, after all, it's of no consequence. The earth still turns round; everyone defecates; only Zola bothers about it.

These nymphs, I want to perpetuate them, with their golden skins, their searching animal odour, their tropical savours. They are here what they are everywhere, have always been, will always be. That adorable Mallarmé immortalised them, gay, with their vigilant love of life and the flesh, beside the ivy of Ville-d'Avray that entwines the oaks of Corot.

Pictures and writings are portraits of their authors. The mind must have an eye only for the work. When it looks at the public, the work collapses.

When a man says to me, "You must," I rebel.

When nature (my nature) says the same thing to me, I yield, knowing that I am beaten.

You say, "Spend yourself, spend yourself again!" It is of no value unless you suffer.

With my own understanding, I have tried to build up a superior understanding that will, if he desires it, become that of my neighbour.

The struggle is cruel, but it is not vain. It springs from pride and not from vanity. On an azure ground a seigniorial coronet, a coronet of nettles, and as a device: "Nothing stings me".

It is a small thing but there is pride in it. Laughing, you climb your Calvary;

your legs stagger under the weight of the cross; reaching the top, you grit your teeth—and then, smiling again, you avenge yourself. Spend yourself again! Woman, what have we in common?—The children!!! Those are my disciples, those of the second Renaissance.

Atone for the sins of others when they are swine? Immolate yourself for these? You do not immolate yourself, you invite defeat.

Civilised! You are proud of not eating human flesh? On a raft you would eat it . . . before God, invoking Him even as you trembled.

To make up for it, you eat the heart of your neighbour every day.

Content yourself with saying, therefore, "I have not done it," since you cannot say with certainty. "I will never do it". . . .

From Gauguin's *Avant et Après*, published under the title *The Intimate Journals of Paul Gauguin* by William Heinemann, 1923, and translated into English by Van Wyck Brooks.

Jean Auguste Dominique Ingres

b. 29 August, 1780. Montauban, France.
d. 14 January, 1867. Paris, France.

Plate 58. Self-portrait, Rome, 1835; age 54/55.
Pencil on faded paper. 26.5 × 20.4 cms. Cabinet des Dessins, Musée du Louvre, Paris.

Entries from the 1841 account book of Madame Ingres, née *Madeleine Chapelle, Ingres' first wife.*

July			Wednesday 7		
Cotton-cord, tape	11f	2	bread		2
pins, thread			milk		8
gum	1f		cutlets	1	12
barley sugar		6	simnel		6
to floor cleaner	1f	10	potatoes		6
pair of gloves	1f	9			2 14
to Ingres	10f		Thursday 8		
coach	3		bread		13
subscription "L' Artiste"	15f		milk		8
coach and bridge-toll	1	2	bacon		18
càfé	1	8	sorrel		4
to Ingres	5f		cherries		5
8 metres lining @ 28	11	4			2f 8

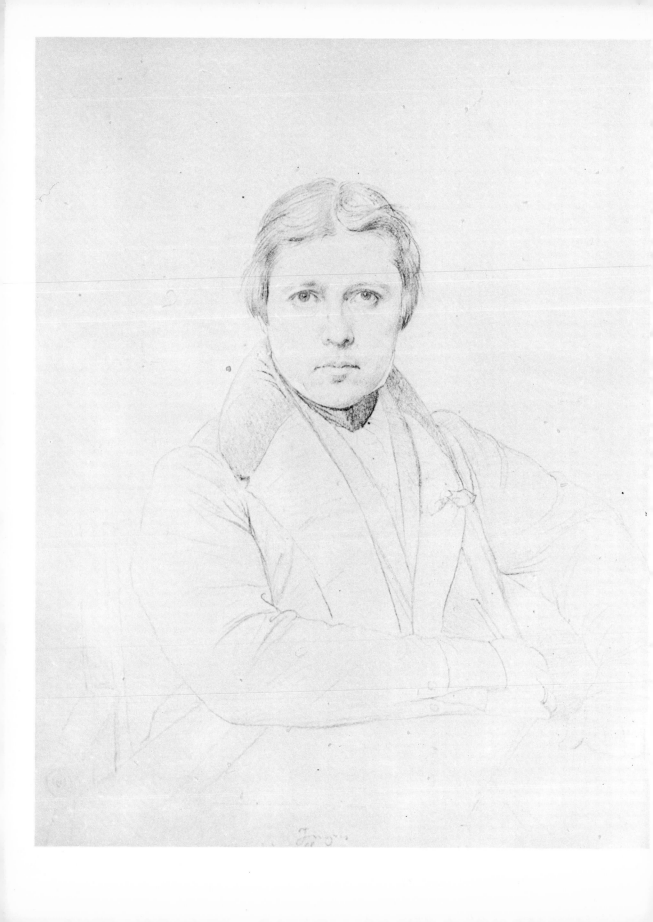

one pair of silk gloves	3	8
2 pairs of mittens	1	10
directory "25 thousand addresses"	5	
journey to Versaille	7f	18
watchmaker for my watch	15f	
laundress	6	16
to Ingres	10f	
coach	3f	
Marguerite's wages	25f	
her laundry	5f	
her wine	3f	12
postage	1	12
shoe repairs		16
postage	1	4
shoe repairs		15
postage		9
coach	1	6
a "Spectacle Français"	3f	10
12 metres all-wool muslin	33f	
2 metres 6 centimetres of black? . . .	16	18
3 pairs cuffs	1	10
trouser lining	1	10
coach	3	5
syrup	1	5
silk-stocking repairs	1	2
pont des Arts (*toll?*)		9
journey to Bellevue	9	10
subscription to baths	6	5
to Ingres	5	
a Gospel	3	
ribbon	3	
toothpicks		4
bridge-toll and omnibus	1	
a pestle	1	10
3 pairs of gloves	4	9
collar (or cravat) for Ingres	6	
to Ingres	5	
tailor for Ingres	401f	
to Ingres	15f	
5 scores of Gluck	40f	
laundress	5f	
coach	3f	
to Ingres	15f	

Friday 9

bread		13
milk		8
beef and liver	1	3
codfish	1	
haricot beans	1	
currants		5
[undecipherable]		8
	4	17

Saturday 10

charcoal	9f	
liquorice		4
a lemon		2
peas and cabbage		16
bread		13
milk		8
sorrel		4
currants		4
butter		12
milk, simnel		8
	12f	11

Sunday 11

bread		2
milk		8
a pâté	1	10
simnel		6
fruit		10
butter	1	6
bacon		6
salt		10
lard	1	
	5	18

Monday 12

macaroni		6
vermicelli		6
rice		7
cheese		8
sugar	2	2
bread		13
milk		8
fish	1	5
vegetables		18
	6	13

Tuesday 13

coach	04	05	bread		2
to Ingres	15f		milk		8
coach	4	05	haricot-beans		10
lace repairs	5		currants		4
the tailoress for Ingres	8	50	blue cheese		7
a cleanser	2		beer		6
postage		8		1	17
bridge-toll		6	**Wednesday 14**		
postage		10	bread		14
hat for Ingres	30f		milk		18
to Ingres	5f		bacon		15
syrup	1f	4	vegetables		14
Works of Flaxman	7f	10	butter		12
to Ingres	15f			3f	13
percaline for a blouse	3	10	**Thursday 15**		
all-wool muslin for Ingres	9	10	bread		13
doorman	5		milk		8
postage	1	13	vegetables	1	2
postage		6	eggs	1	6
shoe-repairs		15	butter		12
laundress		5	blue cheese		7
coach	1	10		4f	8
bridge-toll		5	**Friday 16**		
theatre	3f		bread		15
25 issues of the work The			milk		10
pick of Greek Vases	75f		beef and liver	1	4
to Ingres	5		vegetables		18
Works of Molière	25		chops		15
for a bracelet	16		milk		2
coach	2	10	raspberries		8
postage	1	2	simnel		6
barber	10f		eggs		6
2 pairs of shoes for Ingres	17f			5f	4
omnibus		12	**Saturday 17**		
a cookery book	3f		bread		2
			milk		8
			fish	1	
			mutton		15
			vegetables		9
			currants		4
				2	18

Transcribed and translated from the original, which is in the Musée Ingres, Montauban.

Ernst Barlach

b. 2 January 1870. Wedel, Holstein, Germany.
d. 24 October, 1938. Rostock Hospital, Germany.

Plate 59. Self-portrait, 1928; age 58.
Lithograph, 29.4 × 22.5 cms. (C-V 44.) Kupferstichkabinett, Staatliche
Kunstsammlungen Dresden, DDR.

Two letters from among many written by the sculptor during the years he and many other artists working in Germany endured proscription under Hitler's Third Reich.

Güstrow, 11. 4. 1933

Dear Herr Piper,[1]

I wish you a happy Easter; perhaps you will take flight to the open country, albeit without the book of Nostradamus written in his own hand! I would be heartily glad to receive written proof of your well-being from some point on this earth which is unpolitical and peaceful. This newly ordained world order does not suit me, my little boat is sinking, sinking faster and faster. I can see the moment when I shall drown. I do not trust the way things are going, do not fit in with things, have not dressed myself up in the robes of Nationalism or Aryanism; noise alarms me. Instead of cheering the louder when they all shout "Heil", instead of giving the Fascist salute I simply pull my hat down over my eyes. Have you perhaps heard that they've made an application to have my War Memorial removed from Magdeburg Cathedral? I am afraid of only one thing now, of becoming apathetic and hopeless, ready to pretend.

What this winter is costing me; perhaps if we can manage to meet sometime we can talk about it. I've aged awfully, but, thank God (if He needs my thanks) I'm very perverse and churlish still, and in the end I suppose it is some comfort to know that "one man fills a grave as well as another".

For months I have been writing letters for pennies, but not a soul who owes me money has the slightest intention of paying. I am practically killing myself writing, but they put me off, prevaricate, find excuses; the few prospects of having my work bought or of being commissioned have vanished owing to the new regulations; the big contracts which would have provided work for years to come have become void, but the duties accrued from buildings which I ventured upon on account of these contracts remain. It is true I have been able to let the flat, but these are only trifles, unfortunately. To my own great surprise I have turned into a writer of begging letters. In other words, if, in the course of the coming months, you could let me have part of the 500 marks in question I should now accept them. If you cannot, it doesn't matter; your children who are not provided for come first, I must state that. I can do what you can not; I can, if the roof should burn, grab my stick and vanish as well as possible. This kind of world does not need me; life goes on without me; Klaus would be man enough to think like me. With all that, my façade is still whole, merely undermined and ready to fall apart, a little push would topple it.

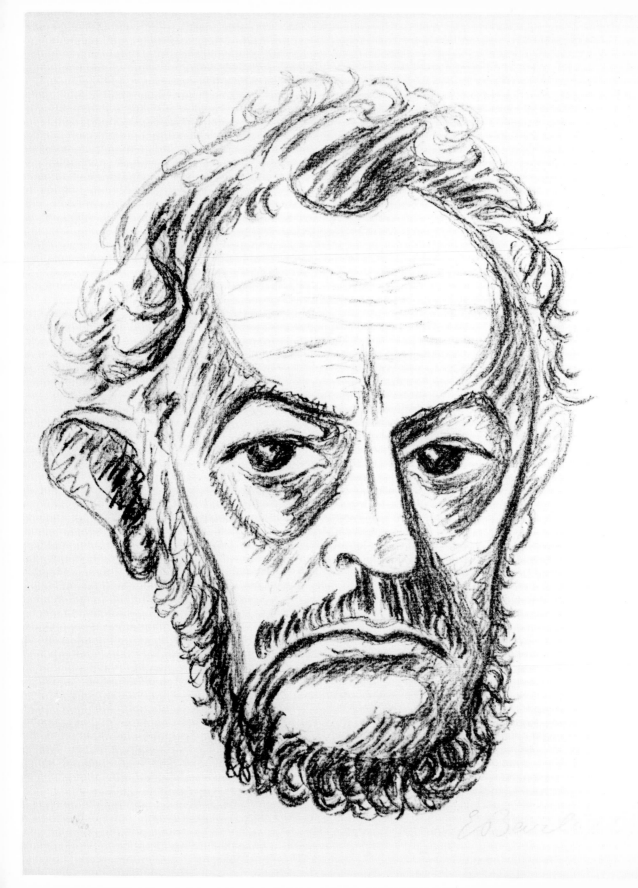

You know that I am looked upon as a Jew making the rounds; I hear it from all sides. I know very well who started it in order to cancel a commission; at least this circle of noble men is known to me, but, ahem, the post-censor!

> My greetings to you and yours, in warm friendship
>
> yours E. Barlach

[to Rudolf Pechel][2] Güstrow, 6.5.1936

Dear Herr Doctor,

Many thanks for your information—if Dr. G.[3] read Fechter's letter[4] in a friendly mood, I should readily expect that it made a deep impression on him; perhaps an answer will come after all, and your people in Munich may not knock in vain; if, indeed if . . . for the affair is getting crazier inasmuch as Piper has been informed by a police official who called on him that the confiscation was not started by the Bavarian political police but by the Ministry of Propaganda in Berlin. The latter allegedly had sent reasons for doing so which, however, though four weeks have passed, have not yet been handed over. The official in question promised or rather expected that they would be given "within the next few days" from the Munich branch. However the reasons were by no means given but their being handed over was made dependent on the proof that I have been officially invited to take part in exhibitions e.g. in Chicago, Venice. Neither Piper nor I have the slightest inkling of the connection. The dates as far as they can be proved are now in Piper's hands.

Concerning it all I do not wish to give or have given an opinion until I can read in black and white what sort of reasons they are and whether they really are from the Ministry of Propaganda in Berlin. If that should be the case (if they really are from the Ministry of Propaganda) I can imagine why Fechter's letter[5] was not answered, and, moreover, that changes have taken place on the spot. Piper had already made a petition to Goebbels and received an answer as follows:

> Berlin etc. 22.4.36

To the publisher etc.

Referring to the petition of 2nd. April 1936
I see no reason for objection to the confiscation
of Ernst Barlach's drawings.

> Heil Hitler!
> Signed by proxy, Walter Funk
> Witnessed, so and so.

There really seems to be no cause.

Therefore, dear Herr Doctor, I thank you once again, with the best Maytime wishes.

> Yours, E. Barlach.

[1]Reinhard Piper (1879–1953) was a publisher. The book, *Ernst Barlach: drawings*, with an introduction by Paul Fechter, which he published in 1935, was confiscated by the Bavarian political police. It was also chosen to represent Barlach in the "Entartete Kunst" exhibition, the exhibition of "degenerate" art which was ordered by Hitler and opened on 19 July, 1937, in Munich.

[2]Rudolf Pechel, b. 1882 in Güstrow; from 1919–42 publisher in Berlin of the *Deutsche Rundschau*, and his courageous resistance against the Third Reich landed him in the concentration camp of Sachsenhausen from 1942–45. Amongst other books he wrote *Deutscher Widerstand* (German Resistance), 1947. He was one of the last to visit Ernst Barlach. He died in 1962 in Lenk, Switzerland.

[3]Dr. Paul Joseph Goebbels (1897–1945) Minister für Volksaufklärung und Propaganda, under Hitler.

[4]Paul Fechter (1880–1958). Writer, journalist and critic; editor of *Deutsche Zukunft*, co-editor of *Deutsche Rundschau*, until both were banned. He championed Barlach's art, including his literary work, both before and after his death.

[5]The letters in their original German are published in *Die Briefe*, edited by F. Dross, R. Piper Verlag, 1969, Vol. II, pages 632 and 806. This translation into English was made by Gertrude Cuthbertson.

Inigo Jones

b. 15 July, 1573. London, England.
d. 21 June, 1652. London, England.

Plate 60. Self-portrait, undated.
Pen and brown ink, 16.0 × 14.0 cms. Total height of both drawings 30.5 cms.
Burlington-Devonshire Collection, RIBA, London.

STONE-HENG RESTORED[1]
by INIGO JONES Esquire

Being naturally inclined in my younger Years to study the *Arts of Design*, I passed into foreign Parts to converse with the great Masters thereof in *Italy*; where I applied my self to search out the Ruins of those ancient *Buildings*, which in Despite of *Time* it self, and Violence of *Barbarians*, are yet remaining. Having satisfied my self in these, and returning to my native *Country*, I applied my Mind more particularly to the Study of *Architecture*. Among the ancient Monuments whereof, found here, I deemed none more worthy the searching after, than this of *Stone-heng*; not only in regard of the *Founders* thereof, the *Time* when built, the *Work* it self, but also for the Rarity of its *Invention*, being different in *Form* from all I had seen before: likewise, of as beautiful *Proportions*, as elegant in *Order*, and as stately in *Aspect*, as any.

King *James*,[2] in his Progress, the Year One thousand six hundred and twenty, being at *Wilton*, and discoursing of this *Antiquity*, I was sent for by the Right Honourable *William* then *Earl of Pembroke*, and received there his Majestys Commands to produce, out of mine own Practice in *Architecture*, and Experience in *Antiquities* Abroad, what possibly I could discover concerning this of *Stone-heng*. What mine Opinion was then, and what I have since collected, in relation thereunto; I intend to make the Subject of this present Treatise. . . .

Several Writers, both Strangers, and our own Countrymen, have treated of *Stone-heng*. Before recite whose Opinions, I think not amiss to seek this Subject from the most ancient Times, endeavouring thereby to give Satisfaction, whether or no the *Druids*, *aliàs Druidæ*, in Authors indifferently written, and in old Time the *Priests* of the *Britains* and *Gauls*, or the ancient *Britains*, for the *Druids* Use, might not be the *Founders* of so notable a Monument; . . .

As far neverthelesse, as from History, ancient or modern, may be gathered, there is little Likelihood of any such Matter, considering especially what the *Druids* were; also, what small Experience the *Britains*, anciently inhabiting this Isle, had, in Knowledge of whatever *Arts*, much less of Building, with like Elegancy and Proportion, such goodly Works as *Stone-heng*.

Concerning the *Druids* in the first Place, true it is, they are reported in ancient Times to have been in great Esteem in this Island, where their Discipline and Manner of Learning was supposed to be first invented, and from hence translated into *Gaul. Disciplina in Britannia reperta* (saith *Cæsar*[3]) *atque inde in Gallium translata esse existimatur.* They are said in like manner to have ordered and disposed all divine Matters, as well in relation to their severall Kinds of Sacrifices, as to expounding whatever Rites of their idolatrous Superstition; insomuch, you may call them (if you please) the Bishops and Clergy of that Age. . . .

. . . Whosoever desires to know more of them, may read *Cæsar, Diodorus Siculus, Strabo, Pliny, Diogenes, Laertius, Ammianus Marcellinus*, and such like ancient Authors. But, whatsoever these, or other Historians have written of the *Druids*, certainly, *Stoneheng* could not be builded by them, in regard, I find no mention, they were at any Time either studious in *Architecture*, (which in this Subject is chiefly to be respected) or skilful in any thing else conducing thereunto. For, *Academies of Design* were unknown unto them: publick Lectures in the *Mathematicks* not read amongst them: nothing of their *Painting*, not one Word of their *Sculpture* is to be found, or scarce of any Science (*Philosophy* and *Astronomy* excepted) proper to inform the Judgment of an *Architect;* . . .

. . . The *Druids* led a solitary contemplative Life, contenting themselves with such Habitations, as either meer Necessity invented, to shelter them from Contrariety of Seasons, without *Art*, without *Order*, without any whatever Means tending to Perpetuity: or, such as *Nature* alone had prepared for them in Dens, and Caves of desert and darksom Woods. . . .

Pomponius Mela, discoursing of the *Druids, Docent multa* (saith he) *nobilissimis gentis clam & diu vicenis annis in specu, aut in abditis saltibus. They teach the Nobility, and better Sort of their Nation, many things, even twenty Years together, secretly in Caves, or close Coverts of obscure Woods and Forests.* Such and no other were their Habitations,

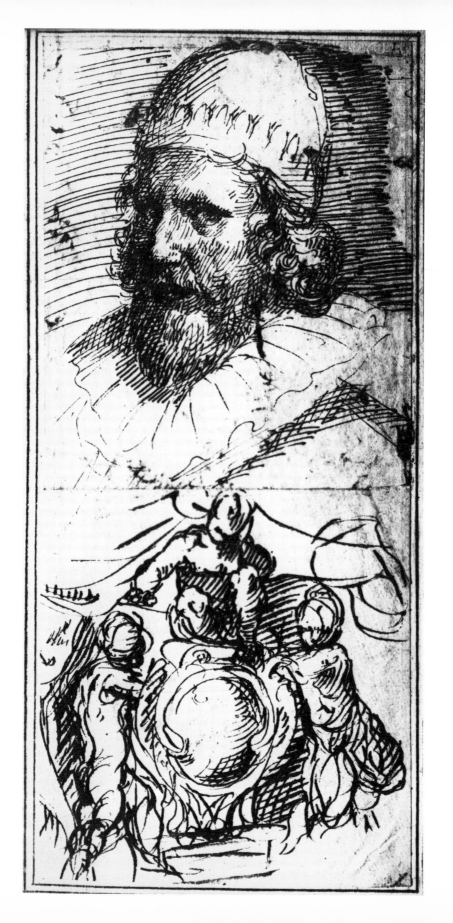

such their Universities, and publick Schools.

As for their *Temples* and sacred Structures, they consisted not in Variety of Forms, Costliness of Materials, or Perfection of human *Arts*, but were of *Nature's* own framing in like Manner, being no other than Groves of Oak. *The* Druids *chose of Purpose (saith* Pliny*) such Groves for their divind Service, as stood only upon Oaks; nay they solemnized no Sacrifice, nor performed any sacred Ceremonies without Branches, and Leaves thereof; from whence they may seem well enough to be named* Dryadæ *in* Greek, *which signifies as much as* Oak Priests. . . .

Concerning the *Britains* in the next Place, The Condition of those ancient Inhabitants of this Island in the *Druids* Time duly considered, (*viz.* in what manner they lived, how unskilful in all Sciences, and civil Customs, what Dieties they had, in what Places they adored them, and what manner of Buildings, or sacred or secular, were used by them) as little Reason appears, that this Antiquity was by them erected.

As for their manner of living, the *Britains* were then a savage and barbarous People, knowing no use at all of Garments. *Vestis usum non cognoscunt* (saith *Herodian.*) Now, if destitute of the Knowledge, even to clothe themselves, much less any Knowledge had they to erect stately Structures, or such remarkable Works as *Stone-heng*. What Fashions they used to adorn their Bodies with, the same Author tells us. *As a rare and rich Habiliment, they wore about their Wasts and Necks Ornaments of Iron* (saith he) *and did pounce and colour their Bodies with sundry Forms, in rude manner representing several Creatures.* . . .

Again, in other their civil Customs, they were no less rude and ignorant; yea, so barbarous, even in things appertaining to common Sustenance, and whatever Husbandry; that (as *Strabo) Quidam eorum ob imperitiam caseos nullos conficiant, cum tamen lacte abundent: alii hortos colendi, & aliarum partium agriculturæ ignari sunt. Many of them, though they had great plenty of milk, yet their want of Skill was such, they knew not how to make Cheese.* . . .

[1]Published posthumously in 1655 by John Webb, a pupil of Inigo Jones.
[2]James I.
[3]Cæsar. Commentaries of the Gaulish war. Lib. 6.

Palma Giovane

b. 1544 Venice.
d. 1628 Venice.

Plate 61. Self-portrait, undated.
Red chalk, 17.6 × 15.7 cms. Ashmolean Museum, Oxford.

The life of Jacopo Palma il Giovane

. . . He did an immense number of drawings of all kinds and in all styles, of the Old and New Testaments, from which he took great inspiration for the work he had to do; and he also drew many such things simply to give vent to his imagination, since no sooner had the tablecloth been removed from the table than he would have his pencil brought, always composing some new theme, and many of these are now in circulation.

But although Palma was accompanied by good fortune and had a large number of friends who continually procured work for him without his having to lift a finger, and although this work was well paid (in his time he earned many thousands of *scudi*, and could have well afforded to pay more attention to quality instead of quantity, thereby enhancing both his own reputation and that of his profession), still, giving himself over entirely to the matter in hand he laboured ceaselessly, having no other aim but to earn all he could (in this his temperament was like Tintoretto's) and to store up wealth, thinking that the riches he had already accumulated were still not sufficient to support him in his old age; but man cannot always be at the top of his form, one sometimes needs respite for quiet and repose, since refreshed spirits come more nimbly to aid the workings of the intellect, producing finer results. And ultimately there is no one more unhappy in this life than he who deprives himself of peace of mind in order to leave to posterity those hard-earned savings which are then often ill-spent.

But he gained little happiness from his sons, since of the two who remained to him, one died after wandering the world, having been taken in by the fraternity of the Convent of the Padri Crociferi in Naples who were so fond of his father; while the other, having devoted himself to a life of profligacy, died at an early age.

He was extremely sound of body, and always lived far from the cares and passions which lead man to an early grave, having nothing else in his head except work. Indeed, even as his wife was being buried, he set himself to paint, and when the women came back from the funeral, he asked them if they had made her comfortable. . . .

From "Vita di Jacopo Palma il Giovine", in *Le Maraviglie dell' Arte*, by Carlo Ridolfi, 1648. The translation for this book is by Judith Landry.

Camille Pissarro

b. 10 July, 1830. St. Thomas, Virgin Islands, West Indies.
d. 13 November, 1903. Paris, France.

Plate 62. Self-portrait, 1890; age 60.
Etching, 18.5 × 17.9 cms. Ashmolean Museum, Oxford.

Two letters from the twenty years of regular and frequent correspondence between Camille Pissarro and his son Lucien who left home to come to England in January, 1883, when he was nearly 20 years old.

Osny près Pontoise
21 May 1883

My dear Lucien

Your mother arrived yesterday from Paris via Auvers where she stayed two days. She is writing to you I hope to give you news of the family and of Marie in particular who is not well unfortunately.

It is folly to pay 3/6 for baking a dish; at Lacroix I had two plates of yours baked, and my 2 big plaques with two small ones at the side, the lot cost me 2f the little plaques 25c and the big ones 0.50c and not broken; you must have gone to someone with a big kiln.—Do not rely on the expertise of the English in these matters, do not think that here in Paris there are not facilities for these trifles, it is quite the contrary.

Yesterday I had a visit from the manufacturer Artigue from Barbotine, he complimented me on my exhibition; he is knowledgeable, he is perceptive and loves art which is very unusual.

I know very well that you cannot draw, my dear Lucien, I have told you a thousand times that it is essential for both eye and hand to grasp the form, and it is only by much drawing, drawing everything, drawing unceasingly that one fine day one is very surprised to find it possible to express something in its true spirit; you must not despair, if you could do some life-drawing in the free night-schools it would be very helpful. There should be something in London for a modest sum, here there would be no problem; you could find out from Duret.

I do not know if I shall be able to come to London this year, it takes money which is always very tight. However I would be glad if I could, it would be profitable from every point of view.

I met one of your boating companions, what an oar! Lalie, he asked me about you and sent good wishes; going with Artigue to the train yesterday I met Truffant with his wind-instrument, he was running to catch the train, there was only time to shake hands.

Your mother is shouting at me that I am leaving no space for her to write[1]—I must make myself scarce.

your affec. father
C. Pissarro

Camille Pissarro

Eragny par Gisors (Eure)
2 May 1891

My dear Lucien

I will be sending you shortly the new etchings which I told you I was hoping to finish but a new abscess had developed! I have been forced to stop all work, I am leaving tomorrow, Sunday, for Paris, and will go to see Parenteau who will probably perform the operation in question[2]—I was at a loss to know how I could leave here without money, misfortunes continue one after the other; I asked Amélie whether she could advance me 900f on the legacy which should be due soon, but she has not got the means herself: as a last resort I wrote to Monet who immediately sent me 1000f with which to pay the rent, 200 to Grancey, and a little for the house and to pay my Paris expenses, it will be quickly gone, but when will I sell something? . . . I sold nothing at my exhibition at Durand's, however I had a nice press-article from Geffroy, but from the other articles which I am sending you will see that I am accused of being without personality that I am sometimes Manet, Monet, *Sisley* and the *pointillistes*; however the discerning critic declares I have plenty of talent and this Cardon I think I have told you already has bought a little gouache of mine from Coutat . . . it is very very curious.—Tell me then when you write what has to be done about your engravings for the Indépendents? . . .

At the same time as the proofs I am sending you *Les Hommes du jour "Paul Cézanne"*.[3] They have not deigned to send me a copy! . . .

Mother is still unwell, she loses blood which makes her very weak, as always she only half looks after herself, while I was in Paris she hardly wrote to me at all. However she did call Dr Avenel who recommended that she should stay in bed and not tire herself, which she did for a few days and has immediately started working in the garden again, and with that she is more and more bad-tempered and aggressive.[4] Truly if I come through all this I will be lucky! . . . but what do I do! . . . wait for some stroke of luck, some chance . . . I have reached the end of my tether and begin to think that I am finished.

Write to me at rue de l'abreuvoir, I am leaving with Titi.[5]

The children send their love also your mother and your affectionate father

C. Pissarro

Georges[6] has almost finished another panel, an antelope beside the sea, it is rather good; another bigger one of forty centimetres of flamingoes with pink feet in a landscape, and the chest is finished at last, and he has so many ideas germinating at the moment provided that mother does not interrupt him . . .

I received a letter from Luce this morning telling me that he has got your frames, he is writing to Kahn and will mention Georges's things.

Here are the titles and No. of the etchings which I intend to send you.

1—3rd state No. 1 peasant at the well 65f
2—2nd state No. 1 poultry market at Gisor 65f
3—2nd state No. 1 vegetable market at Pontoi 65f

4—1st state No. 1—2nd. Series, Beggars' footpath at Pontoise 65f

I have my portrait[7] which I will send you when I am in Paris.

As for watercolours I am giving them up, I am unable to get on with them since I had my relapse.—I shall see what there is to be done in Paris, I am going to try to send you a little money.—But I am so flustered when I can see with one eye only that I lose the thread of things and cannot make up my mind. I will see when I get to Paris how things go.

<div align="center">

until then
C. P.

</div>

N.B. I am just arriving in Paris. I hope you will have written and that I get your letter tomorrow morning. I will go to see Parenteau tomorrow Monday.

From the original letters in the Ashmolean Museum, Oxford.

[1]Mme Pissarro did write to Lucien on the last page of the letter, but as in all the letters her writing has now been obliterated; nothing remains for posterity.
[2]An operation on his eye.
[3]A drawing of Cézanne by Pissarro had appeared in this publication.
[4]Mme Pissarro's frustration is understandable; they had a big family to bring up, and no money, and she must be forgiven if sometimes she thought her husband would be better employed digging the garden for food, than painting pictures which did not sell.
[5]Titi was Lucien's brother Félix, aged 16 at this time.
[6]Georges, the eldest of Lucien's four brothers, was 19 at this time.
[7]The self-portrait etching reproduced here is the portrait to which Pissarro was referring. Lucien's print was inscribed *I^er état No. 9 à mon fils Lucien.*

Baccio Bandinelli

b. 1493. Florence.
d. 1560. Florence.

Plate 63. Self-portrait, on the right, in a study, *Three male heads*, undated.
Pen and brown ink, 67'9 × 47.4 cms. Devonshire Collection, Chatsworth.

Vasari describes the rivalry between Bandinelli and Michelangelo.[1]

. . . In the time of Leo X, a piece of marble nine and a half braccia by five braccia[2] had been quarried at Carrara with the marble for the façade of S. Lorenzo at Florence. In this piece Michelangelo proposed to make a Hercules killing Cacus to put on the piazza beside his colossal David. He made several models and designs, and had sought the favour of Cardinal Giulio de' Medici and Pope Leo, saying that the

David had many faults, caused by Maestro Andrea, the sculptor who had first sketched it. But on the death of Leo both the façade and the statue were abandoned. Pope Clement, however, wished to employ Michelagnolo for the tombs of the Medici in the sacristy of S. Lorenzo so that it was necessary to quarry fresh marble. The accounts for this were kept by Domenico Boninsegni. He endeavoured to obtain Michelagnolo's secret co-operation to make a profit out of the façade of S. Lorenzo, but Michelagnolo refused, as he did not like his genius to be used for the purpose of defrauding the Pope. Domenico was so enraged that he employed every means to humiliate and injure Michelangelo, though he acted covertly. He contrived that the façade should be abandoned and the sacristy advanced, saying that the two works would keep Michelangelo employed for many years. He persuaded the Pope to give the marble for the giant to Baccio, who was then free, saying that these two great men would stimulate each other by competition. The Pope thought the advice good and followed it. Baccio made a large wax model of Hercules holding the head of Cacus with his knee between two rocks and squeezing him with his left arm, holding him between his legs in a painful attitude, Cacus suffering from the violence of Hercules, with every muscle strained. Hercules, with his head bent towards his foe, is grinding his teeth and striking his adversary's head with his club. When Michelagnolo heard that the marble had been given to Baccio he was very angry, but try as he would he could not change the Pope, who was pleased with Baccio's model. That artist boasted that he would surpass Michelagnolo's David, while Boninsegni declared that Michelagnolo wanted everything for himself. Thus the city was deprived of a great ornament which Buonarrotti would undoubtedly have produced. Baccio's model is now in Duke Cosimo's wardrobe, who values it highly, as do artists. Baccio was sent to Carrara to see the marble, the wardens of S. Maria del Fiore giving him a commission to bring it by the Arno as far as Signa, eight miles from Siena.[3] But when it was being taken out it fell into the river, which was low, and sunk so deeply in the sand owing to its weight that the wardens could not get it out, despite all their efforts. The Pope being anxious to recover it at all costs, employed Piero Rosselli, an ingenious old builder, to divert the stream, and then to take out the marble with levers, a work for which he won great praise. On this accident some satirical verses in Tuscan and Latin were written against Baccio, who was hated for his evil-speaking about other artists. One of them said that the marble, after being destined for the genius of Michelagnolo, had learned that it was to be mauled by Baccio, and in despair had cast itself into the river. . . .

[1]Giorgio Vasari was a contemporary of Bandinelli and Michelangelo. This extract is taken from his *Lives of the Painters, Sculptors and Architects*, translated by A. B. Hinds, edited by William Gaunt, first published as an Everyman edition in 1927, J. M. Dent & Sons Ltd. The original *Le Vite de' più eccellenti Architetti, Pittori, et Scultori Italiani* was first published in 1550.

[2]A braccia may be taken at 21 English inches, but varies greatly in different parts of Italy.

[3]This should read Florence, and not Siena.

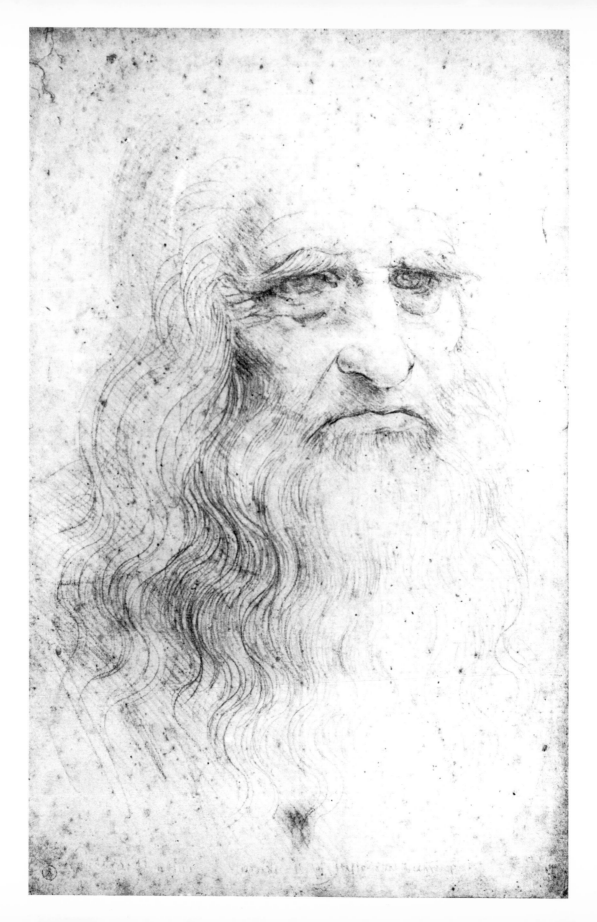

Leonardo da Vinci

b. 15 April, 1452. Vinci, Tuscany.
d. 2 May, 1519. Palais de Cloux, near Amboise, Loire, France.

Plate 64. Self-portrait, *c.* 1512; age 60.
Red chalk, 33.3 × 21.4 cms. Biblioteca Reale, Turin.

Five items from among the 1566 manuscript notes left by Leonardo—written in the original from right to left.

1170. Wrongly do men lament the flight of time, accusing it of being too swift, and not perceiving that it is sufficient as it passes; but good memory, with which nature has endowed us, causes everything long past to seem present.

1171. Acquire learning in youth which restores the damage of old age; and if you understand that old age has wisdom for its food, you will so conduct yourself in youth that your old age will not lack sustenance.

1172. The acquisition of any knowledge is always of use to the intellect, because it may thus drive out useless things and retain the good. For nothing can be loved or hated unless it is first known.

1173. As a day well spent brings happy sleep, so a life well used brings happy death.

1174. The water you touch in a river is the last of that which has passed, and the first of that which is coming. Thus it is with time present.

Life, if well spent, is long.

From *The Literary Works of Leonardo da Vinci*, compiled and edited from the original manuscripts by Jean Paul Richter, Sampson Low, 1883. The manuscripts are preserved in the Ambrosian Library and the Castello Sforzesco, Milan.

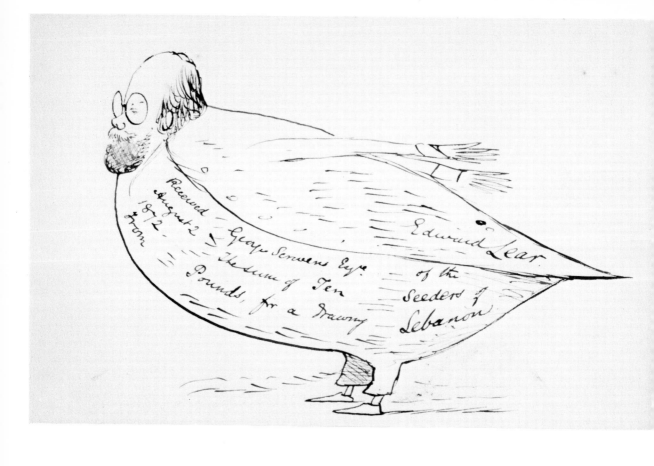

Edward Lear

b. 12 May, 1812. Bowman's Lodge, Holloway, London.
d. 29 January, 1888. Villa Tennyson, San Remo, Italy.

Plate 65. Self-portrait in caricature, on a receipt, August 2nd 1872; age 60.
Pen and ink, 12.1 × 19.1 cms. Whereabouts of drawing unknown.

<div align="right">

Villa Emily. San Remo
Xmas Day. 1871

</div>

My dear Lady Waldegrave & Chichester Fortesque,[1]

As your last letter to me was a joint Composition, I shall write a few lines to
both at once, just to wish you both a happy Xmas & New Year and many such.
I was very glad to hear from you, though I never wonder when I don't,
knowing how fully occupied both must be. I can't say as I knows how to fill this
sheet, for there is literally nuffin to say, except that barring one day of rain, we
have had cloudless days here since Nov[ber] 26. Up to the 21inst. it was cold in the
wind or shade, but June in the shunsine,—but since that day of rain it is quite
warm & most lubly for to see.

I'm sorry to hear Lady Strachey[2] is so unwell: I often think how nicely her
little boy would repeat a poem I have lately made on the Jonghy Bonghy Bo.
Mrs Bruce, I hear from her sister Pamela who is wintering here, is better. I
wonder if you have both been edified by my "More Nonsense"[3]—wh. I find is
enthusiastically received by the world in general. I was only away from San
Remo a little while in Noctober, going as far as Genoa with Franklin
Lushington of Thames P.[4] Court—who came to stay with me a bit. I told
S.P.Q.R.F about my visit to Rome, in a letter I wrote last Sept[ber]. (Bye the
bye—there is a nelderly Mr Faithful Fortesque here: is he anybody's uncle or
aunt?)

I am bizzy in these short days in working at small pictures in oil,—& what is
my spare bedroom in spring or summer I make my painting room now—as it is
warmer.

San Remo is fullish: Knatchbells, Philip Miles, Calls, a'Courts, Monteiths, Dr
K Buchanan & Co—Dr. Isabella Hope & Co—Pitts, Levison Gowers[?] Ridleys,
Galtons & what not—but I see as few people as possible, till I open my Studio
for Wednesdy afternoons, wh. I can't do yet. Have sold one 12£ drawing, as is
all I fear I may sell, but nobody knows. My garden is a great delight & looking
beautiful. Mice are plentiful, & so are green caterpillars; I think of
experimenting on both these as objects of Culinary attraction.—

Whether I shall come to England next year or Knot is as yet idden in the mists
of the fewcher. My elth is tolerable, but I am 60 next May, & feel growing old.
Going up & down stairs worries me & I think of marrying some domestic hen-
bird & then of building a nest in one of my own Olive trees, whence I should

only descend at remote intervals during the rest of my life.

 This is an orfle letter for stupidity—but there is no help for it.

 Goodbye, & with every good wish.

<div align="right">

Yours affectionately

Edward Lear.

</div>

He ends the letter with a drawing of himself under a big sun-hat, his right arm round his domestic hen-bird (Lear had never married) in a nest, up a tree.

[1]Fortescue had been a friend of Lear for about 30 years. He held various Parliamentary posts, married Lady Waldegrave in about 1863, and later became Lord Carlingford. In the original letter (in Somerset Record Office, Taunton), Lear has written the names—Lady Waldegrave & Chichester Fortescue—in the shape of a large O. One of the homes of Lady Waldegrave was Strawberry Hill, Twickenham.

[2]Lady Waldegrave's niece.

[3]*More Nonsense*, published by Robert John Bush in 1872, must already have been on the market in late 1871.

[4]Thames Police Court. Lear's friend, Lushington, was a barrister.

Jacopo Pontormo

b. 24 May, 1494. Pontormo, near Empoli, Italy.
d. 31 December(?), 1556. Florence, Italy.

Plate 66. Self-portrait,[1] undated.
Black chalk, 10.5 × 8.2 cms; on a "Rogers" mount. Ashmolean Museum, Oxford.

A random selection of entries from the diary Pontormo kept between 1554 and 1556, the year he died, aged 62. His house was in Florence, and he had been working since 1546 on frescoes in the church of S. Lorenzo which were still unfinished at his death.[2]

1554	Sunday the 7th. of January, 1554, in the evening I fell and struck my shoulder and was ill, and stayed at Bronzino's[3] house six days. After I returned home I was still ill until Carnival which was the 6th. of February, 1554.
	On Sunday morning the 11th. of March 1554, dined with Bronzino, chicken and veal and felt well (it is true that I got home and to bed rather late, and on waking I felt flatulent and full,—it was a rather beautiful day.) In the evening supped on a little roasted bacon
March 12	which made me thirsty, and Monday evening I supped on a cabbage and one *pesce d'uovo*.
13th	Tuesday evening supped on a half head of *cavretto* and soup.
14th	Wednesday evening had the other half fried and a good quantity of raisins, and 5 farthingsworth of bread, and capers in salad.
15th	Thursday evening a soup of good capon and salad with *barbatella*; Thursday morning had a giddiness which lasted all day and felt unwell and lightheaded.
16th	Friday evening salad of *barbatella* and *pesce d'uovo* made with two eggs.
17th & 18th	Saturday fasted. Sunday was the evening of the olives (*Palm Sunday*), I supped on a little boiled capon and a little salad, and had three farthingsworth of bread.
19th	Monday evening since supper I felt very energetic and well-disposed. Had lettuce salad and a light soup of good capon and 4 farthingsworth of bread.
22nd	Thursday evening, a lettuce salad and caviare and one egg. The Duchess came to S. Lorenzo, also the Duke.[4]
June	On Saturday the 2nd. of June in the evening I bought a chair which cost me 16 lire.
Oct. 18th	The 18th., the eve of St. Luke, started to sleep downstairs with the new quilt.
	The 19th. October I felt ill having caught a cold, and afterwards was troubled with phlegm which for several evenings I was unable to get

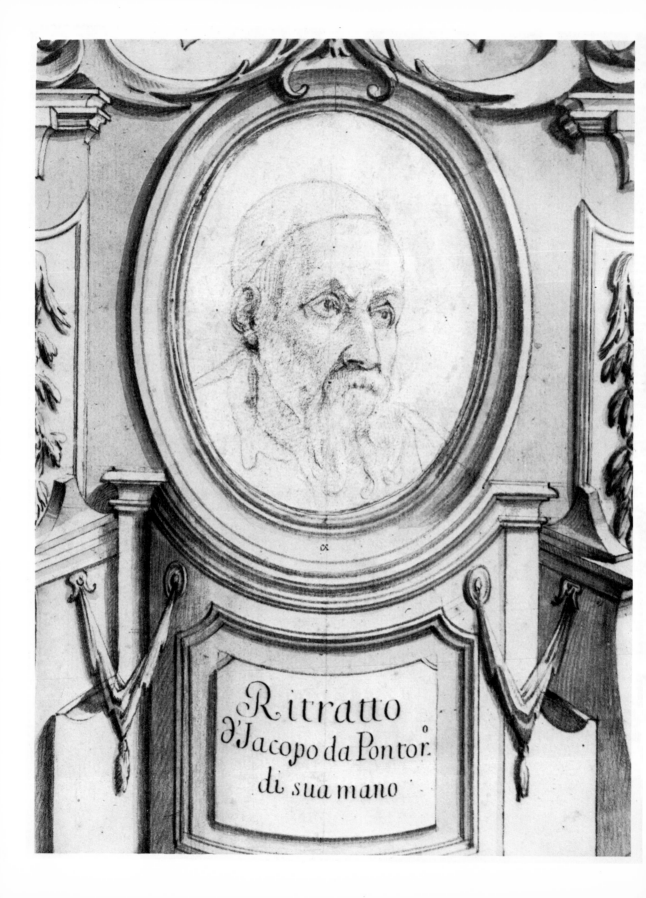

Ritratto
d'Jacopo da Pontor.º
di sua mano

rid of, the same has happened before. I do not know if it is because the weather improved, but from then I recovered a little and started to eat quite well; and in 3 days had 30 ounces of bread, that is to say 10 oz. a meal, once a day, and a little to drink. And before the 16th of the month bottled 6 barrels of *vino da Radda*.

1555 30th. January 1555 began the figure who is crying over the child. 31st., painted a little of her drapery. The weather bad, I have had stomach pains for two days, and bowel trouble. The moon has reached the first quarter.

August 25th Sunday, lunched with Bronzino and did not go to Mass.

Sunday, . . . lunched with Bronzino and in the evening at supper had severe toothache.

Monday, became vexed with Bastiano[5] and did no work, and until Saturday stayed at home to draw.

Sunday, lunched with Bronzino, and in the evening did not eat.

Monday, I drew.

Tuesday, started this figure below the head. [*Figure*]

Wednesday, the body below the breast.

Thursday, the whole leg.

Friday, it rained.

Saturday, was St. Matthew's day.

Sunday

Oct. 5th Sunday, the 5th. October Batista went to Pogio, and in the evening had *tucte cosacce e di voglia* and had toothache again.

Monday Tuesday Wednesday Thursday Friday worked below the figure as far as the frame. Saturday, prepared the cartoon which goes at the side. A cabbage for supper cooked by myself, and during the night removed something from my tooth and ate much better.

1556 On the first day of January 1556, Wednesday, lunched with Bronzino and had supper of wild duck with Ataviano.

Jan. 2nd Thursday evening supped on boiled pork and a *farciglione* and Batista did not want to eat.

3rd Friday, supper with Bronzino of fish which Padovano gave me, a lemon and some eggs.

4th Saturday morning it started to rain and the weather became bad after ten fine days; in the evening I bought a cloak which cost me 12 lire, and met Bastiano who brought four scudi from the fathers for rent.

Sunday dined with Bronzino.

March 3rd March 3rd., did the head of the figure drawn thus. [*Figure*]

4th day of March painted part of the body as far as the breast, and suffered from the cold and wind so much at night and yesterday could not work.

The 6th., I finished the whole torso.

7th., did the legs.

15th., Sunday, Bronzino knocked, and then Daniello; I do not know what they wanted.[6]

18th., plastered the wall under the window.[7]

Thursday the 19th., met Daniello and Attaviano who wanted to give me lunch; then I met Bronzino at S. Lorenzo who was sending his picture to Pisa.

Friday

Saturday

Sunday, Bronzino, Daniello and Ataviano came to the house, and I bought bamboo and willows for the orchard; and Bronzino wanted me to come to lunch, and huffily told me:—one would think you were coming to the house of an enemy!—and left in anger.

July 20th Monday evening the 20th. July, supped, and remained without eating until Wednesday evening. Did part of the arm and part of the leg and the said back. On Tuesday I requested Batista to see them. Wednesday the 22nd. I did the head and part of the shoulder. Supper with Daniello.

On the said 20th. in the morning I received a measure of grain. In the evening I washed my feet, and I hit my leg against the door so badly that it still hurts me, and we are now at the 25th. . . .

From *Jacopo Carruci da Pontormo* by Frederic Mortimer Clapp, Yale University Press, 1916; reprinted by Junius Press, NY 1972. This translation was specially done by Antoinette and Nigel Rubbra. The diary is preserved in the Biblioteca Nazionale, Florence.

[1]The drawing was once in the C. Rogers collection, hence the elaborate ornamental mount into which it has been set. Inscribed below is *Ritratto d'Jacopo da Pontor⁰. di sua mano*, but to quote the Parker catalogue "neither the authorship of the drawing or the identity of the sitter can be accounted as certain".

[2]The frescoes, finished by Bronzino, have not survived.

[3]Angelo Bronzino (1503–72): pupil and friend of Pontormo.

[4]Duke Cosimo de'Medici: who commissioned the frescoes.

[5]Bastiano Naldini: young pupil of Pontormo who lived with him.

[6]Pontormo's workroom was up aloft, reached by a ladder which he could draw up after him and remain oblivious to and out of the reach of callers.

[7]Pontormo refers to the *intonaco* or smooth final layer of plaster with which the wall was freshly prepared for each daily stint of fresco painting.

Henri Matisse

b. 31 December, 1869. Le Cateau-Cambrésis, France.
d. 3 November, 1954. Nice, France.

Plate 67. Four self-portraits, October 1939; age 69.
Crayon, each 36.8 × 26.0 cms. Private Collection.

Exactitude is not truth

Among these drawings, which I have chosen with the greatest of care for this exhibition, there are four—portraits perhaps—done from my face as seen in a mirror. I should particularly like to call them to the visitors' attention.

These drawings seem to me to sum up observations that I have been making for many years on the characteristics of a drawing, characteristics that do not depend on the exact copying of natural forms, nor on the patient assembling of exact details, but on the profound feeling of the artist before the objects which he has chosen, on which his attention is focussed, and the spirit of which he has penetrated.

My convictions on these matters crystallized after I had verified the fact that, for example, in the leaves of a tree—of a fig tree particularly—the great difference of form that exists among them does not keep them from being united by a common quality. Fig leaves, whatever fantastic shapes they assume, are always unmistakably fig leaves. I have made the same observation about other growing things: fruit, vegetables, etc.

Thus there is an inherent truth which must be disengaged from the outward appearance of the object to be represented. This is the only truth that matters.

The four drawings in question are of the same subject, yet the calligraphy of each one of them shows a seeming liberty of line, of contour, and of the volume expressed.

Indeed, no one of these drawings can be superimposed on another, for all have completely different outlines.

In these drawings the upper part of the face is the same, but the lower is completely different. In no. 158, it is square and massive; in no. 159, it is elongated in comparison with the upper portion; in no. 160, it terminates in a point; and in no. 161, it bears no resemblance to any of the others.

Nevertheless the different elements which go to make up these four drawings give in the same measure the organic makeup of the subject. These elements, if they are not always indicated in the same way, are still always wedded in each drawing with the same feeling—the way in which the nose is rooted in the face—the ear screwed into the skull—the lower jaw hung—the way in which the glasses are placed on the nose and ears—the tension of the gaze and its uniform density in all the drawings,—even though the shade of expression varies in each one.

It is quite clear that this sum total of elements describes the same man, as to his character and his personality, his way of looking at things and his reaction to life,

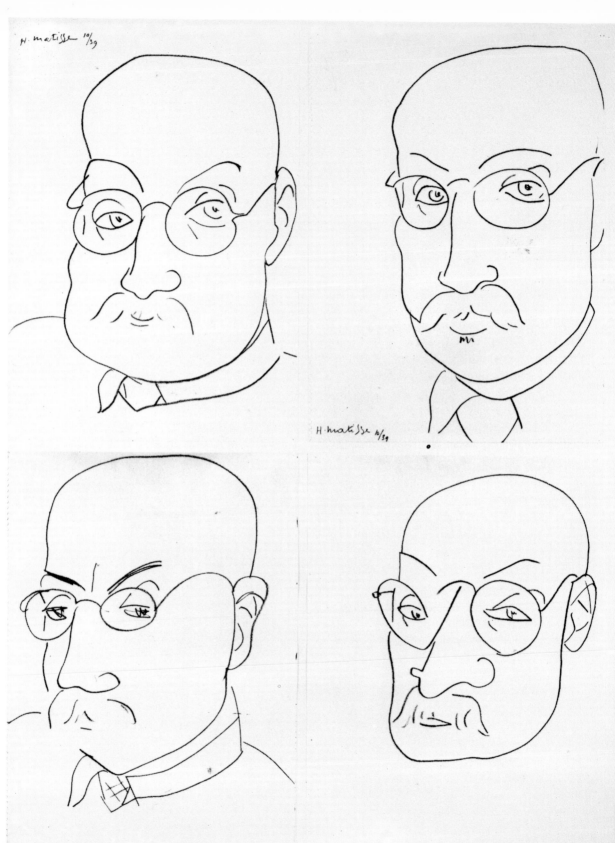

and as to the reserve with which he faces it and which keeps him from an uncontrolled surrender to it. It is indeed the same man, one who always remains an attentive spectator of life and of himself.

It is thus evident that the anatomical, organic, inexactitude in these drawings, has not harmed the expression of the intimate character and inherent truth of the personality, but on the contrary has helped to clarify it.

Are these drawings portraits or not?

What is a portrait?

Is it not an interpretation of the human sensibility of the person represented?

The only saying of Rembrandt's that we know is this: "I have never painted anything but portraits."

Is the portrait in the Louvre, painted by Raphael and showing Joan of Aragon in a red velvet dress, really what is meant by a portrait?

These drawings are so little the result of chance, that in each one it can be seen how, as the truth of the character is expressed, the same light bathes them all, and that the plastic quality of their different parts—face, background, transparent quality of the spectacles, as well as the feeling of material weight—all impossible to put into words, but easy to do by dividing a piece of paper into spaces by a simple line of almost even breadth—all these things remain the same.

Each of these drawings, as I see it, has its own individual invention which comes from the artist's penetration of his subject, going so far that he identifies himself with it, so that its essential truth makes the drawing. It is not changed by the different conditions under which the drawing is made; on the contrary, the expression of this truth by the elasticity of its line and by its freedom lends itself to the demands of the composition; it takes on light and shade and even life, by the turn of spirit of the artist whose expression it is.

L'exactitude n'est pas la vérité.

<div align="right">

HENRI MATISSE
Vence, Mai, 1947.

</div>

Written by Matisse for the catalogue of his retrospective exhibition of paintings, drawings and sculpture at the Philadelphia Museum of Art in 1948, © 1948 Philadelphia Museum of Art. This translation is by Esther Rowland Clifford.

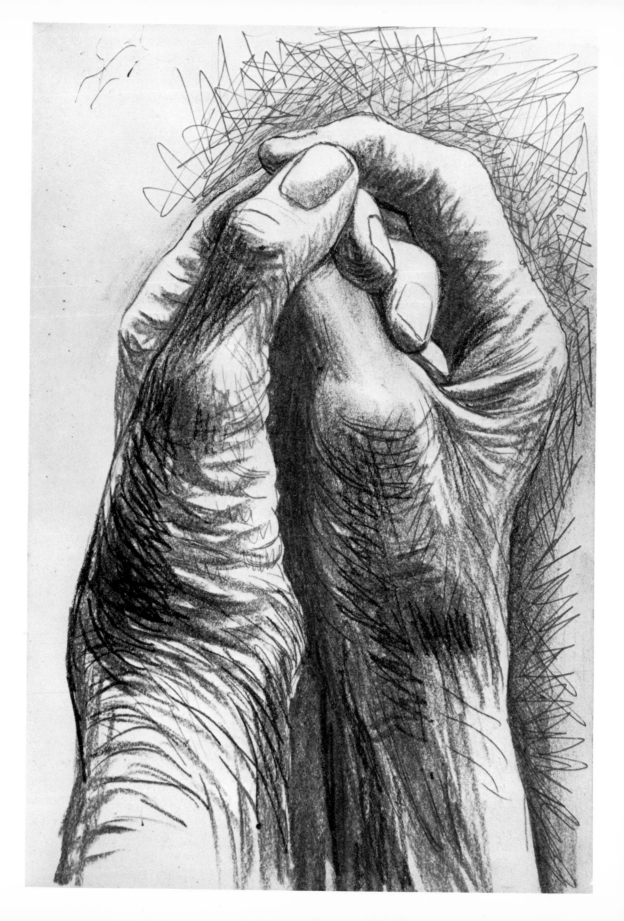

Henry Moore

b. 30 July 1898. 30 Roundhill Road, Castleford, Yorkshire.

Plate 68. Self-portrait hands, 1973; age 74/75.
Pencil, pen and ink, ball point, wax crayon and charcoal, in sketchbook,
25 × 17.4 cms. Private collection.

Henry Moore talks about work, 1964.

You see, I think a sculptor has to be a practical person—he can't be just a dreamer. If you're going to shape a piece of stone into a sculpture you must handle a hammer and chisel; you must be able to do it without knocking your hand; you must be a workman; you must be somebody with his feet on the ground.

I don't know whether it is true or not, but in England, north country people are looked upon as being very matter-of-fact, practical, hard-headed people. This may have something to do—I don't know; it's just a fanciful idea, probably—but this may have something to do with the fact that in England now there are some twenty or thirty young sculptors who've cropped up since the war; four or five of them are certainly Yorkshire. There's me, there's Barbara Hepworth, there's Armitage, there's Ralph Brown and Thornton.[1] Well, I though of five immediately who come from Yorkshire. There are probably another three or four if I went on thinking, but that may be just a fanciful idea, as I say. Perhaps there is something about Yorkshire itself. Of course, Yorkshire being a very big county, has a lot of variety in it, but although I now live in Hertfordshire and have done so for the last twenty years, I don't think that the landscape around here has influenced my sculpture very much, although the sky and the clouds and the trees are the same wherever you are, and those are the big factors. Perhaps what influenced me most over wanting to do sculpture in the open air and to relate my sculpture to landscape comes from my youth in Yorkshire; seeing the Yorkshire moors; seeing, I remember, a huge natural outcrop of stone at a place near Leeds[2] which as a young boy impressed me tremendously—it had a powerful stoniness like Stonehenge has—and also the slag heaps of the Yorkshire mining villages, the slag heaps which for me, as a young child, were like great mountains. They had the scale of the pyramids; they had this triangular, bare, stark quality that was just as though one were in the Alps. Perhaps such impressions when you're young are what count.

You see, I think a sculptor is a person who is interested in the shape of things. A poet is somebody who is interested in words; a musician is someone who is interested in or obsessed by sounds. But a sculptor is a person obsessed with the form and the shape of things, and it's not just the shape of any one thing, but the shape of anything and everything: the growth in a flower; the hard, tense strength, although delicate form of a bone; the strong solid fleshiness of a beech tree trunk. All these things are just as much a lesson to a sculptor as a pretty girl—as a young girl's figure.

They're all part of the experience of form and space and therefore, in my opinion, everything, every shape, every bit of natural form: animals, people, pebbles, shells, anything you like are all things that can help you to make sculpture. And for me, I collect odd bits of driftwood—anything, I find, that has a shape that interests me—and keep it around in that little studio so that if any day I go in there, or evening, within five or ten minutes of being in that little room there will be something that I can pick up or look at that would give me a start for a new idea. That is why I like leaving all these odds and ends around in a small studio—to start one off with an idea.

. . . For example, the maquette for this two-piece locking piece came about from two pebbles which I was playing with and which seemed to fit each other and lock together; and this gave me the idea of making a two-piece sculpture[3]—not that the forms weren't separate, but that they knitted together. I did several little plaster maquettes, and eventually one nearest to what the shape of this big one is now pleased me the most and then I began making the big one. But in making the big one, the small one changes because you have to alter forms when they are bigger from what they are when they're small, because your relationship to them is a different one. You see there is a difference between scale and size. A small sculpture only three or four inches big can have about it a monumental scale, so that if you photographed it against a blank wall in which you had nothing to refer to but only itself—or you photographed it against the sky, against infinite distance—a small thing only a few inches big might seem, if it has a monumental scale, to be any size. Now this is a quality that I personally think all really great sculpture has; it's a quality which, for me, all the great painters have—Rubens, Masaccio, Michelangelo—all the great painters, artists, and sculptors have this monumental sense.

. . . One of the things I would like to think my sculpture has is a force, is a strength, is a life, a vitality from inside it, so that you have a sense that the form is pressing from inside trying to burst or trying to give off the strength from inside itself, rather than having something which is just shaped from outside and stopped. It's as though you have something trying to make itself come to its shape from inside itself. This is, perhaps, what makes me interested in bones as much as in flesh because the bone is the inner structure of all living form.[4] It's the bone that pushes out from inside; as you bend your leg the knee gets tautness over it, and it's there that the movement and energy come from. If you clench a knuckle, clench a fist, you get in that sense the bones, the knuckles pushing through, giving a force that if you open you hand and just have it relaxed you don't feel. And so the knee, the shoulder, the skull, the forehead, the part where from inside you get a sense of pressure of the bone outwards—these for me are the key points. You can then, as it were, between those key points have a slack part, as you might between the bridge of a drapery and the hollow of it, so that in this way you get a feeling that the form is all inside it. . . .

From *Five British Sculptors . . . (Work and Talk)*, by Warren Forma, Grossman, 1964.

[1] Barbara Hepworth: born in Wakefield, 1903. She died in a fire at her studio in St.

Ives, Cornwall, May 20, 1975. Kenneth Armitage, born in Leeds, 1916. Ralph Brown, born in Leeds, 1928. Leslie Thornton, born in Skipton, 1925.

[2]The huge natural outcrop of stone is at Adel.

[3]*Locking-piece*; one of the three bronzes is on the Thames Embankment, between the Tate Gallery and Vauxhall Bridge, London. The others are in Brussels and The Hague.

[4]Henry Moore has drawn between 15 and 20 self-portrait hands.

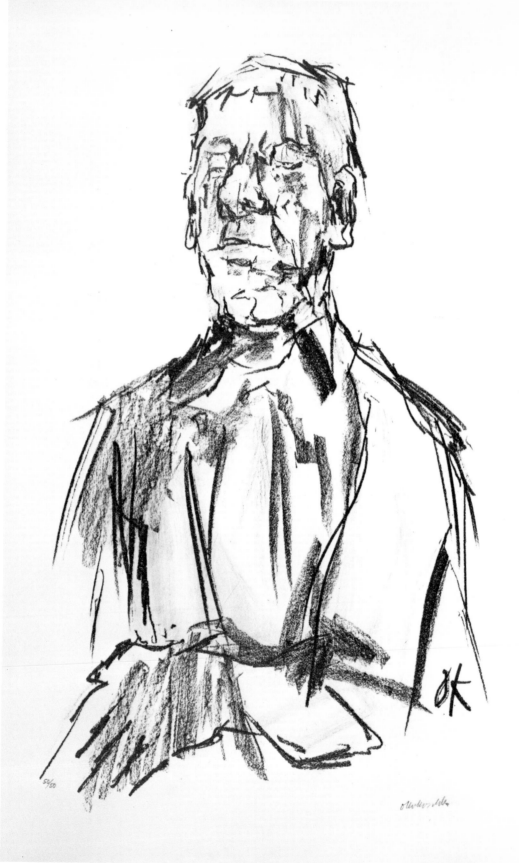

50/50

Oskar Kokoschka

b. 1 March, 1886. Pöchlarn, on the Danube, Austria.

Plate 69. Self-portrait, 1965; age 79.
Lithograph, 100.3 × 69.9 cms. Marlborough Fine Art Ltd, London.

. . . Here I would like to recall a self-portrait by Rembrandt which hangs in the National Gallery in London and is dated 1669; it is his last. I saw it properly for the first time on one of those London winter days when, without the means to survive, I felt myself to be on the outer fringes of human existence. The picture gave me courage to take up my life again. Rembrandt was suffering from dropsy; his eyes ran continually, and his sight was failing. How firmly he studies in the mirror the end of his own life! The artist's spiritual objectivity, and his ability to draw up a balance-sheet of his own life and give it pictorial form, convey themselves powerfully to the beholder.

To look at one's own physical decay, to see oneself as a living being in the process of changing into a carcass, goes far beyond the revolutionary Goya's PLUCKED TURKEY, a dead bird in a still-life. For there is a difference, after all, between being involved, oneself, and seeing it happen to another. A human spirit is about to be extinguished, and the painter records what he sees. . . .

From *My Life*, by Oskar Kokoschka. Thames and Hudson, 1974. Translated by David Britt from the original German, published in 1971 by F. Bruckmann KG, Munich.

Hokusai

b. 1760. Honjo in the district of Edo called Katsushika, Japan.
d. 1849. Edo, Japan.

Plate 70. Self-portrait,[1] 1842; age 82; by Japanese counting, age 83.
Brush drawing in black on pale grey Japanese paper, 26.8 × 17 cms. Rijksmuseum voor Volkenkunde, Leiden, Holland.

The Preface, by Ishikawa Gabō, to volume 2 of Hokusai's Mangwa, *or* Random Sketches.

Though no enthusiast, I can never take up this volume without feelings of amazed delight, and instinctively clap my hands at the sheer joy of it. For it shows me the wild creatures of mountain and plain, the fish that swim in the sea or stream, the birds, the insects, the grasses and the trees—all limned to life by the inimitable hand of a genius.

But above all, I delight in the presentation of the human form, whether it be the dignified figure of a man of rank, or the artless simplicity of the rustic kind, the humble Shinto shrine-keeper or the priest with the air of having attained to the Higher Perception, the proud aloofness of the philosopher or the bewitching air of the light-o'love, dissolute youth, bent old age or the crawling infant, the sedan-porter, the carter, the waterman, the ostler, the nurse and the mid-wife, the samurai's squire, the nobleman's page, the dyer, the thatcher, the bell-ringing courier, the tile-maker, the plasterer, the pedlar, the fortune-teller, the woodman, the diving-woman [*?Kadzukime*], the wrestler, the barber, folk going their ways, folk hob-and-nobbing, every type and every occupation drawn with the perfection of life and movement.

The painter is Hokusai uo ō, long established on a pinnacle of fame. Truly a Northern Star [hokushin] is he to those who turn his pages. His art conquers the heart as the gentle breeze stirs the early rice. What though my heart is no longer young, my tastes dulled? Let me but glance through these pages and my youth is renewed as broad smiles break over my features. I joy to think that my heart is not yet dead—nay, I am up to the ears in infatuation for the inspired master's matchless art.

(signed) ROKUJUYEN SHUJIN[2]
(Master of the Six Trees Garden)

The following writing of Hokusai himself is to be found in the envoy of his picture-book Fugaku Hyakkei—*or* One Hundred Views of Mount Fuji.

From the age of six I have had a mania for sketching the forms of things. From about the age of fifty I published many designs but of all I produced prior to the age of seventy there is nothing very remarkable. At the age of seventy-three I finally came to understand a little the true structures of nature, animals, grasses, woods,

birds, fishes and insects. Therefore, at eighty I shall gradually have made progress, at ninety I shall have penetrated the mystery of all things; at a hundred I shall have become truly marvellous, and at a hundred and ten, to me, each dot, each line, all shall possess a life of its own.

I only beg that every gentleman of long life take care to note the truth of my words.

At the age of seventy-five, former Hokusai, now Gwakyu Rojin (Old maniac for drawing) writes.

From *Fugaku Hyakkei*, published 1834–35 in three volumes. This translation was made by Yasu Mizoguchi from the Hokusai of Edmond de Goncourt, published in Paris, 1896.

[1] The self-portrait is drawn on a letter from Hokusai to his publisher. Mr. Tomimoto Kazuo has made this translation of the letter which may not be entirely correct but gives a good idea of the content. "The sketches which I made for this booklet I made when I was forty-one to forty-two years old. You will also find some which may be considered as duplicates. Also you will find one or two which when properly corrected I believe to be rather good. The rest of it is early and immature work. That you can discard with a smile and with my goodwill. Thus is written by the eighty-three years old Hachiemon." [2] Nom-de-plume of Ishikawa Gabō, a famous *littérateur* who was born in 1753 and died in 1830. The longhand translation of 1914, by T. Wakameda, and H. Inada, is in the Victoria and Albert Museum, London.